How to Paint
SKIN TONES

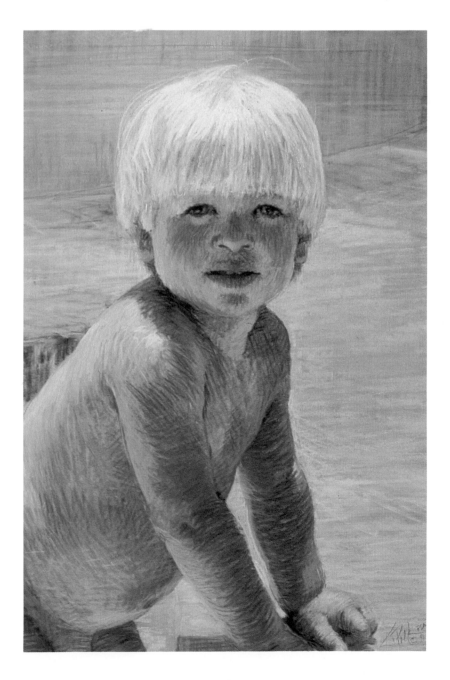

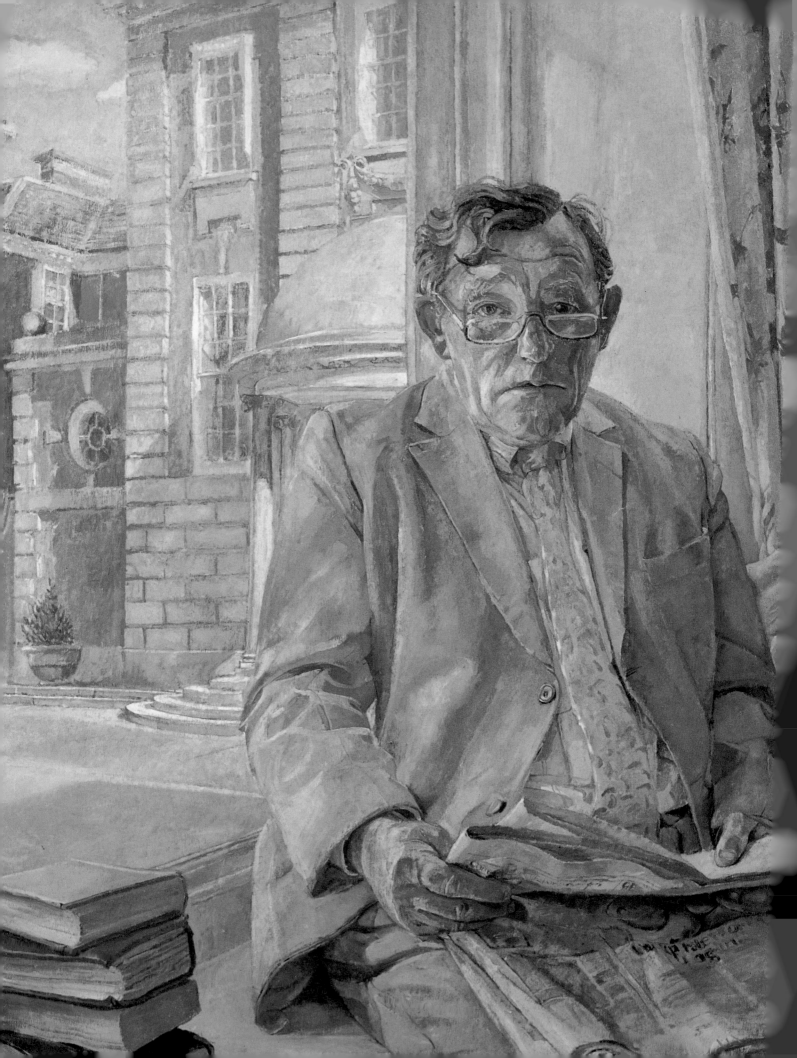

How to Paint
SKIN TONES

James Horton

Consultant Editor

Hazel Harrison

NORTH
LIGHT
BOOKS

Cincinnati, Ohio

First published in North America
in 1995 by North Light Books,
an imprint of F&W Publications, Inc.,
1507 Dana Avenue, Cincinnati, OH 45207
1-800/289-0963
Reprinted 1996 , 1998
Copyright © 1995 Quarto Inc.

ISBN 0-89134-670-8

This book was designed and produced by
Quarto Inc.
The Old Brewery
6 Blundell Street
London N7 9BH

Senior Editor Laura Washburn
Senior Art Editor Penny Cobb
Designer Vicki James
Photographers Colin Bowling, Paul Forrester,
Ian Howes, Laura Wickenden, John Wyand
Picture Researcher Jo Carlill
Picture Manager Giulia Hetherington
Editorial Director Sophie Collins
Art Director Moira Clinch

Typeset by Central Southern Typesetters, Eastbourne
Manufactured by Regent Publishing Services Ltd,
Hong Kong
Printed by Leefung-Asco Printers Ltd, China

Hill
by Kay Polk (p1)

Duncan Stewart Esq.
Principal, Lady Margaret Hall, Oxford
by Daphne Todd (p2)

Contents

Color charts
*Series of charts suggesting useful color mixtures for basic
skin tones, shadows and highlights*

Chapter 3: **Different Skin Colors**

50

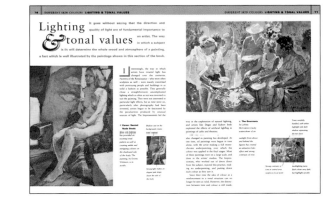

Introductions

Clear introductions to each theme plus inspirational paintings by artists working in different media and styles

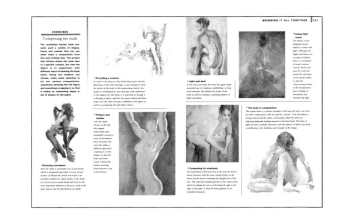

Exercises

"Hands-on" drawing and painting practice to build up your technical and observational skills

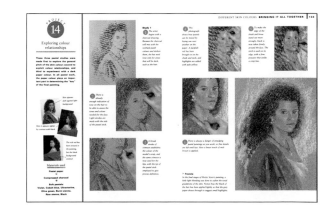

Projects

Step-by-step demonstrations to help you put what you have learned into practice

INTRODUCTION

The art of representational painting has been through many changes of style and technique in its long history, and for most of that time the human form has provided the core of subject matter. This book concentrates on one particular aspect of the subject – the painting of skin. This might appear to be a narrow area on which to focus but is in fact a rich source of material; for most of its history, Western art has been dominated by the typically pale Caucasian skin, but in the modern world we are exposed to the widest cross-section of racial types.

One of the primary aims of this book is to dispel the notion that skin color comes in only one shade, and can be rendered with a tube of paint labeled "flesh tint." Such colors are of no real help because there are wide variations of color even within skins that might be loosely described as "white" or "pink." The use of "formula" colors is also liable to hinder your first-hand observations and analysis of colors, which is the real business of objective painting.

The book looks at the major groupings of skin color, from pale Caucasian skin through mid-tones to dark African skin. A series of projects, exercises and finished paintings shows how a variety of artists, working with different media and in different styles, have achieved the often complex and subtle color effects. These not only illustrate the wonderful range of subject matter available through different skin types, but also show that, just as there are many skin colors, there are also many different ways of painting. The art and craft of painting, particularly as it was practiced in the past, is a highly flexible one in which many different techniques can be identified. And technical skills are important; paintings are so often begun full of hope and enthusiasm, only to fail through lack of knowledge

▲ *Pastels are well suited to rendering skin tones, as a very wide range of colors is available.*

▲▶ *Oil paints, the traditional medium for portraits and figure paintings, are easy to mix, and capable of many different effects.*

▼ *Conté crayons, which come in black, white and a selection of earth colors, are ideal for tonal studies.*

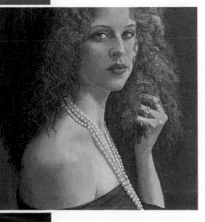

◀ **Lucy Jaroc**
In JAMES HORTON's *oil painting, the dark, almost plain background brings out the translucency and delicate colors of the skin.*

of the materials or through poor execution. It is a fallacy to believe that technical mastery destroys the "art." On the contrary, good technical practice ensures that you have an adequate vehicle for your feelings – any musician will confirm this.

We have also included a series of charts, which give useful suggestions for color mixes. These will help to provide a good working base in the early stages, but as you experiment with your chosen medium and gain experience, you will come up with your own ideas on color mixing.

Color is only one aspect of painting; tone is also important, as it is the nuances of light and dark that give a face or figure the appearance of solidity. Several of the exercises and projects concentrate on the relationship of tone to color, showing you how to observe the important shifts of tone that describe form, and how to achieve a good balance of tones and colors in your work.

The final section of the book touches on the more general concerns of painting, such as lighting, color relationships and composition. However well you observe and reproduce the colors of skin, a portrait or figure study will not fully succeed unless you can think of it as a painting, for which you use a specifically painterly language, rather than attempting a copy of the three-dimensional world.

There is an exciting world waiting to be discovered through painting people of different appearances and skin colors. The exercises and projects in the book will give technical help and we hope that the many illustrations will prove inspirational, providing you with appetite and enthusiasm for the subject.

James · V · Horton

▲ **Eve Astley**
Three-quarter views are most usual in portraiture, but in JAMES HORTON's *oil painting the profile works very well.*

▼ *Useful items of equipment: conté pencil, graphite pencil and charcoal for drawing, and soft brush for watercolor work.*

▼ *Watercolors require practice and careful handling, but can render skin tones very well.*

◀ *Bristle brushes are normally used for oil painting, but paint can also be applied with a palette knife.*

1

What You See

The first thing you as an artist must learn to do is to look at your subject and decide how you will translate it into paint. It is not simply a matter of learning to render skin colors accurately; you must also be able to make the person you are painting look solid and three-dimensional, which involves thinking about tonal value as well as colors. In the exercises and projects in this chapter, the emphasis is on using your eyes and mind to analyze what you see.

▶ Clockwise from top left:
Early Morning Breeze (detail) *James Horton*, **Brian** *Kitty Wallis*, **In from the Cold – Mr Thomas Patten, gardener (detail)** *Stephen Crowther*, **Boys Bathing after a Storm** *James Horton*

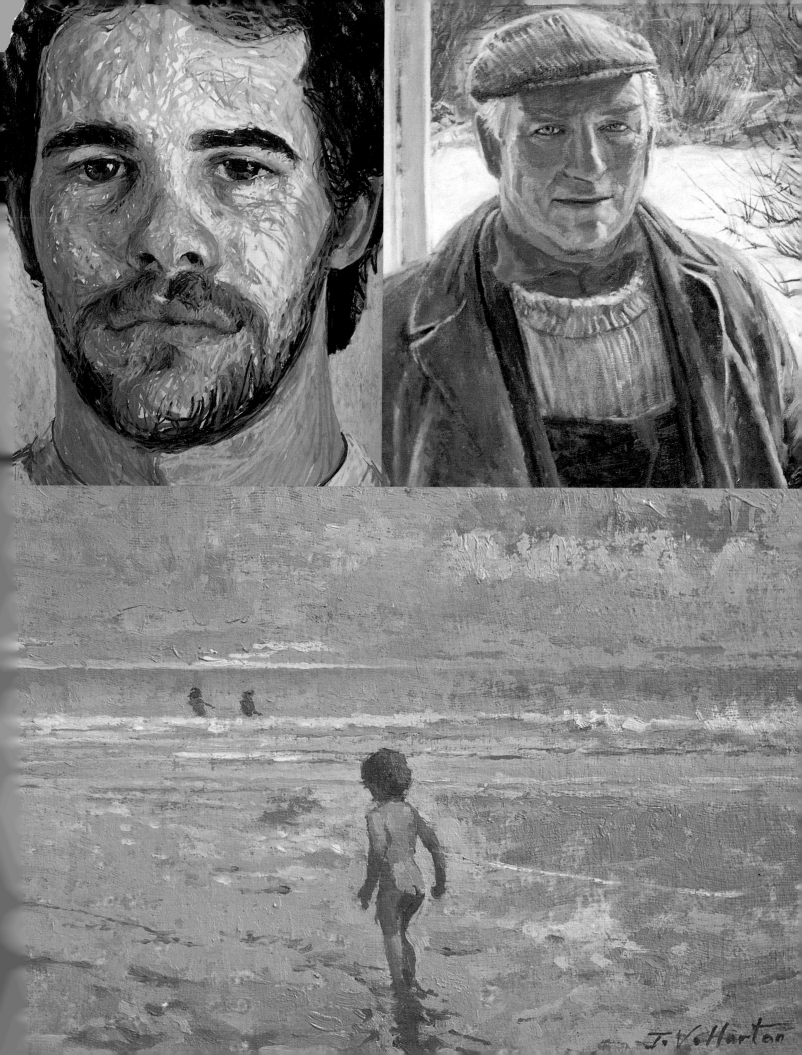

Tone &color

The word tone would seem to imply a monochromatic approach, and perhaps to be more relevant to drawing than to painting. But in fact it is simply one of the properties of color – tone means the relative lightness or darkness of a color. Tone has more than one role to play in painting, as we shall see later on, but what is most important initially is understanding how it models form. The light that falls on an object produces a range of tones, from highlight areas through various mid-tones to dark shadows. Place a mug on a table in strong light and you will see a minimum of four different tones – but only one color.

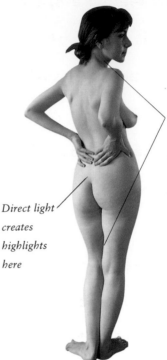

Darker tones where the form turns away from the light

Direct light creates highlights here

LIGHT & COLOR

And here is where the trouble starts. If the mug is blue, logic tells you that it will continue to be blue all over. But once you start to look at it as a painter you may identify purples in the shadow areas and perhaps pale mauves where the light strikes. So you must think not only about how light or dark the colors are, but also about how they differ from the "local" (actual) color. Since it is the color itself that our brains register immediately, it takes a little practice to be able to identify the precise tone of a color.

▼ Tone and color

It is easier to identify tone in a monochrome picture than in a color one. One trick when painting is to half-close your eyes to reduce the impact of distracting colors.

PITCH

A mistake often made when dealing with light colors, such as pale skin, is to pitch colors too high, with highlights almost white. But they seldom are; you only have to put a piece of white paper against a person's skin to see this for yourself. Pitch is a very important concept in painting, and one

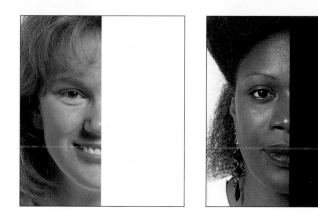

▲ **Understanding pitch**
Try holding white paper against pale skin, or black paper against dark, and you will soon understand the importance of pitch. This kind of comparison is the essence of evaluating colors and tones.

where a musical analogy may be helpful. A song can be sung in a low or high register, but the tune is the same. If you start singing too high, however, you may find that the top notes are out of your reach, while if you start too low, the bottom notes may be out of your register. You cannot change the tune, so you must find a starting point that will encompass both high and low. It is the same with tones; you cannot change the subject, but you can key it up or down, finding a level that allows the darkest and lightest colors to remain within the range of plausibility.

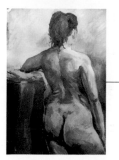

Pale tones: High pitch

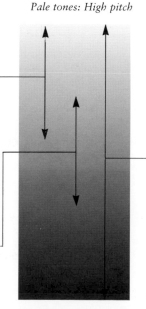

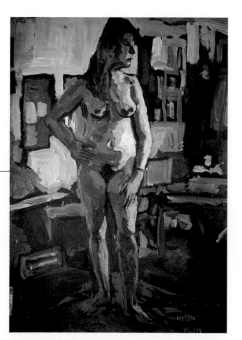

Dark tones: Low pitch

◄ **The range of tones**
Each of these studies depicts a fair-skinned dark-haired model but very different "pitches" have been chosen. The tonal scale (center) illustrates the various approaches: Olwen Tarrant's study of Anna (far left, top) is pitched high, using overall pale tones; Daniel Stedman's study of Kerry (far left, bottom) uses a range of mid-tones, while the same artist's study of Melany (left) is pitched low, with a predominance of dark tones that make the highlights sing.

PROJECT 1

Colored-paper collage

Collage is a method used by many artists, either on its own or in combination with conventional painting media. As a way of learning about color, it can be both exciting and rewarding, as it encourages you to think in terms of blocks of color, to consider how colors react when laid side by side, and how color can work as form. In this project colors and tones are gradated by using different pieces cut or torn to shape, so that the picture is built up rather like a mosaic.

Face is simplified in collage, but head firmly modeled

In collage, this area of dark tone translated into cool blues and mauves

Materials used

Cartridge paper (working surface)
●
Selection of colored papers
●
Selection of magazine sheets
●
Paper glue
●
Pencil

1 *Even though line is not an important element in collage work, most artists begin with some sort of preliminary sketch both to indicate where the main areas of color should be laid and to plan the composition. Here pencil has been used.*

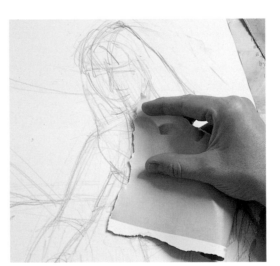

2 *As with painting, some approximated colors must first be put down to establish a key to which the successive layers can be related. The artist is attempting to find a basic flesh pink as a starting point.*

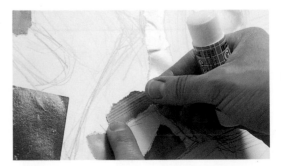

3 *Patches of color are placed all over the picture area. It is necessary to get these first statements down as quickly as possible, as you don't feel in control when putting marks into a blank area. Once the initial colors are in place they will begin to interact.*

4 Although the collage is still at an early stage, the network of colors is already lively and interesting, and the forms are beginning to emerge.

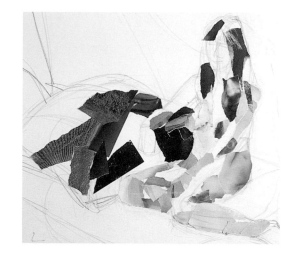

5 In this area, the drawing has now been almost completely worked over, and has gained complexity and interest as the pieces of paper become more refined in their placing.

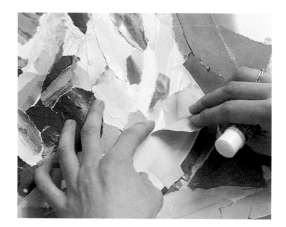

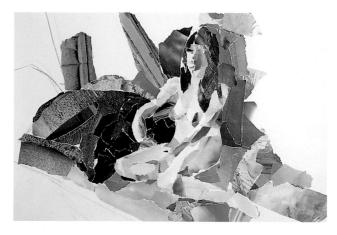

6 The gradations of color in the figure and background are working well. At this stage it is possible to see how adjacent colors on the figure blend when viewed from a distance to give an effect of solid form.

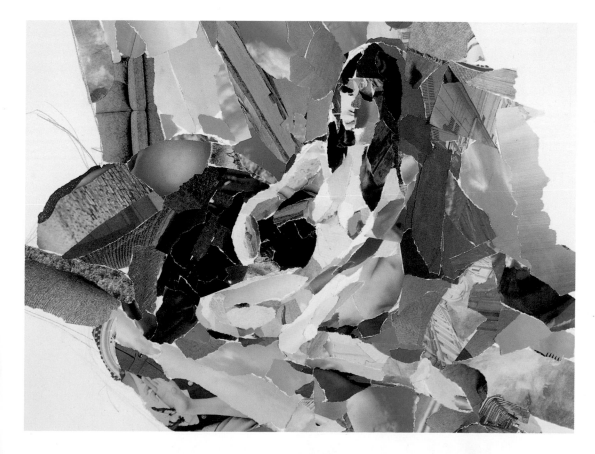

◀ **Justine**
The final picture, by KAREN RANEY, shows the considerable subtleties of color possible with collage. It also illustrates the way in which a large variety of different shapes are used in order to "draw" with color.

Monochrome collage

This project also uses the collage method, but here it is limited to an exploration of tone. Using only black, white and shades of gray forces you to simplify the subject into broad areas of tone and to identify the tone of each color. You will also need to look carefully at the shapes made by each area before placing each piece of paper. This is a valuable exercise, because instead of trying to reproduce exactly what you see, you will have to think in terms of shape, pattern and the organization of a two-dimensional surface.

Tonal contrasts are small here, requiring careful analysis

Shape made by shadow along shin bone defines form

Materials used

Cartridge paper (working surface)

•

Selection of gray paper, plus black and white

•

Paper glue

•

Pencils

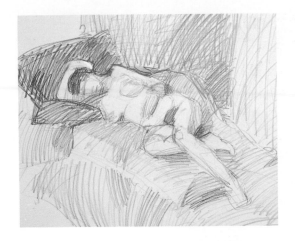

1 *The artist has begun by making a drawing that is quite resolved in itself. To lay a basis for the collage it was necessary to deal with both the linear aspect and the main masses.*

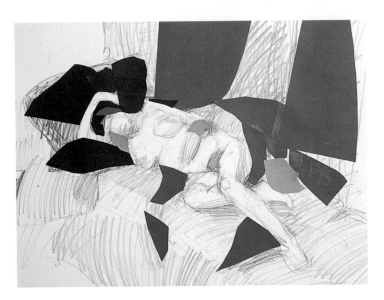

2 *The first pieces of cut paper have now been placed fairly evenly around the picture area. It is important at the beginning to avoid concentrating on one area, as you need to get a feel for the distribution of tones as quickly as possible.*

3 *A piece of gray paper is now carefully cut to fit a particular shape. The paper can be torn for less intricate shapes, but in this case the artist preferred to take a fairly precise approach.*

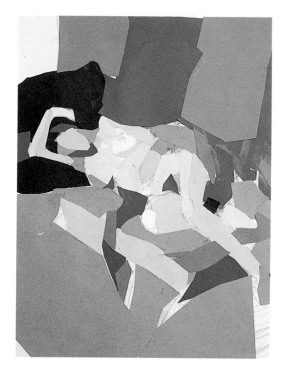

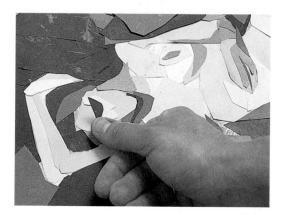

4 The collage is now quite well resolved, showing a good range of tone and contrast which demonstrates the value of learning about the pictorial organization of tone.

5 This detail illustrates how complex the collage process can become, with one layer placed over another, and final small pieces punctuating the larger flat areas. As in painting, it is usual to begin with a broad statement, which is refined as work progresses.

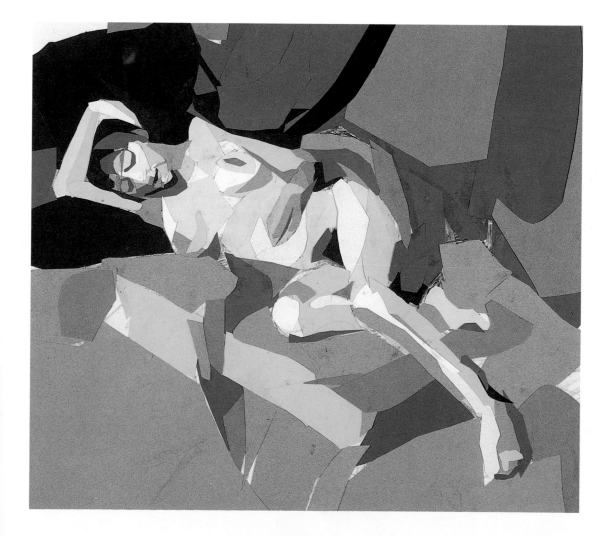

◀ **Justine Reclining**

The finished collage shows a strong pattern tone well ordered on the picture plane. Although KAREN RANEY has created intricate and complex cut-paper patterns in some areas, the overall simplification of tone has been carefully controlled.

PROJECT 3

Tonal study

Drawing forms the basis of more or less every aspect of visual art, and in this project a study was made using several different grades of pencil to explore the general distribution of tones in a nude figure. When making such studies, remember what you learned in Project 2, the monochrome collage. You are not only seeking an accurate representation of the fall of light, but also an interesting arrangement of shapes within the construction – known as the tonal pattern.

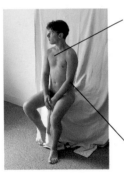

Complex pattern of lights and darks here has been simplified in drawing

Careful attention paid to shape of shadows, which describe the form

Materials used

Cartridge paper
•
Range of lead pencils, 2B–6B
•
Putty eraser

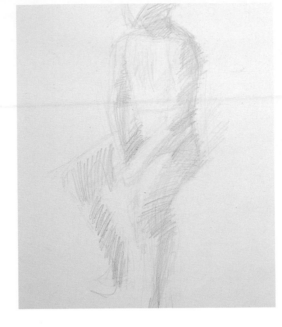

1 *The drawing is begun with the hardest pencil, to produce a very loose application of tone and only a bare minimum of linear definition.*

2 *The artist continues to build broad areas of tone. The lines that are visible are still loose and flexible.*

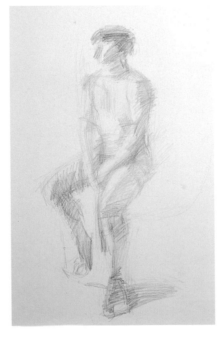

3 *The drawing is taking shape well, beginning to acquire strength and solidity, with the shapes made by each area of tone starting to emerge clearly.*

5 This detail of the lower leg shows how well the description of the form has been achieved by tonal masses, which blend together well when viewed from a distance. For this area, a very soft (6B) pencil is used.

4 *A putty eraser is used, not to correct mistakes but to create a highlight area, a method known as lifting out.*

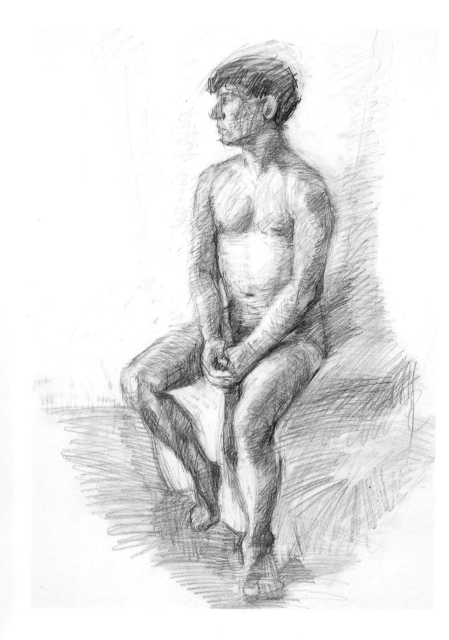

6 *In the head and neck area also, form is achieved with block tone simplified and held together without the use of a strong line.*

◄ **Tim**

In the final stages KAREN RANEY *sharpened the tonal relationships, again using the softer pencils for the darkest areas. Throughout the drawing she has avoided using hard outlines, which can destroy the impression of form in a picture, and instead has concentrated on the way the forms are modeled by light.*

CHAPTER

2

Paint Facts

In this chapter we give you some basic facts about the different painting media in order to help you choose the one that suits you best. But the heart of the chapter is a comprehensive series of color charts – one for each medium – in which you are shown suggestions for useful skin-color mixtures. These are intended only as a starting point – in time you will come up with your own ideas based on a personal choice of colors – but they may well save you a lot of time and trouble in the early stages.

▶ Clockwise from top left:
Mother (detail) *Paul Bartlett,* **Portrait of a Man** *Tom Coates,* **Chelsea Girl** *Maureen Jordan*

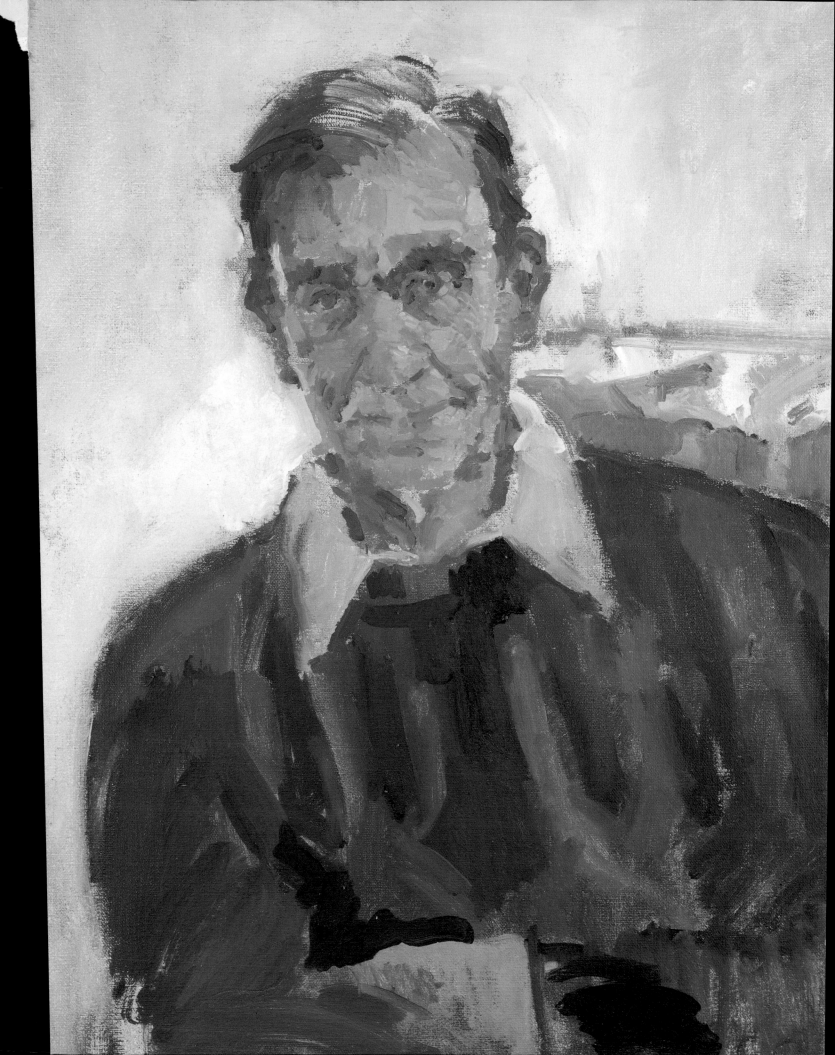

Understanding color mixing

Whichever of the painting media you choose, you will always have to mix colors in order to render skin accurately. Flower painters can sometimes indulge themselves by using a brilliant red or purple straight from the tube, but the colors of skin are subtler, and can seldom be matched by an unmodified tube color.

No one can provide a set of recipes for color mixing – achieving a good approximation of a color you see in your subject is something that will come with practice. The first step is to learn how to look at colors analytically, thinking of them in terms of the colors in your paint box, and the second is to familiarize yourself with your chosen medium. Not all paints behave in the same way, either when they are mixed on the palette or when they are applied to paper or canvas.

Every type of paint – oils, acrylics, watercolors, gouache paints and pastels – has the same basic component, which is pigment. In its raw form, this is a dry

▼ *Mixing oils on a palette.*

◀ *Mixing oils on canvas using a knife.*

◀ *Mixing watercolor on watercolor paper by overlaying.*

▲ *Mixing watercolor on the palette.*

powder, which is mixed, or bound, with various different mediums in order to turn it into paint. It is the medium used by the paint manufacturer that gives each kind of paint its individual character, making it either thick and opaque or thin and transparent.

With the exception of pastel, both opaque and transparent paints can be premixed in the same way – by combining two or more colors on a palette and blending them together with a brush or palette knife. But colors can be mixed on the picture surface too. In watercolor work, the classic method of building up colors and tones is to lay one wash over another, and to some extent this method can also be used with the opaque paints. Both oils and acrylics can be thinned and made transparent by the addition of a medium: Project 9 shows semi-transparent oil color laid in successive layers over a monochrome underpainting.

Another method of mixing on the working surface is by juxtaposing small dabs or strokes of color so that they mix optically when the picture is seen from a distance. This method is only suitable for the more solid, opaque paints such as oils, acrylics and pastels, where the strokes can remain separate – with watercolor they would simply run together.

▲ *Mixing pastels via crosshatching and overlaying colors.*

The painting media

OIL PAINTS are bound with oil, usually linseed, which is mixed with the pigment to give the characteristic thick, buttery consistency. Oil paints are slow to dry, so thick colors laid over one another will mix together on the canvas whether you want them to or not. This method, which is known as working "wet into wet" (**1**) can be useful for modifying colors, but if thick paint is used from the outset you can end up with a churned-up mess, so the most common method (and a safer one for beginners) is to start with paint thinned with turpentine, which dries fast, and work up to thicker colors as the painting progresses – called working "fat over lean" (**2**).

ACRYLIC PAINTS are water-based, bound with a kind of "plastic" resin, and can imitate both oils and watercolors as well as having many possibilities of their own. The tube consistency of acrylics is similar to oils, and they are mixed on a palette in the same way, but blending colors on the working surface is more difficult, as acrylics dry very fast. To use them thinly, like watercolors, you simply dilute the tube colors with water. Because of the plastic binder used in their manufacture, acrylics are immovable once dry, so you can build up pictures in successive layers. You can correct any errors in color by overworking with thick paint (**3**), and you can also use transparent glazes (**4**) to modify colors.

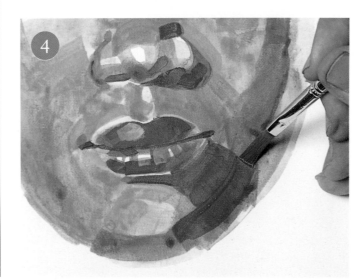

WATERCOLORS are pigment bound with gum arabic, and they are always transparent. When premixing watercolors, always bear in mind that the colors will dry much lighter than they appear in your palette (5). Because of their transparency, watercolors are worked from light to dark, with the white paper reserved for highlight areas (6). You can obtain dark or very vivid colors by building up in layers (7), allowing each to dry before the next is applied. As with acrylic, colors can also be altered by laying one over another, but don't become reliant on this method, as too much overlaying can result in an overworked appearance. Watercolors remain water-soluble even when dry, so each new application tends to "melt" the colors below and mix with them.

GOUACHE PAINTS are an opaque version of watercolors, and artists often combine the two, using thick gouache for highlights (8) and transparent watercolor for the darker colors. Like acrylic, gouache can be used thickly in its tube consistency, or thinned with water and applied in transparent washes. Colors can be laid over one another, but again be careful, as gouache paints also remain water-soluble.

PASTELS are almost pure pigment, bound with a little gum to hold them together in their stick shape. They differ from the other painting media in that they cannot be premixed; color mixing must be done on the paper either by laying one color over another (9) or by juxtaposing marks of different colors that mix optically. The way one layer of color shines through another produces vibrant color mixtures that are exploited by many pastel painters, but you can also achieve thorough mixes on paper by blending two or more colors together with your fingers or a rag (10).

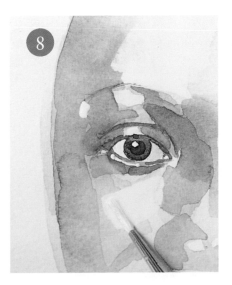

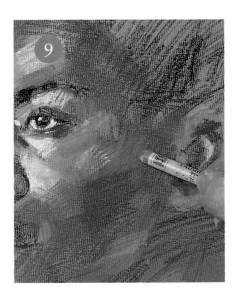

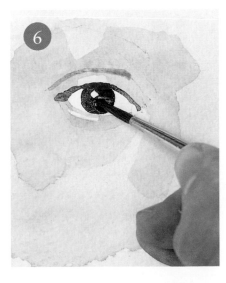

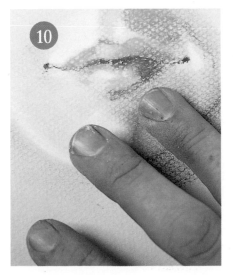

Using the color charts

The following pages include a series of color charts, one for each of the painting media. These give suggestions for a basic color for each of the main skin types, and show further colors which can be added for minor variations and effects of light and shadow. In the opaque media, white is used in the mix to lighten colors, while for watercolor, the "white" is extra water, with the paper reserved for any pure white highlights. Six pages are devoted to each media. These six pages are divided into three categories: pale, mid- and dark-toned skin. Each category covers two pages.

▶ We have selected these particular color charts as a starting point only. All artists have their own recipes for color mixing and there is no substitute for experimenting yourself. You could try and paint your own chart, substituting yellow ochre for lemon yellow, for instance; or why not try Payne's gray, mauve or even a green to give lively and unexpected shadow mixes. Or look at the Projects pages in this book and try some of the combinations of colors suggested in the materials lists.

Basic skin color is made up from a combination of the colors shown on either side.

The colors in the left-hand column are added in increasing amounts to the basic skin color. Three different mixes are shown as starting suggestions, but you can experiment with varying proportions.

Left-hand page shows suggestions for darkening the basic skin color.

Right-hand page shows suggestions for lightening the basic skin color.

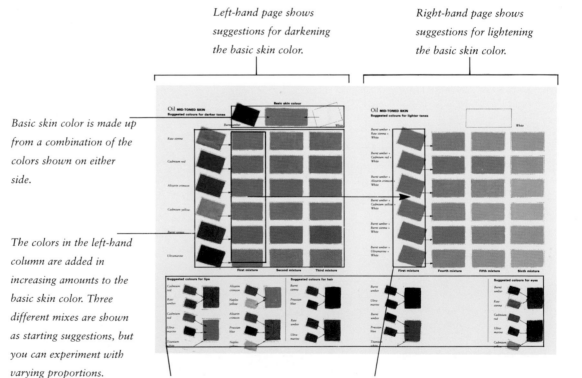

Along the bottom of each spread are various color mixes for lips, hair and eyes relevant to the skin tone. Again, try them for yourself and then experiment.

Here we have repeated the first basic skin color mixture (shown on the opposite page) and then added increasing amounts of white. (In the watercolor section this is increasing amounts of water, so that the white of the paper acts as the lightener.)

Watercolor PALE SKIN

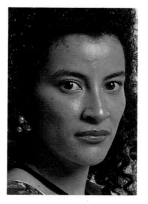

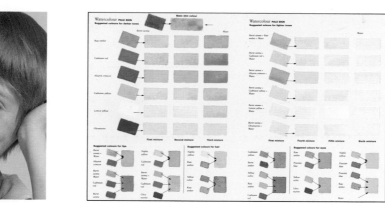

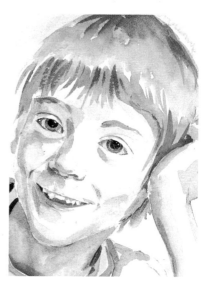

Six pages of watercolor charts for pale, medium and dark skin tones. Use the charts as a starting point and experiment farther, as we have done in the projects throughout the book.

Pastel MID-TONED SKIN

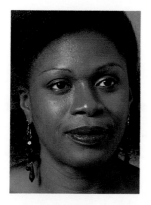

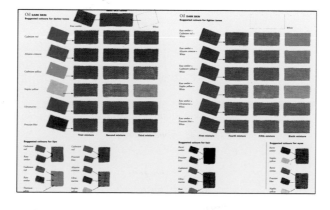

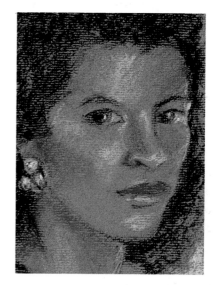

Six pages of pastel charts for pale, medium and dark skin tones. Use these charts as a starting point and experiment farther, as we have done in the projects throughout the book.

Oil DARK SKIN

Six pages of oil charts for pale, medium and dark skin tones. Use these charts as a starting point and experiment farther, as we have done in the projects throughout the book.

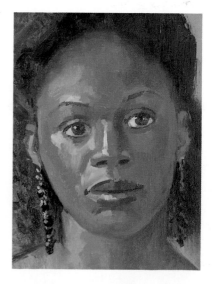

Oil PALE SKIN
Suggested colors for darker tones

Basic skin color

Burnt sienna

White

Raw umber

Cadmium red

Alizarin crimson

Cadmium yellow

Lemon yellow

Ultramarine

First mixture **Second mixture** **Third mixture**

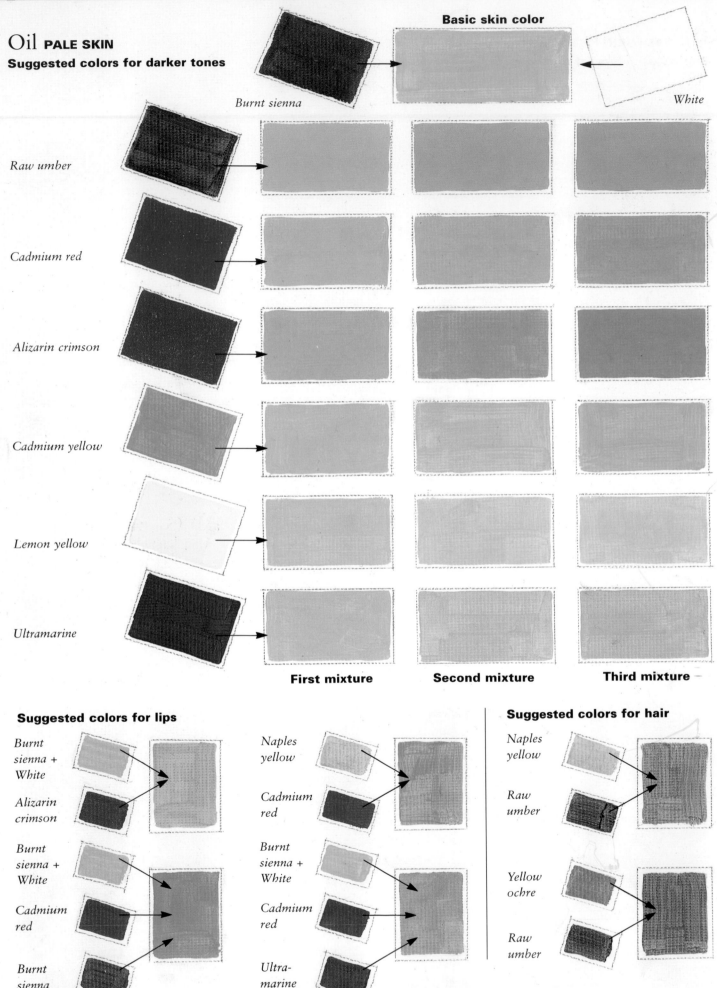

Suggested colors for lips

Burnt sienna + White

Alizarin crimson

Burnt sienna + White

Cadmium red

Burnt sienna

Naples yellow

Cadmium red

Burnt sienna + White

Cadmium red

Ultramarine

Suggested colors for hair

Naples yellow

Raw umber

Yellow ochre

Raw umber

Oil PALE SKIN
Suggested colors for lighter tones

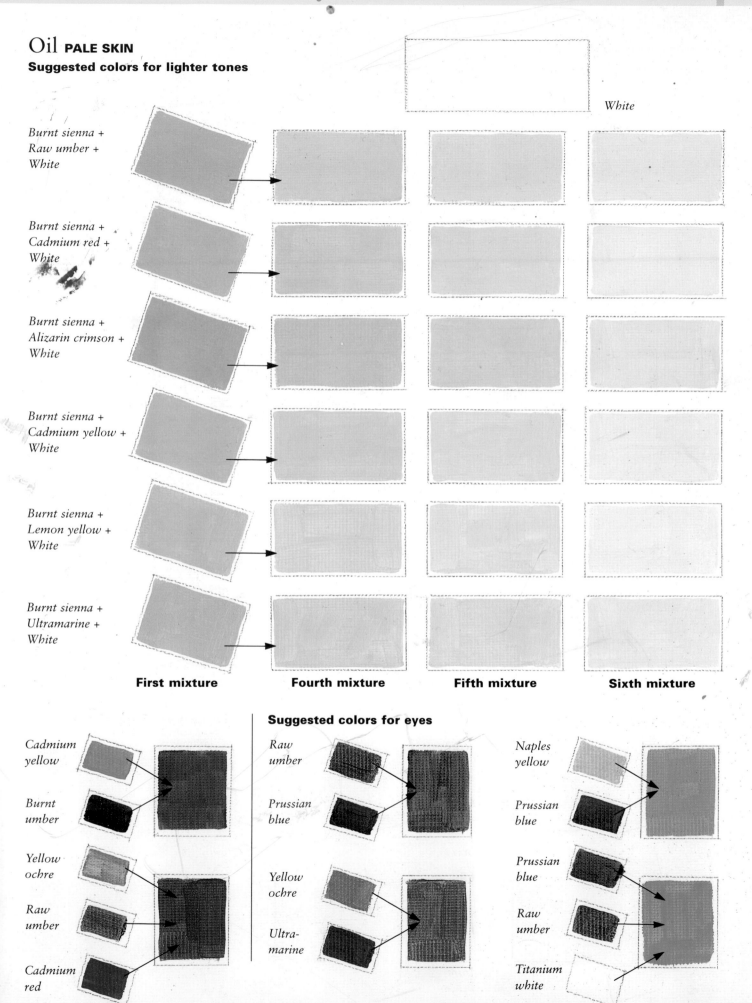

White

Burnt sienna +
Raw umber +
White

Burnt sienna +
Cadmium red +
White

Burnt sienna +
Alizarin crimson +
White

Burnt sienna +
Cadmium yellow +
White

Burnt sienna +
Lemon yellow +
White

Burnt sienna +
Ultramarine +
White

First mixture **Fourth mixture** **Fifth mixture** **Sixth mixture**

Suggested colors for eyes

Cadmium yellow

Burnt umber

Yellow ochre

Raw umber

Cadmium red

Raw umber

Prussian blue

Yellow ochre

Ultra-marine

Naples yellow

Prussian blue

Prussian blue

Raw umber

Titanium white

Oil MID-TONED SKIN
Suggested colors for darker tones

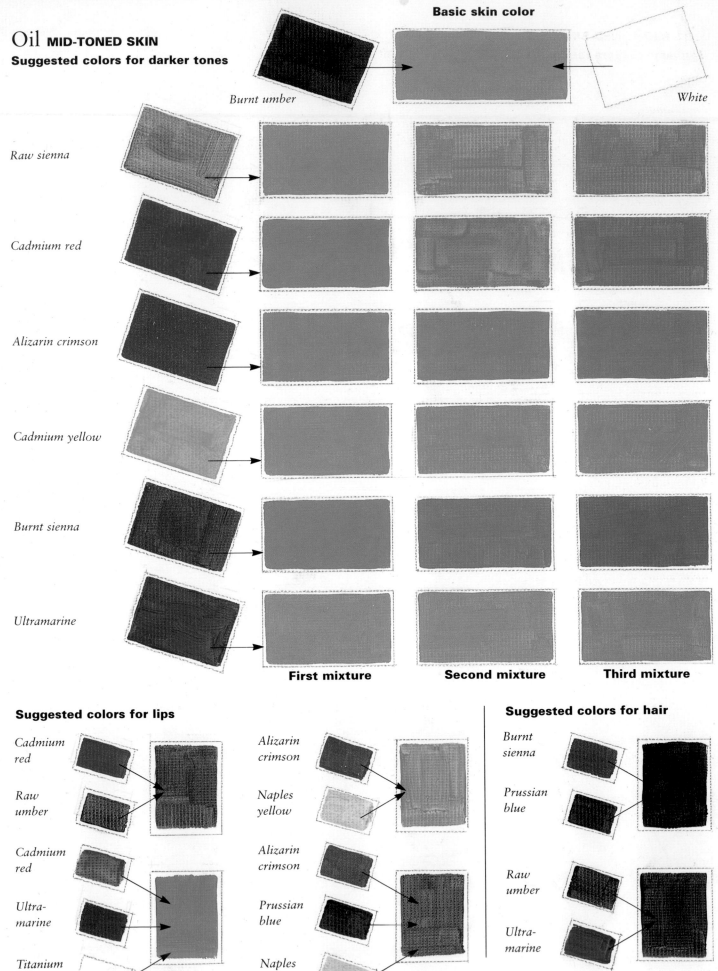

Basic skin color

Burnt umber

White

Raw sienna

Cadmium red

Alizarin crimson

Cadmium yellow

Burnt sienna

Ultramarine

First mixture **Second mixture** **Third mixture**

Suggested colors for lips

Cadmium red

Raw umber

Cadmium red

Ultramarine

Titanium white

Alizarin crimson

Naples yellow

Alizarin crimson

Prussian blue

Naples yellow

Suggested colors for hair

Burnt sienna

Prussian blue

Raw umber

Ultramarine

Oil MID-TONED SKIN
Suggested colors for lighter tones

White

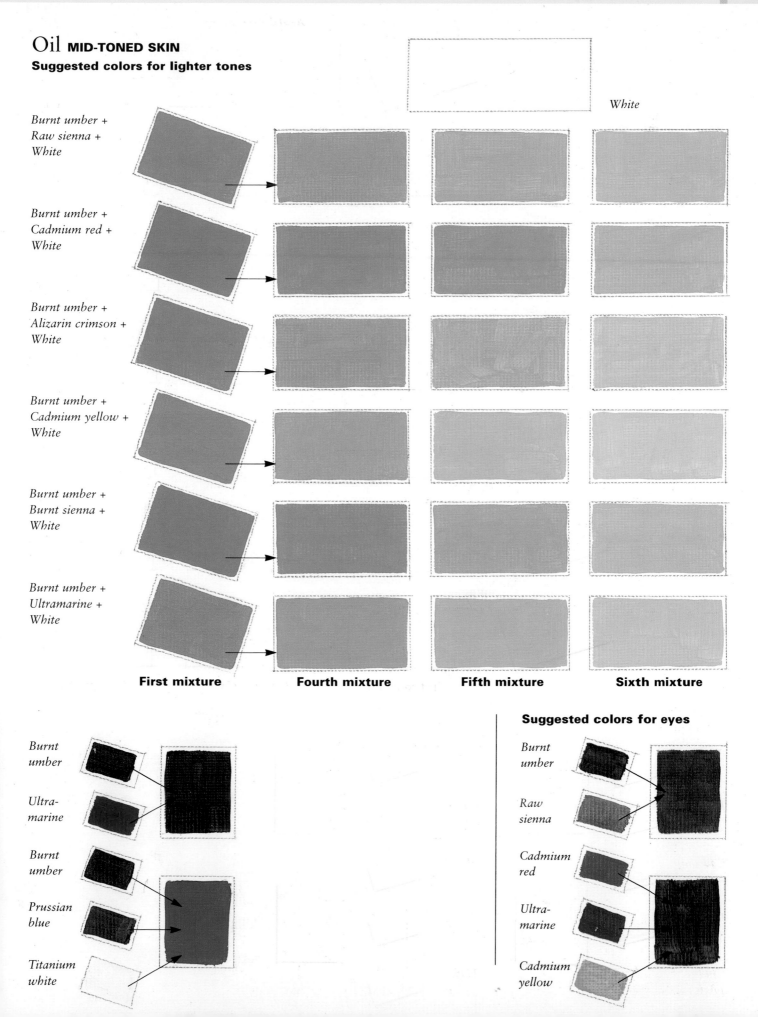

*Burnt umber +
Raw sienna +
White*

*Burnt umber +
Cadmium red +
White*

*Burnt umber +
Alizarin crimson +
White*

*Burnt umber +
Cadmium yellow +
White*

*Burnt umber +
Burnt sienna +
White*

*Burnt umber +
Ultramarine +
White*

First mixture **Fourth mixture** **Fifth mixture** **Sixth mixture**

*Burnt
umber*

*Ultra-
marine*

*Burnt
umber*

*Prussian
blue*

*Titanium
white*

Suggested colors for eyes

*Burnt
umber*

*Raw
sienna*

*Cadmium
red*

*Ultra-
marine*

*Cadmium
yellow*

Oil DARK SKIN
Suggested colors for darker tones

Basic skin color

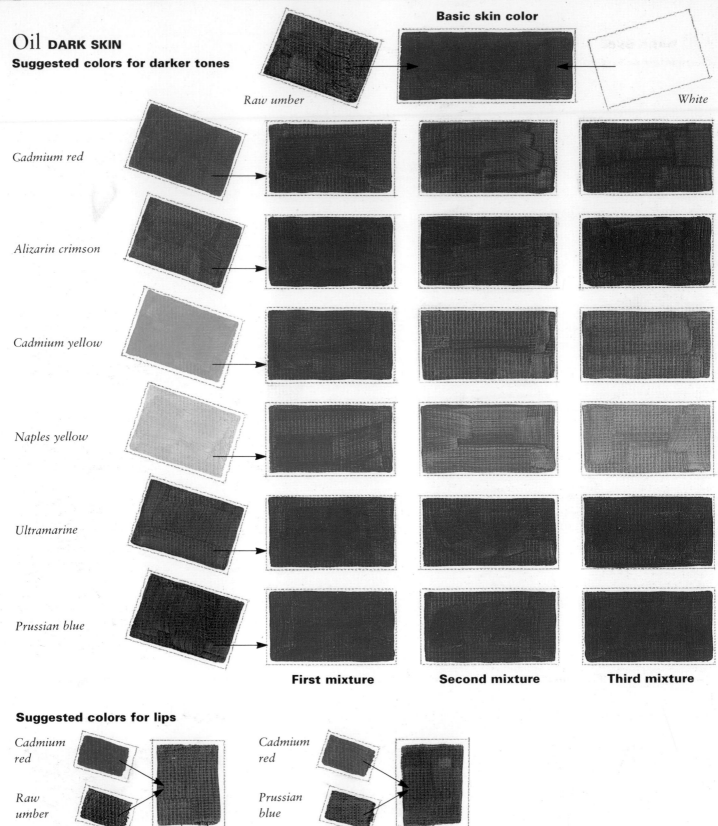

Raw umber

White

Cadmium red

Alizarin crimson

Cadmium yellow

Naples yellow

Ultramarine

Prussian blue

First mixture **Second mixture** **Third mixture**

Suggested colors for lips

Cadmium
red

Raw
umber

Cadmium
red

Raw
umber

Titanium
white

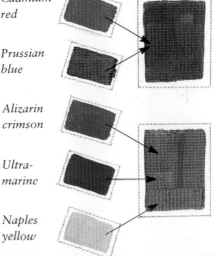

Cadmium
red

Prussian
blue

Alizarin
crimson

Ultra-
marine

Naples
yellow

Oil DARK SKIN
Suggested colors for lighter tones

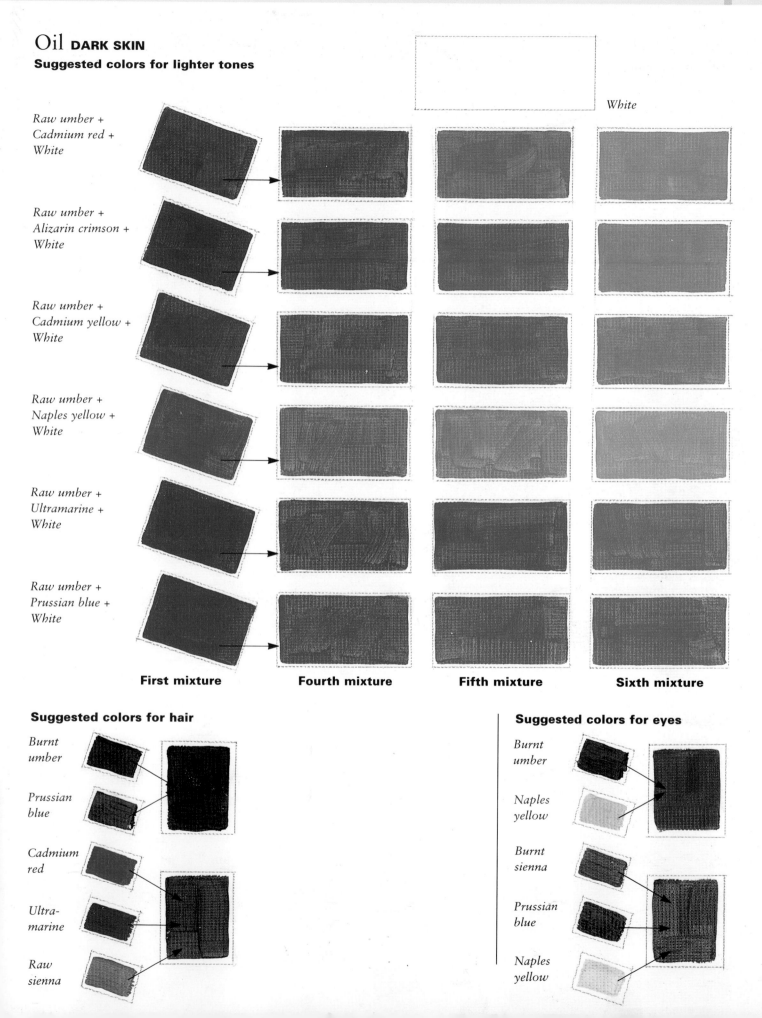

Raw umber +
Cadmium red +
White

Raw umber +
Alizarin crimson +
White

Raw umber +
Cadmium yellow +
White

Raw umber +
Naples yellow +
White

Raw umber +
Ultramarine +
White

Raw umber +
Prussian blue +
White

White

First mixture **Fourth mixture** **Fifth mixture** **Sixth mixture**

Suggested colors for hair

Burnt umber

Prussian blue

Cadmium red

Ultra-marine

Raw sienna

Suggested colors for eyes

Burnt umber

Naples yellow

Burnt sienna

Prussian blue

Naples yellow

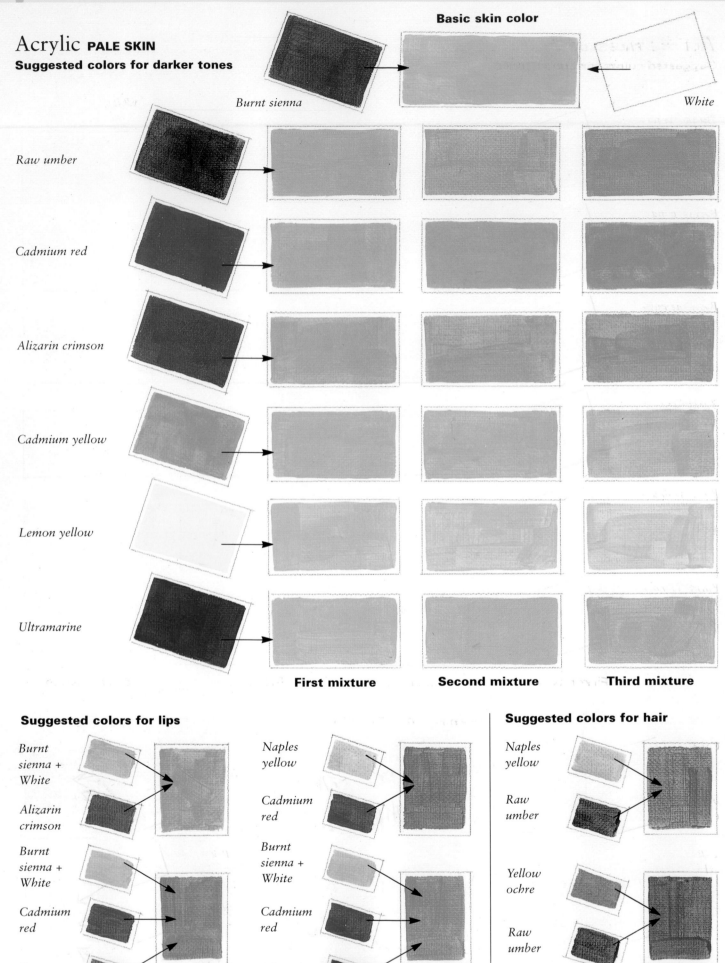

Acrylic PALE SKIN
Suggested colors for darker tones

Basic skin color

Burnt sienna

White

Raw umber

Cadmium red

Alizarin crimson

Cadmium yellow

Lemon yellow

Ultramarine

First mixture　　**Second mixture**　　**Third mixture**

Suggested colors for lips

Burnt sienna + White

Alizarin crimson

Burnt sienna + White

Cadmium red

Burnt sienna

Naples yellow

Cadmium red

Burnt sienna + White

Cadmium red

Ultramarine

Suggested colors for hair

Naples yellow

Raw umber

Yellow ochre

Raw umber

Acrylic PALE SKIN
Suggested colors for lighter tones

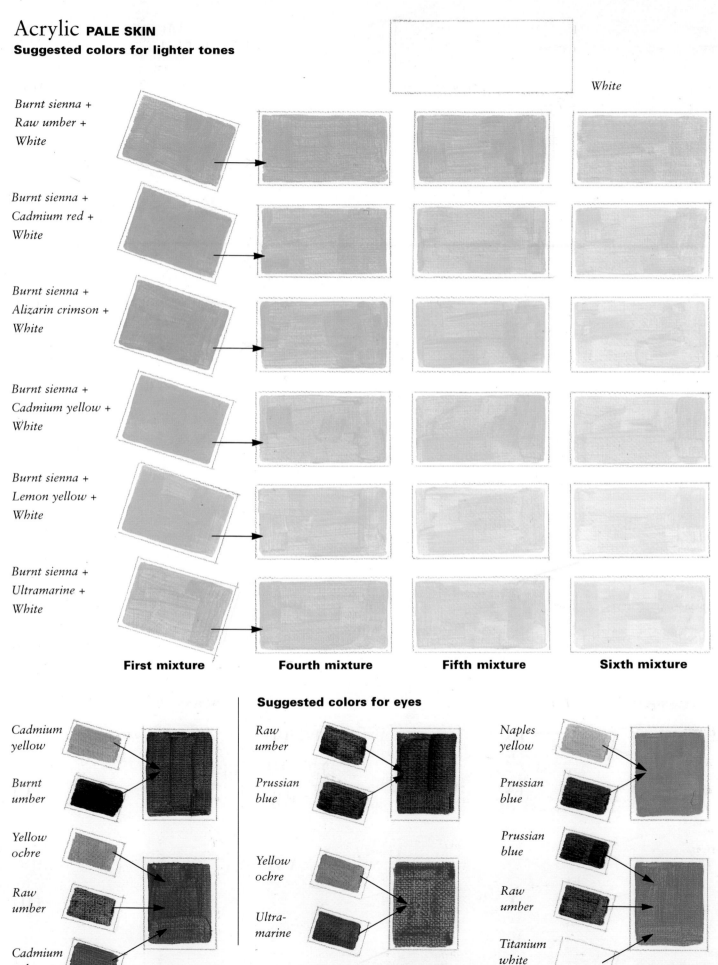

White

Burnt sienna + Raw umber + White

Burnt sienna + Cadmium red + White

Burnt sienna + Alizarin crimson + White

Burnt sienna + Cadmium yellow + White

Burnt sienna + Lemon yellow + White

Burnt sienna + Ultramarine + White

First mixture **Fourth mixture** **Fifth mixture** **Sixth mixture**

Suggested colors for eyes

Cadmium yellow

Burnt umber

Yellow ochre

Raw umber

Cadmium red

Raw umber

Prussian blue

Yellow ochre

Ultra-marine

Naples yellow

Prussian blue

Prussian blue

Raw umber

Titanium white

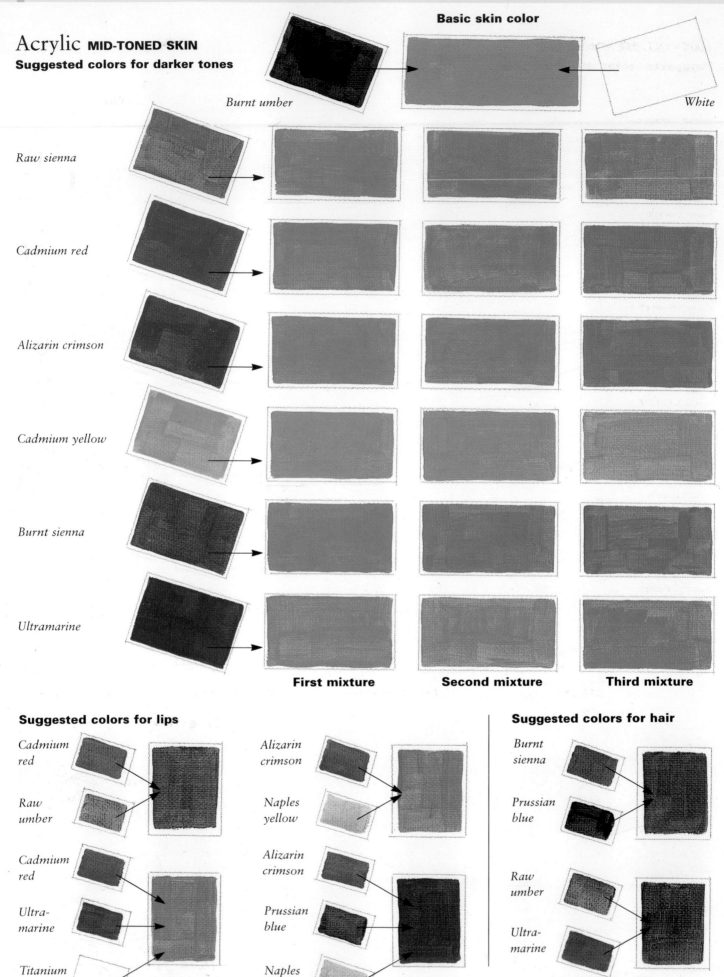

Acrylic MID-TONED SKIN
Suggested colors for darker tones

Basic skin color

Burnt umber

White

Raw sienna

Cadmium red

Alizarin crimson

Cadmium yellow

Burnt sienna

Ultramarine

First mixture **Second mixture** **Third mixture**

Suggested colors for lips

Cadmium red

Raw umber

Cadmium red

Ultramarine

Titanium white

Alizarin crimson

Naples yellow

Alizarin crimson

Prussian blue

Naples yellow

Suggested colors for hair

Burnt sienna

Prussian blue

Raw umber

Ultramarine

Acrylic MID-TONED SKIN
Suggested colors for lighter tones

*Burnt umber +
Raw sienna +
White*

*Burnt umber +
Cadmium red +
White*

*Burnt umber +
Alizarin crimson +
White*

*Burnt umber +
Cadmium yellow +
White*

*Burnt umber +
Burnt sienna +
White*

*Burnt umber +
Ultramarine +
White*

White

First mixture **Fourth mixture** **Fifth mixture** **Sixth mixture**

*Burnt
umber*

*Ultra-
marine*

*Burnt
umber*

*Prussian
blue*

*Titanium
white*

Suggested colors for eyes

*Burnt
umber*

*Raw
sienna*

*Cadmium
red*

*Ultra-
marine*

*Cadmium
yellow*

Acrylic DARK SKIN
Suggested colors for darker tones

Basic skin color

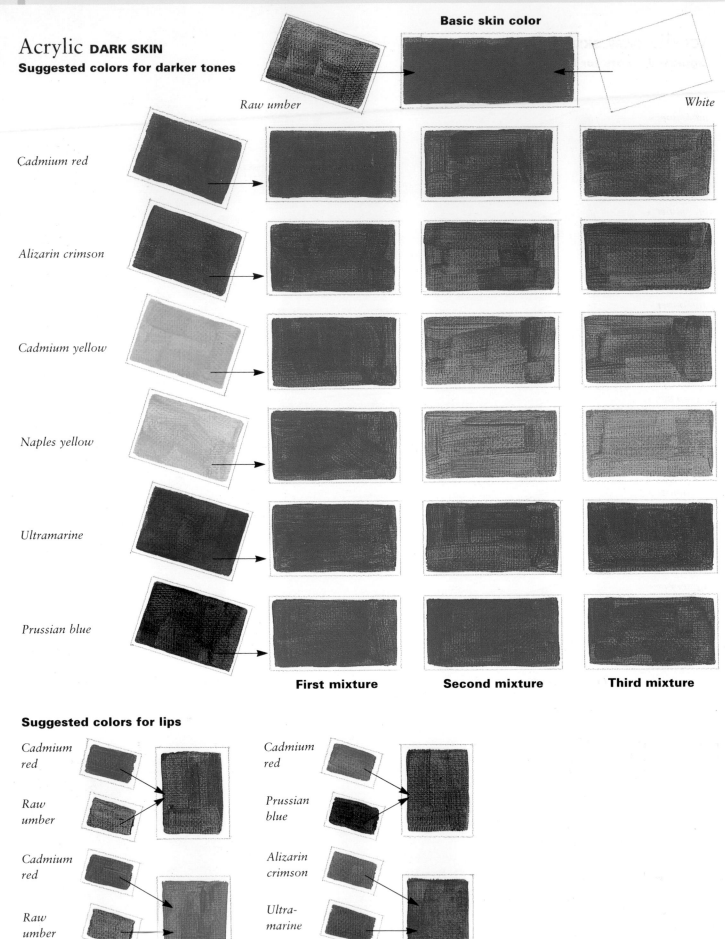

Raw umber

White

Cadmium red

Alizarin crimson

Cadmium yellow

Naples yellow

Ultramarine

Prussian blue

First mixture **Second mixture** **Third mixture**

Suggested colors for lips

Cadmium red

Raw umber

Cadmium red

Raw umber

Titanium white

Cadmium red

Prussian blue

Alizarin crimson

Ultra-marine

Naples yellow

Acrylic DARK SKIN
Suggested colors for lighter tones

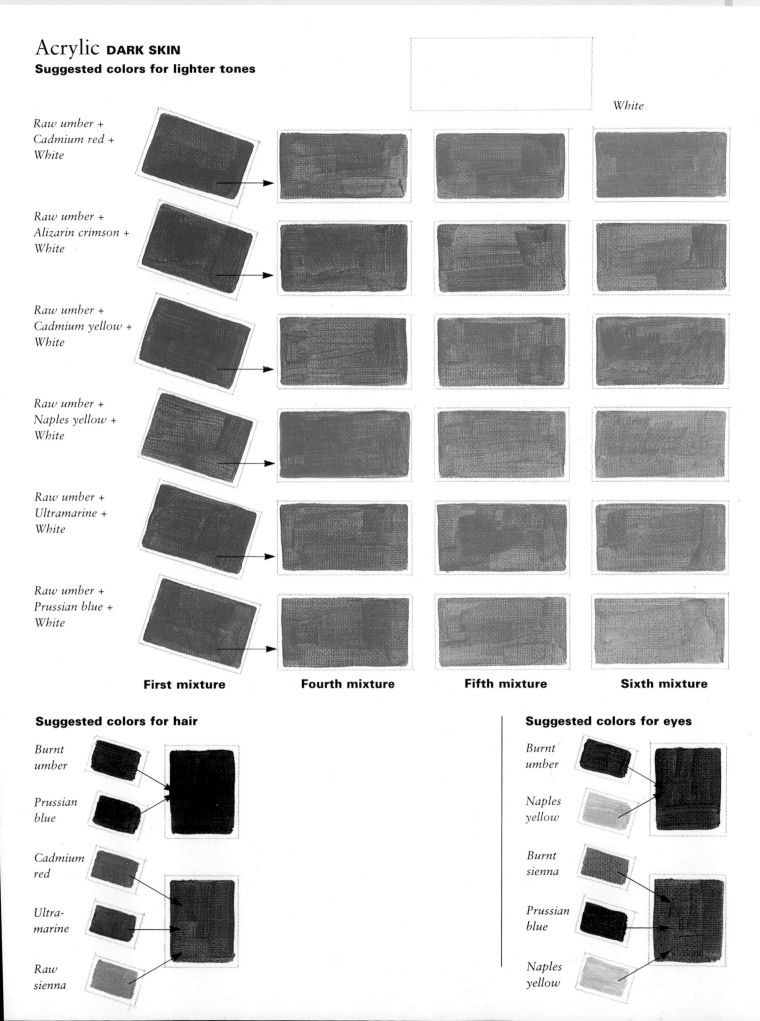

White

*Raw umber +
Cadmium red +
White*

*Raw umber +
Alizarin crimson +
White*

*Raw umber +
Cadmium yellow +
White*

*Raw umber +
Naples yellow +
White*

*Raw umber +
Ultramarine +
White*

*Raw umber +
Prussian blue +
White*

First mixture **Fourth mixture** **Fifth mixture** **Sixth mixture**

Suggested colors for hair

*Burnt
umber*

*Prussian
blue*

*Cadmium
red*

*Ultra-
marine*

*Raw
sienna*

Suggested colors for eyes

*Burnt
umber*

*Naples
yellow*

*Burnt
sienna*

*Prussian
blue*

*Naples
yellow*

Watercolor PALE SKIN
Suggested colors for darker tones

Burnt sienna

Basic skin color

Water

Raw umber

Cadmium red

Alizarin crimson

Cadmium yellow

Lemon yellow

Ultramarine

First mixture **Second mixture** **Third mixture**

Suggested colors for lips

Burnt sienna + Water

Alizarin crimson

Burnt sienna + Water

Cadmium red

Burnt sienna

Naples yellow

Cadmium red

Burnt sienna + Water

Cadmium red

Ultra-marine

Suggested colors for hair

Naples yellow

Raw umber

Yellow ochre

Raw umber

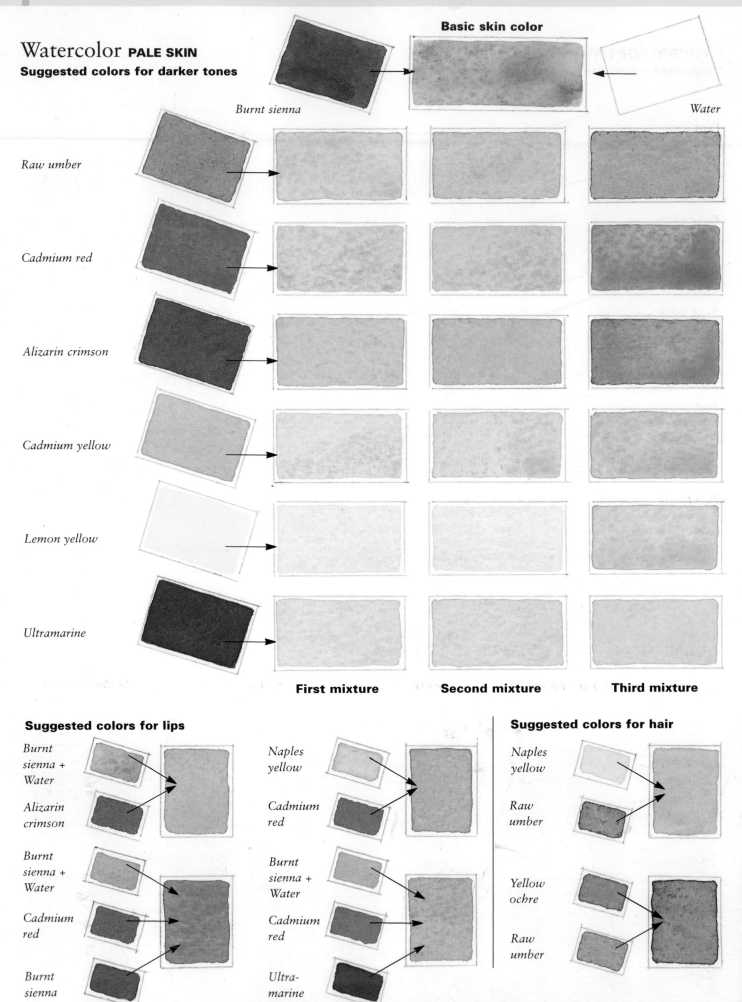

Watercolor PALE SKIN
Suggested colors for lighter tones

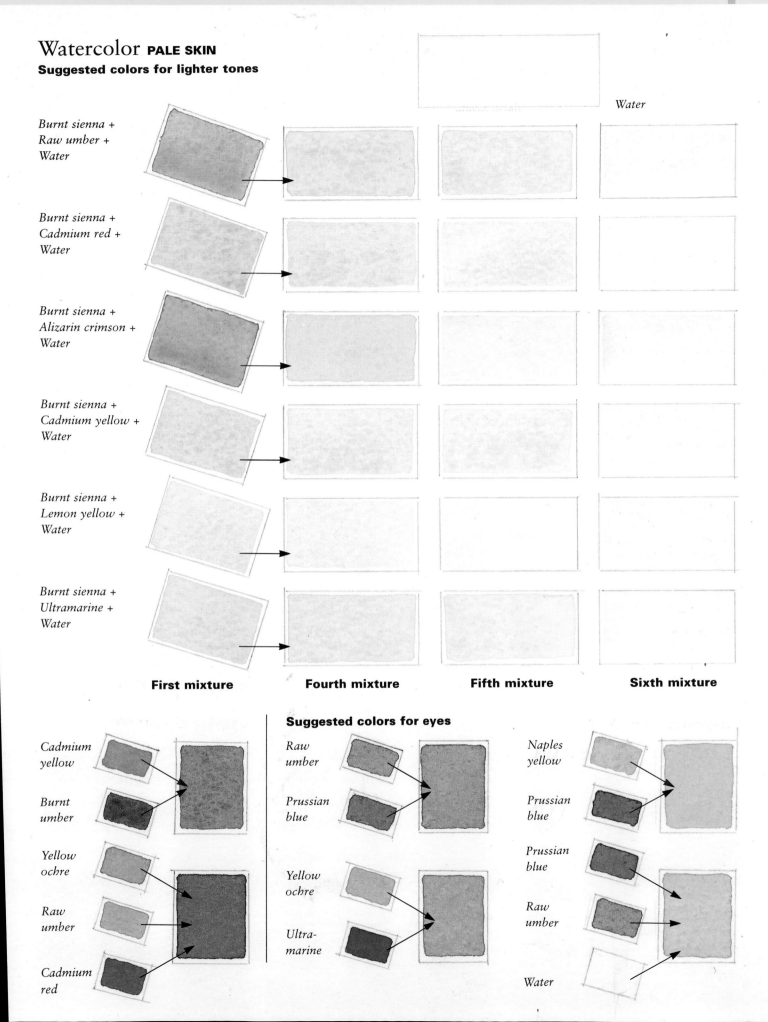

Water

*Burnt sienna +
Raw umber +
Water*

*Burnt sienna +
Cadmium red +
Water*

*Burnt sienna +
Alizarin crimson +
Water*

*Burnt sienna +
Cadmium yellow +
Water*

*Burnt sienna +
Lemon yellow +
Water*

*Burnt sienna +
Ultramarine +
Water*

First mixture **Fourth mixture** **Fifth mixture** **Sixth mixture**

Suggested colors for eyes

*Cadmium
yellow*

*Burnt
umber*

*Yellow
ochre*

*Raw
umber*

*Cadmium
red*

*Raw
umber*

*Prussian
blue*

*Yellow
ochre*

*Ultra-
marine*

*Naples
yellow*

*Prussian
blue*

*Prussian
blue*

*Raw
umber*

Water

Watercolor MID-TONED SKIN
Suggested colors for darker tones

Basic skin color

Burnt umber

Water

Raw sienna

Cadmium red

Alizarin crimson

Cadmium yellow

Burnt sienna

Ultramarine

First mixture **Second mixture** **Third mixture**

Suggested colors for lips

Cadmium red

Raw umber

Cadmium red

Ultra-marine

Water

Alizarin crimson

Naples yellow

Alizarin crimson

Prussian blue

Naples yellow

Suggested colors for hair

Burnt sienna

Prussian blue

Raw umber

Ultra-marine

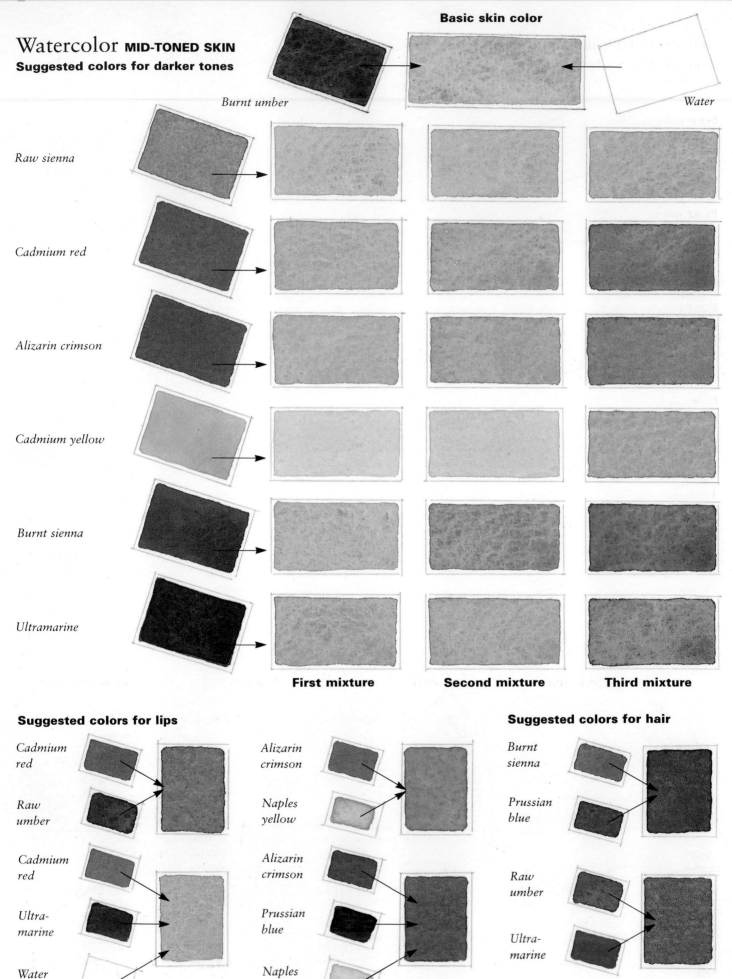

Watercolor MID-TONED SKIN
Suggested colors for lighter tones

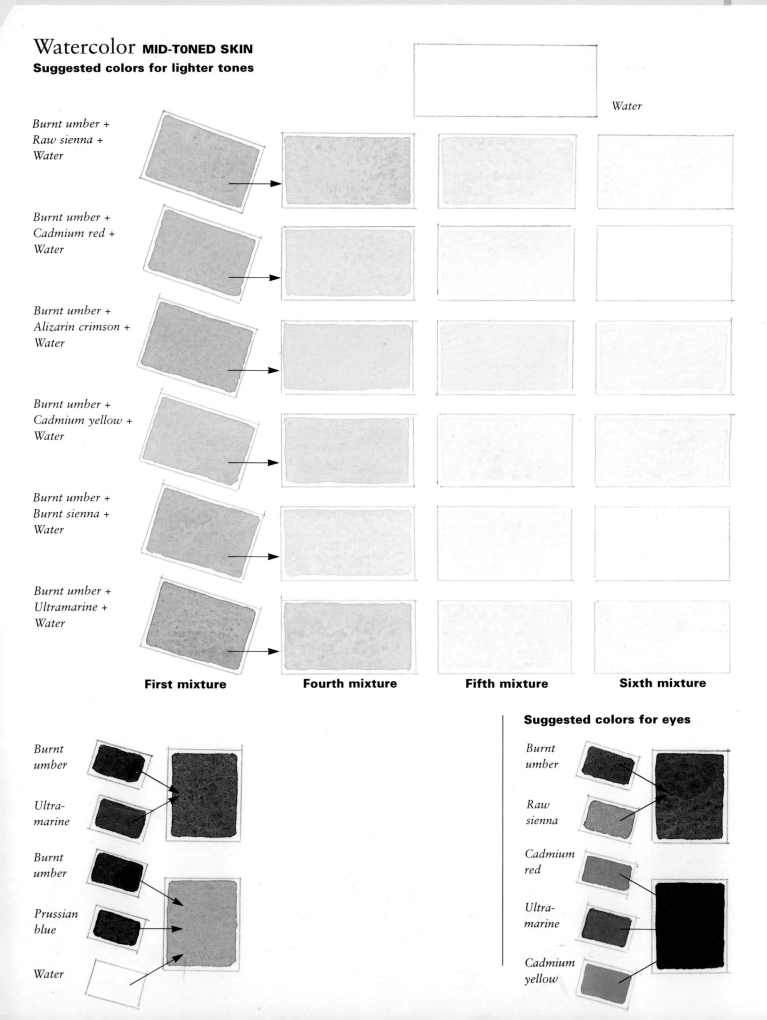

*Burnt umber +
Raw sienna +
Water*

*Burnt umber +
Cadmium red +
Water*

*Burnt umber +
Alizarin crimson +
Water*

*Burnt umber +
Cadmium yellow +
Water*

*Burnt umber +
Burnt sienna +
Water*

*Burnt umber +
Ultramarine +
Water*

Water

First mixture **Fourth mixture** **Fifth mixture** **Sixth mixture**

*Burnt
umber*

*Ultra-
marine*

*Burnt
umber*

*Prussian
blue*

Water

Suggested colors for eyes

*Burnt
umber*

*Raw
sienna*

*Cadmium
red*

*Ultra-
marine*

*Cadmium
yellow*

Watercolor DARK SKIN
Suggested colors for darker tones

Basic skin color

Raw umber

Water

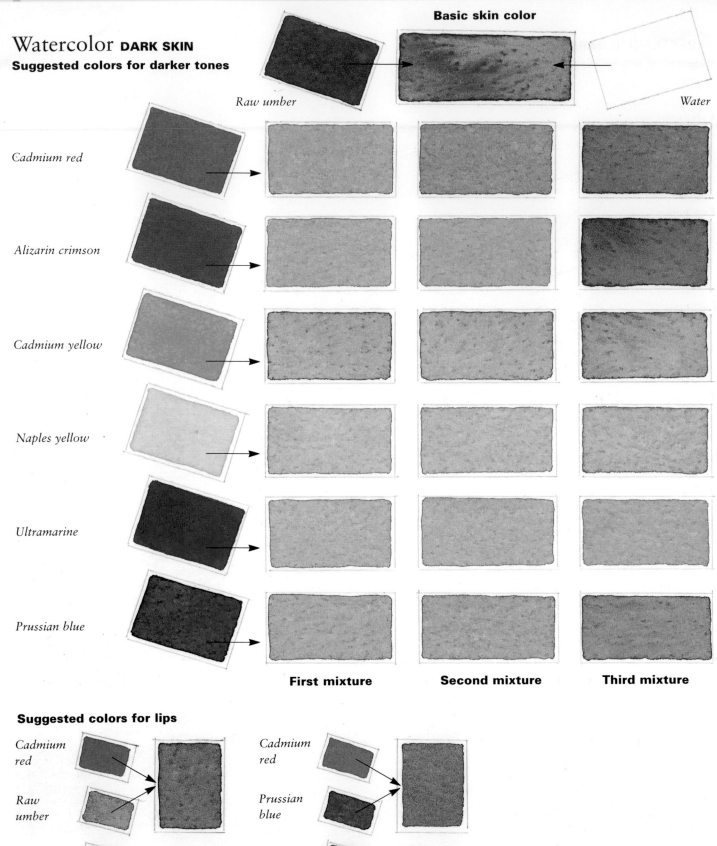

Cadmium red

Alizarin crimson

Cadmium yellow

Naples yellow

Ultramarine

Prussian blue

First mixture **Second mixture** **Third mixture**

Suggested colors for lips

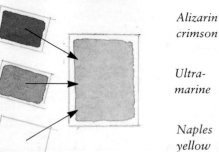

Cadmium red

Raw umber

Cadmium red

Raw umber

Water

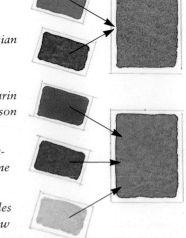

Cadmium red

Prussian blue

Alizarin crimson

Ultra-marine

Naples yellow

Watercolor DARK SKIN
Suggested colors for lighter tones

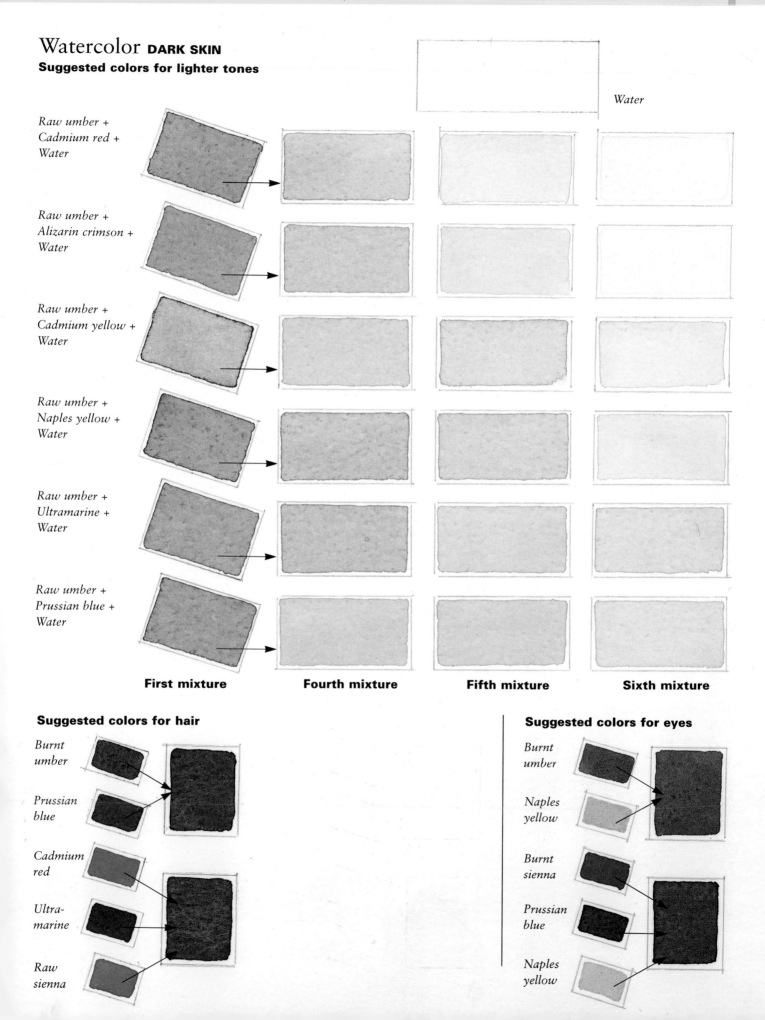

Water

*Raw umber +
Cadmium red +
Water*

*Raw umber +
Alizarin crimson +
Water*

*Raw umber +
Cadmium yellow +
Water*

*Raw umber +
Naples yellow +
Water*

*Raw umber +
Ultramarine +
Water*

*Raw umber +
Prussian blue +
Water*

First mixture **Fourth mixture** **Fifth mixture** **Sixth mixture**

Suggested colors for hair

*Burnt
umber*

*Prussian
blue*

*Cadmium
red*

*Ultra-
marine*

*Raw
sienna*

Suggested colors for eyes

*Burnt
umber*

*Naples
yellow*

*Burnt
sienna*

*Prussian
blue*

*Naples
yellow*

Pastel **PALE SKIN**
Suggested colors for darker tones

Basic skin color

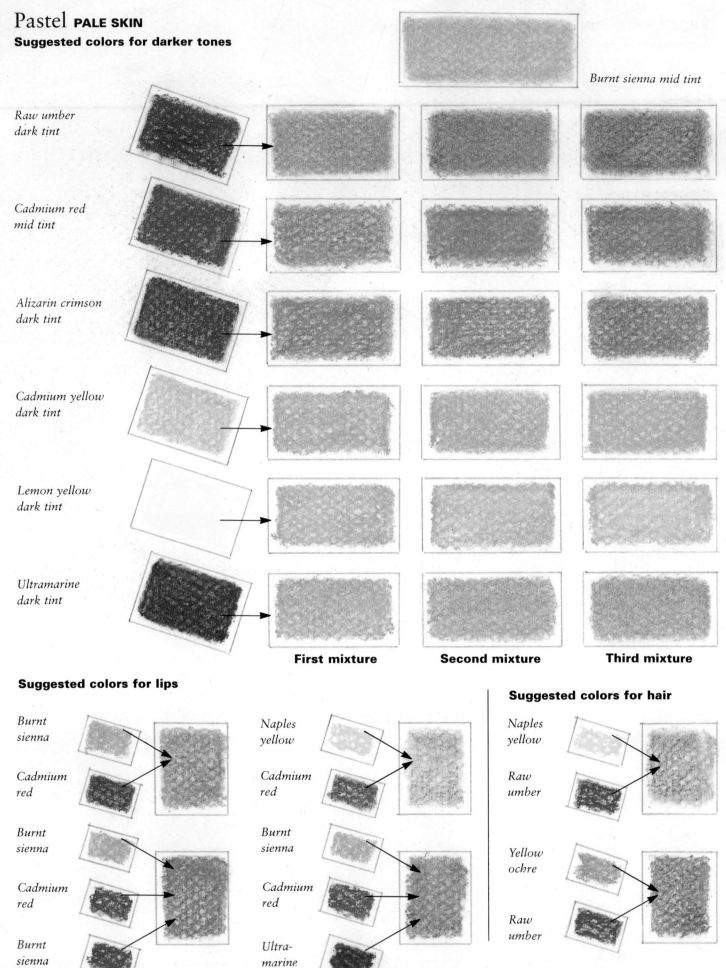

Burnt sienna mid tint

Raw umber dark tint

Cadmium red mid tint

Alizarin crimson dark tint

Cadmium yellow dark tint

Lemon yellow dark tint

Ultramarine dark tint

First mixture **Second mixture** **Third mixture**

Suggested colors for lips

Burnt sienna

Cadmium red

Burnt sienna

Cadmium red

Burnt sienna

Naples yellow

Cadmium red

Burnt sienna

Cadmium red

Ultra-marine

Suggested colors for hair

Naples yellow

Raw umber

Yellow ochre

Raw umber

Pastel **PALE SKIN**
Suggested colors for lighter tones

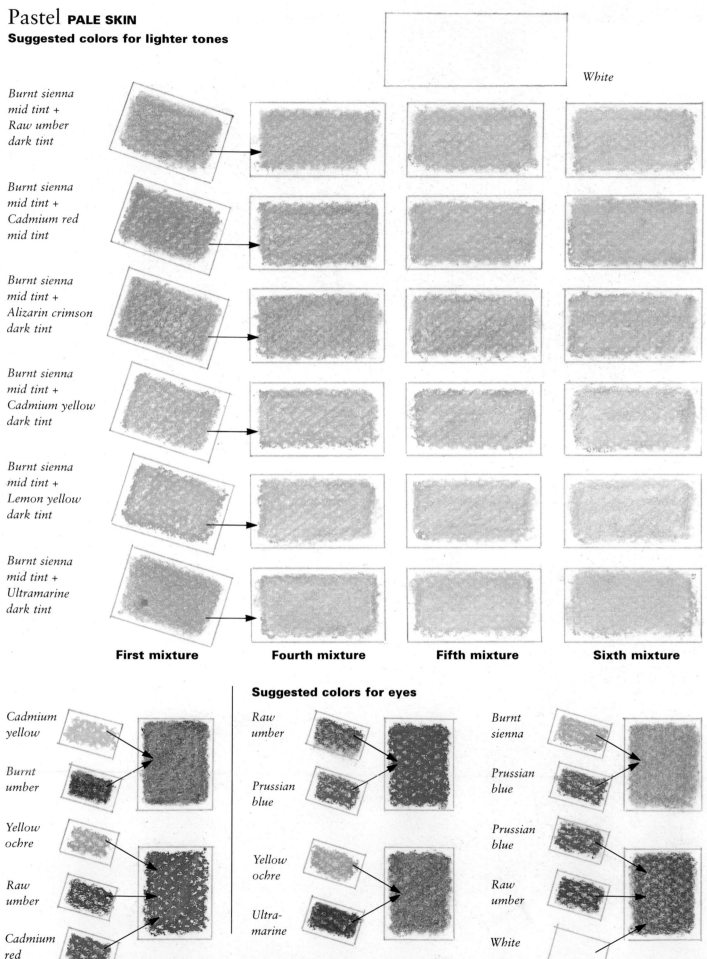

White

*Burnt sienna
mid tint +
Raw umber
dark tint*

*Burnt sienna
mid tint +
Cadmium red
mid tint*

*Burnt sienna
mid tint +
Alizarin crimson
dark tint*

*Burnt sienna
mid tint +
Cadmium yellow
dark tint*

*Burnt sienna
mid tint +
Lemon yellow
dark tint*

*Burnt sienna
mid tint +
Ultramarine
dark tint*

First mixture **Fourth mixture** **Fifth mixture** **Sixth mixture**

Suggested colors for eyes

*Cadmium
yellow*

*Burnt
umber*

*Yellow
ochre*

*Raw
umber*

*Cadmium
red*

*Raw
umber*

*Prussian
blue*

*Yellow
ochre*

*Ultra-
marine*

*Burnt
sienna*

*Prussian
blue*

*Prussian
blue*

*Raw
umber*

White

Pastel MID-TONED SKIN
Suggested colors for darker tones

Basic skin color

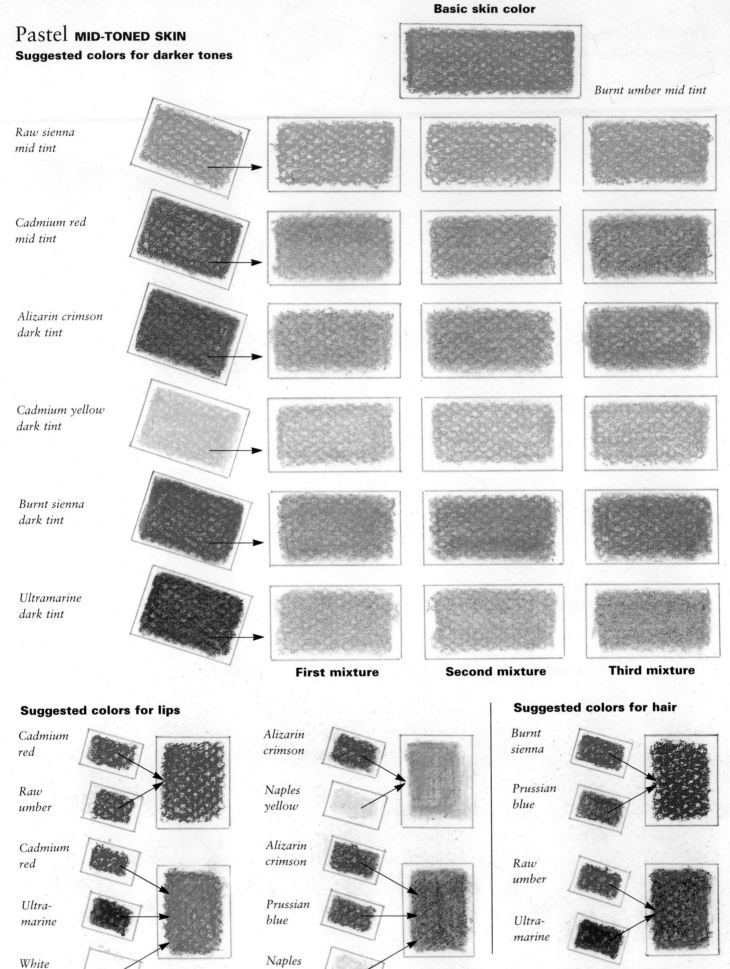

Burnt umber mid tint

Raw sienna mid tint

Cadmium red mid tint

Alizarin crimson dark tint

Cadmium yellow dark tint

Burnt sienna dark tint

Ultramarine dark tint

First mixture　　**Second mixture**　　**Third mixture**

Suggested colors for lips

Cadmium red

Raw umber

Cadmium red

Ultra-marine

White

Alizarin crimson

Naples yellow

Alizarin crimson

Prussian blue

Naples yellow

Suggested colors for hair

Burnt sienna

Prussian blue

Raw umber

Ultra-marine

Pastel MID-TONED SKIN
Suggested colors for lighter tones

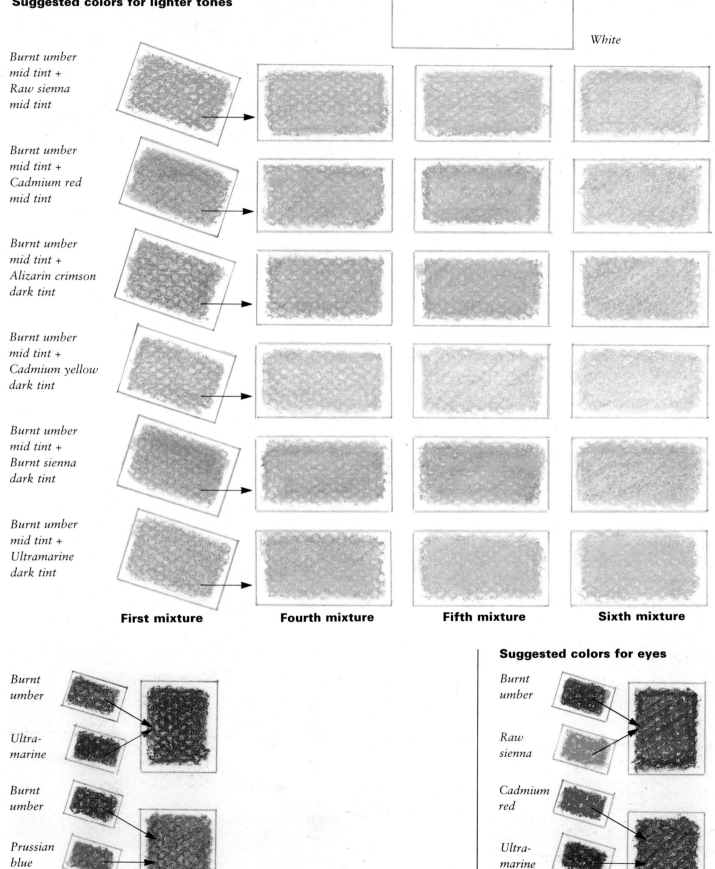

White

Burnt umber
mid tint +
Raw sienna
mid tint

Burnt umber
mid tint +
Cadmium red
mid tint

Burnt umber
mid tint +
Alizarin crimson
dark tint

Burnt umber
mid tint +
Cadmium yellow
dark tint

Burnt umber
mid tint +
Burnt sienna
dark tint

Burnt umber
mid tint +
Ultramarine
dark tint

First mixture **Fourth mixture** **Fifth mixture** **Sixth mixture**

Burnt
umber

Ultra-
marine

Burnt
umber

Prussian
blue

White

Suggested colors for eyes

Burnt
umber

Raw
sienna

Cadmium
red

Ultra-
marine

Cadmium
yellow

Pastel DARK SKIN
Suggested colors for darker tones

Basic skin color

Raw umber dark tint

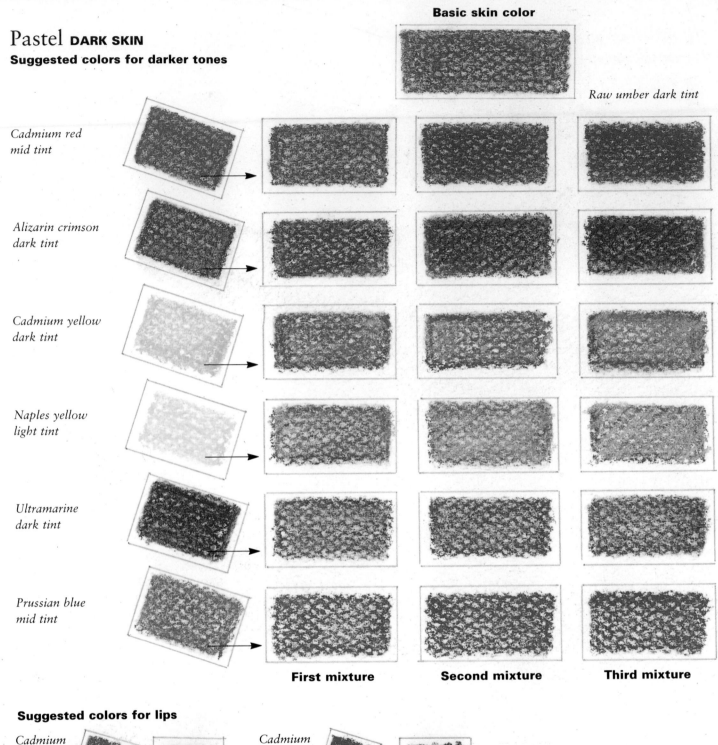

Cadmium red
mid tint

Alizarin crimson
dark tint

Cadmium yellow
dark tint

Naples yellow
light tint

Ultramarine
dark tint

Prussian blue
mid tint

First mixture　**Second mixture**　**Third mixture**

Suggested colors for lips

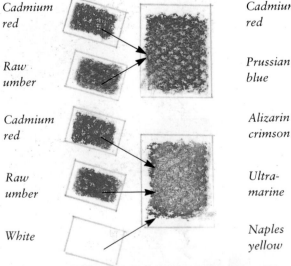

Cadmium
red

Raw
umber

Cadmium
red

Raw
umber

White

Cadmium
red

Prussian
blue

Alizarin
crimson

Ultra-
marine

Naples
yellow

Pastel DARK SKIN
Suggested colors for lighter tones

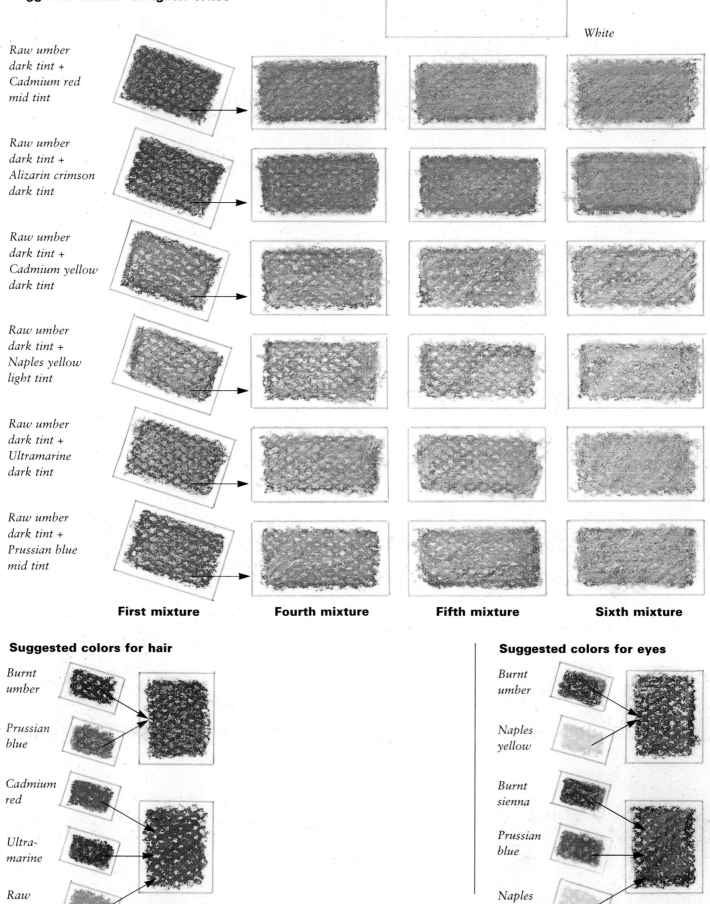

Raw umber dark tint + Cadmium red mid tint

Raw umber dark tint + Alizarin crimson dark tint

Raw umber dark tint + Cadmium yellow dark tint

Raw umber dark tint + Naples yellow light tint

Raw umber dark tint + Ultramarine dark tint

Raw umber dark tint + Prussian blue mid tint

White

First mixture **Fourth mixture** **Fifth mixture** **Sixth mixture**

Suggested colors for hair

Burnt umber

Prussian blue

Cadmium red

Ultra-marine

Raw sienna

Suggested colors for eyes

Burnt umber

Naples yellow

Burnt sienna

Prussian blue

Naples yellow

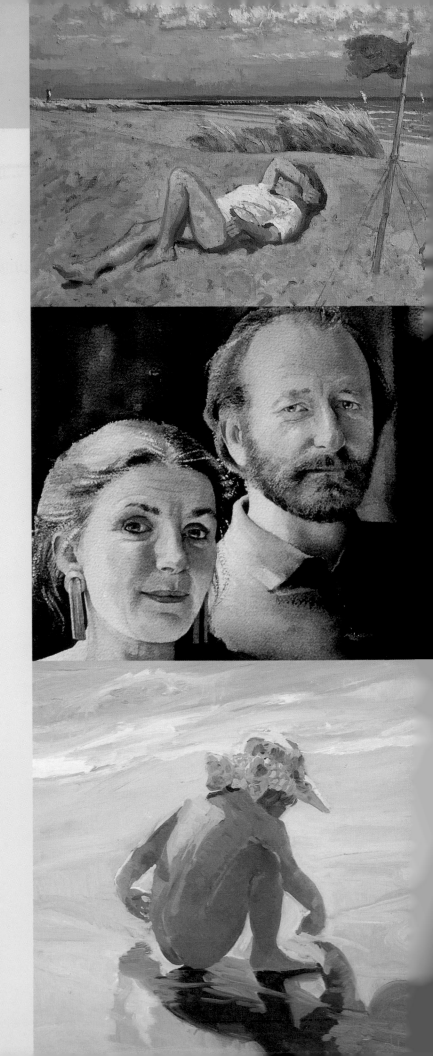

CHAPTER

3

Different Skin Colors

Naturally there can be no one recipe for painting skin since there are so many different types and colors. But because the variations within each skin type are quite subtle, you won't need a large palette of colors to deal with them – the skill lies in recognizing the colors in your subject and knowing which paints you can use to mix them. This chapter shows how a wide variety of skins can be rendered without the use of "special" colors.

▶ Clockwise from top left:
Joshua's Camp, Walberswick *James Horton*, **Girl Whose Name Means Blue Sky** *Doug Dawson*, **First Reflection** *Denise Burns*, **Mr & Mrs A. Mules (detail)** *Glynis Barnes-Mellish*

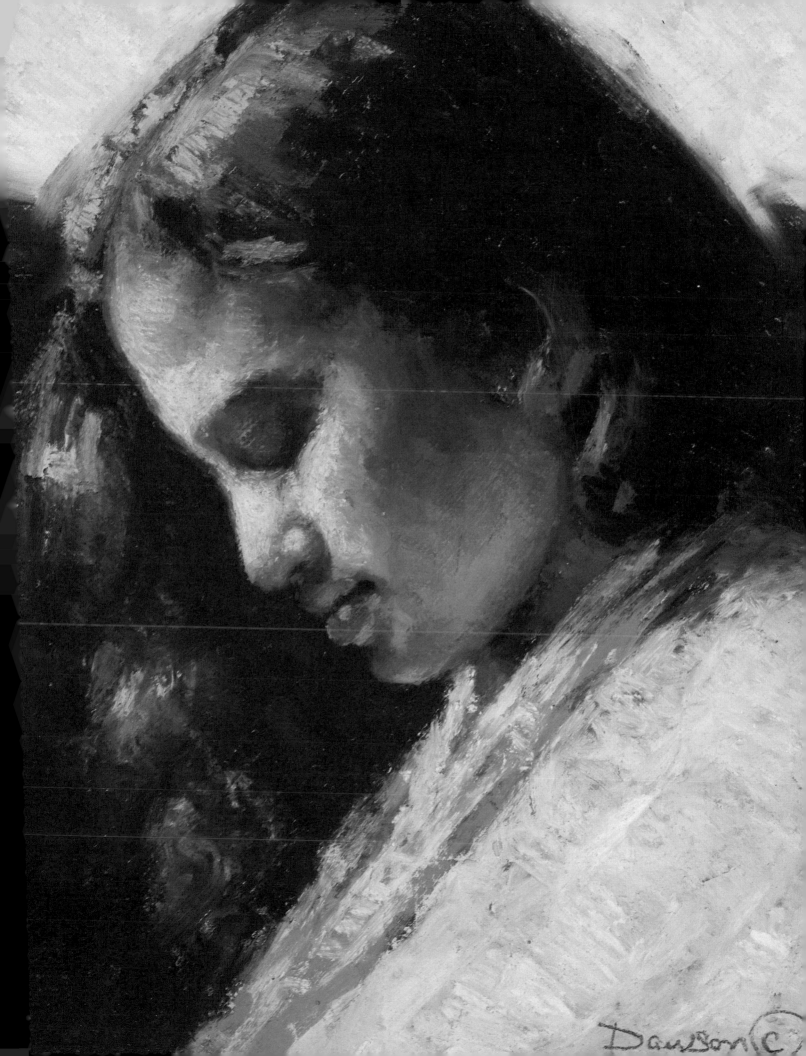

How many skin colors?

The answer to the question, of course, is that there are a great many. In their variety, skin colors might be compared to the shades and hues of green in a summer landscape. The foliage of a tree has its own distinctive color which may differ radically from that of a neighboring tree, and this is before you even begin to consider effects of light and shade, which will create a variety of other colors in each separate tree.

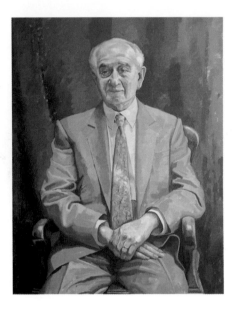

▲ **David Lincoln**
In this oil portrait, JAMES HORTON *has exploited a whole range of light and dark tones.*

And so it is with skin, but at least trees can be roughly categorized as green, while there is no one color that is common to all skin, even within the same ethnic group. Words and phrases such as "white," "black," "olive-skinned" and so on may be convenient in everyday life, but when it comes to painting they don't begin to touch on the range you are dealing with.

Although skin presents a rich variety of colors, you do not need a large palette of paints or pastels in order to capture these colors. In comparison with

▼▶ *We may refer to "white," "brown" or "black," but each person's skin has a highly individual color character.*

a subject such as flowers, which may call for specially vivid reds and purples, some of which cannot be mixed and must be bought as tube colors, skin colors are subtle and can be mixed perfectly well from a basic palette of about twelve colors. The projects and exercises included in this chapter are all done with a "basic" palette – the kind of palette that can be adapted to any subject (with the possible exception of flowers).

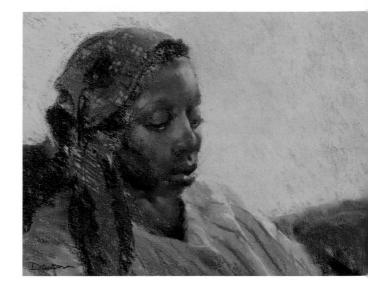

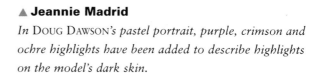

▲ **Jeannie Madrid**
In Doug Dawson's *pastel portrait, purple, crimson and ochre highlights have been added to describe highlights on the model's dark skin.*

It is usually a mistake to work with a very large palette because this does not teach you how to mix colors, and color mixing is part of the process of learning to recognize colors and tones. Once you have survived the occasional failure, mixing colors is enjoyable, giving you a real sense of achievement when you get it right. There is nothing more satisfying than being able to say to yourself that you know the exact combination of colors that will produce a certain subtle but elusive effect. Choose your basic colors wisely, using the guidelines overleaf, practice mixing them, and you will soon be able to say this with perfect truth.

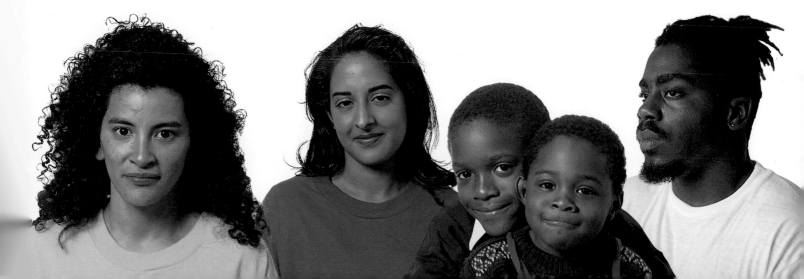

A basic palette

If you are new to painting, a visit to an art shop can be a bewildering experience. Out of all those tubes of color and multicolored sticks of pastel – often well over a hundred of the latter – which ones do you need? Naturally you cannot buy them all, nor would it help you if you did, because even a whole manufacturer's range would not represent all the colors you see in real life. So you will have to try to make an informed choice.

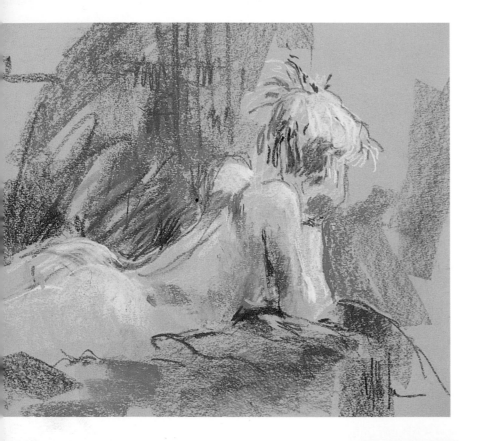

Most artists' palettes, whether the medium is oils, watercolor, gouache or acrylic, contain about twelve basic colors, sometimes with the addition of one or two special colors that the artist finds particularly useful. Pastel is a little different, so it will be dealt with in a separate section.

Primary colors

You can't, however, choose your colors until you have some idea of what you are looking for. There are three colors that cannot be

▼ Repose

Although the pastel has been applied more thickly in KAY POLK's *painting, the paper color still plays its part. Because it is textured, the pastel does not cover it completely.*

▲ Nude Against Pink

In pastel work, the choice of paper color is vital because it can be left uncovered in places to stand as a color in its own right. In MAUREEN JORDAN's *study the beige paper represents the basic skin color. White highlights and mid-brown shadows have been added with a light touch, as has the lovely patch of reflected pink on the arm.*

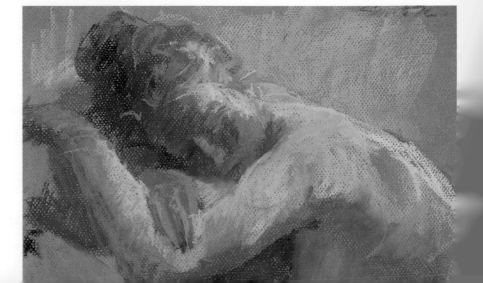

made by mixing other colors. These – red, blue and yellow – are called the primary colors, and they are your first requirement. But you will need six, not just three, because there is more than one kind of red, blue and yellow.

The main difference lies in the "temperature" of the colors. If you compare two of the reds found in most palettes, alizarin crimson and cadmium red, you will see that the crimson is slightly blue and the cadmium red more orangy by contrast. The crimson would be described as "cool" and the cadmium red, together with colors such as Venetian red, as "warm." The other two primaries also have warm and cool versions: in the yellow range, cadmium red is warm and lemon yellow cool, while in the blues, ultramarine is warm and Prussian and pthalocyanine blue are both cool and greenish. In fact the range of blues is especially large, and although you will certainly need ultramarine, you may find you prefer another blue, such as cerulean, for the cool version, or even that you need all three.

Secondary and tertiary colors

The colors you make by mixing two primary colors are called the secondaries – blue and yellow, as we all know, make green. But if you only had one version of each primary you would not be able to make a great range of greens; with only a warm blue and yellow, for example, you could not make a cool green, and the same goes for the other secondaries – orange and purple.

Strictly speaking, since secondaries can be mixed, you should not need to buy them as tube colors, but most painters have some, particularly greens. Not only are some of the tube greens more vivid than those you can mix, they are also useful for modifying other colors. For example, a little green mixed into red produces an interesting red-brown.

Another secondary color that is difficult to mix is purple. Alizarin crimson and ultramarine does make a kind of purple, but it is duller and less vibrant than a tube color such as cobalt violet.

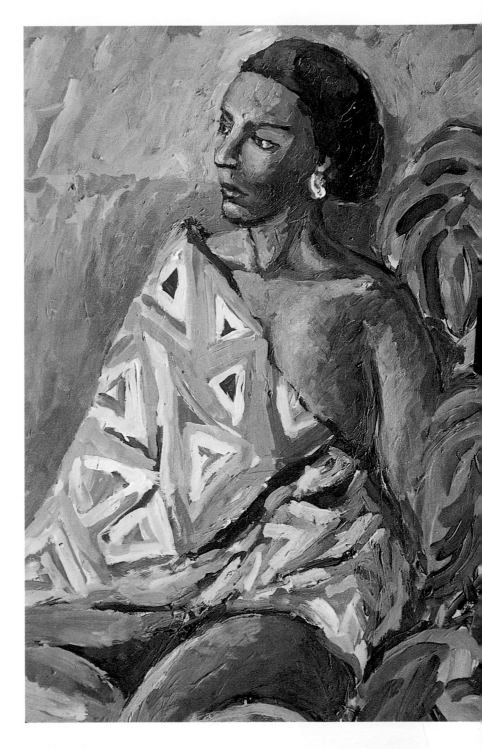

▲ ▶ Young Female West Indian (Pat)
In his oil painting, DANIEL STEDMAN has chosen a variety of colors within the same "family" – rich browns, red-browns and muted pinks – but has also introduced touches of blue and green to link the figure with the drapery (see detail). He has used the paint thickly, working wet into wet so that the colors have mixed on the picture surface.

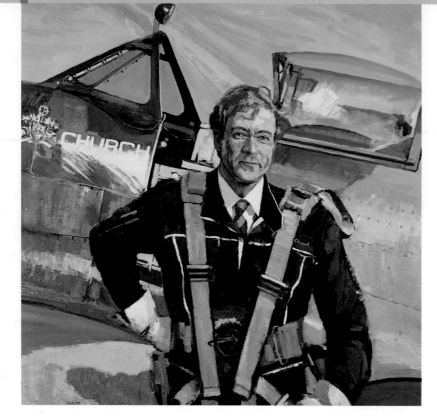

◄ ▲ Posthumous Portrait of the Late Charles Church

The vivid colors of the background act as a foil for the warm colors of the face in TREVOR STUBLEY's oil painting. The busy setting required firm treatment of the face, and relatively strong tonal contrasts have been used. As can be seen in the detail, however, the colors are all very closely related, so that the skin reads as an overall brownish-pink.

So far, we have recommended eight colors. For the opaque paints you will, of course, also need white, and you will probably find one or two browns useful – raw umber and burnt umber would be good choices. Browns and other neutral colors are called tertiary because they are a mixture of one secondary color and one primary (i.e. three colors in all). You can , of course, mix these, but it is rather more laborious than mixing greens. Other useful colors for skin are yellow ochre, Naples yellow, Venetian red and burnt sienna. Black is a controversial color; some artists avoid it, while others find it hard to do without. Ultimately, the choice of colors is a personal matter.

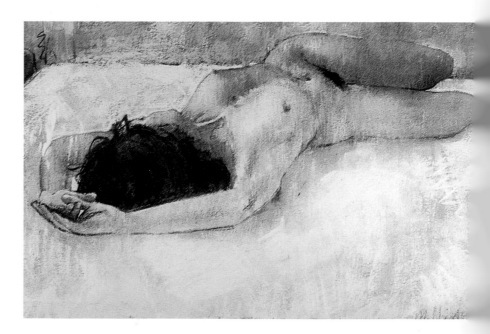

Pastel colors

Because pastels cannot be premixed, manu-facturers produce very extensive ranges of color, some as many as two hundred. Of course you do not need this many to start with, but you will certainly require more pastel sticks than you would tubes of paint – twenty-five is a bare minimum. This is because each pastel color is made in several different tones, called tints. The color ultra-

▲ ► Reclining nude

You can sometimes create a more exciting effect by deliberately limiting the colors. Working in pastel, and building up the tonal values, GLYNIS BARNES-MELLISH has produced an almost monochromatic composition, which nevertheless beautifully expresses the luminosity of the skin. Touches of crisp linear drawing pull the head and hands into sharp focus.

►▼ Adam and Matt Westcott

The notoriously tricky medium of watercolor has been used with great skill and assurance by GLYNIS BARNES-MELLISH. The deliberately induced blotches and runs of paint in the background contrast with the careful treatment of the faces. Although the skin color looks completely realistic, there is in fact little color variation; the modeling of forms is largely tonal, and the soft effect was produced by building up the colors very slowly from light to dark. The highlights on the hair are the result of scratching with a blade.

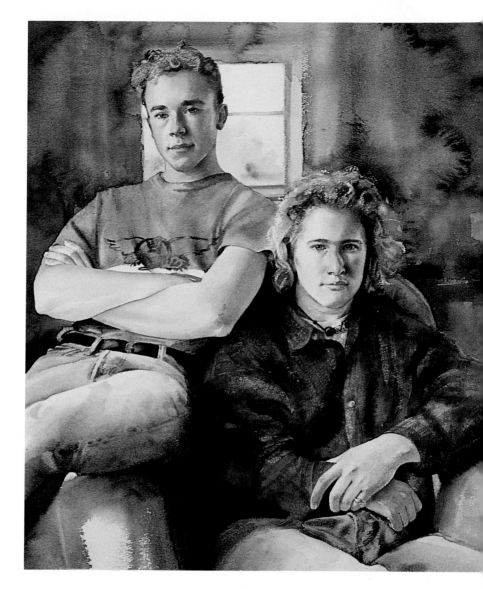

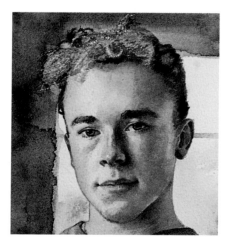

► Elderly Lady

This sensitive and sympathetic rendering of an elderly person has been painted with great restraint and subtlety. The effect is almost monochromatic, yet there is enough color in the face to give credibility to the skin; notice the delicate pinks around the eyes and on the nose and cheeks. JEHAN DALY has worked in oils, using the paint very thinly so that the grain of the canvas is only lightly covered.

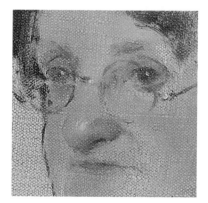

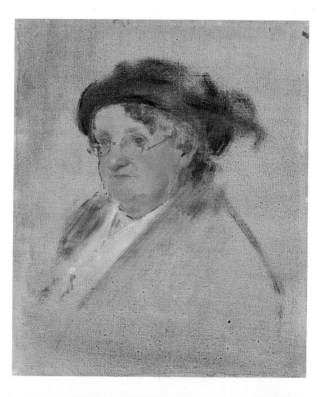

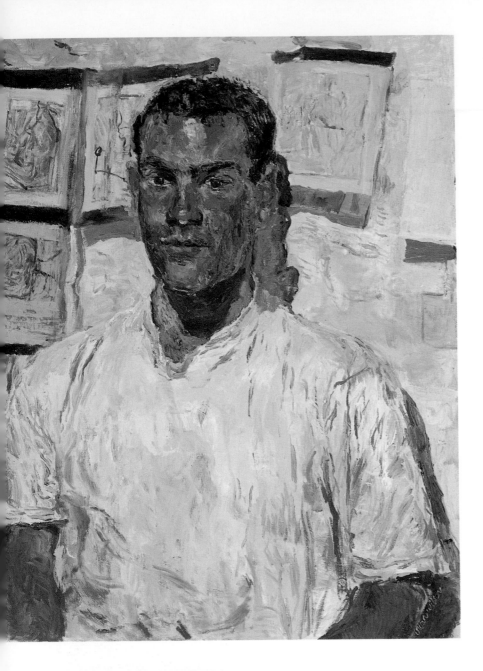

marine, for example, has a dark version (made by the addition of black) and two or three light ones (with added white) as well as a pure version which is the color of the actual pigment.

You can still use the guidelines given for paints, choosing a warm and cool for each of the primaries, but you will need at least two tints of each of these colors. Because the capacity for color mixing is limited, a greater range of secondary colors is essential, as are some browns and grays. You must have white, because without it you cannot lighten the tones of colors, and most pastel palettes also contain black, as it is difficult to achieve any depth of color without it.

Organizing your palette

If you are working with pastels leave them in their box until you need a particular color. Oil or acrylic paints, however, have to be laid out on a palette and you can save yourself a lot of trouble and wasted paint by laying them out in the same order whenever you work. Thick blobs of paint, particularly the darker colors, all look much the same, and unless you know where you have put the ultramarine or the raw umber you may find yourself having to abandon a mixture because you have accidentally used black instead. And apart from the purely practical aspect, the more you get used to using your colors in a set order, the more familiar you will become with your palette.

The order is not especially important as long as it is maintained. Some artists group all the cool colors on one side and the warm ones on the other, but an easy-to-remember order – which is also the traditional one – is black, the blues, greens if you have them, reds and red-browns, and finally yellows, with white in the middle. Remember that you will need more white than other colors, but you may need very little of the stronger colors like Prussian blue and cadmium red. To avoid wastage, squeeze out a bare minimum.

◄ ▲ **Cassino – Twenty-Year-Old Man**

This oil by SUSAN WILSON *shows the importance of setting: the background and T-shirt contrast excitingly with the rich skin colors. The lively brushwork gives strength and vitality to the face.*

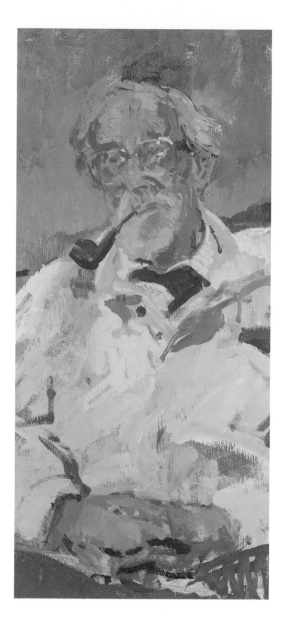

◀ Old Artist

A small palette consisting almost entirely of browns, red-browns, pinks and gray-greens has been employed in TOM COATES's *oil painting, and repeated on face, background and clothing so that the work has complete unity. The detail shows the economy with which the face has been described – a few well-placed brushmarks were all that was needed to suggest the forms and features.*

MASTER WORK *This painting is a wonderful example of the direct-color method used by the Camden Town Group of artists, of which Gilman was a founder member. There is virtually no linear drawing; all descriptions of form and space are made with carefully placed dabs of color. The value of each separate small area of color is adjusted so that they blend in the eye – a process known as optical mixing. The effects of this can be seen clearly on the model's back, where it seems almost impossible that so many colors could be squeezed into one small area.*

Nude on Bed HAROLD GILMAN (1876–1919)

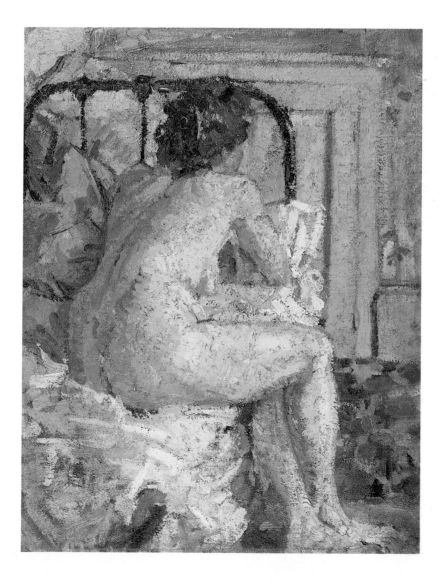

Using a restricted palette

An exercise often given in art schools to help students acquire color-mixing skills is to work with only the three primary colors – red, yellow and blue – plus black and white. In theory you should be able to mix any color you want from these three, but it is not quite that simple, as there are different versions of the primaries, some having a warm bias and some a cool one. Ultramarine blue, for example, veers slightly toward red, and is warm, while phthalocyanine blue and Prussian blue are cool, with a slight greenish tinge. You will find out a great deal about color "temperatures" and how they affect your mixtures by using first a warm palette and then a cool one, as shown here. These paintings are in oils, but you can carry out the same exercise using the equivalent colors in gouache or acrylic.

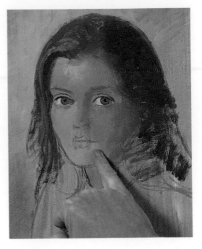

Using the warm primaries

1 *The artist has begun by tinting the ground of his canvas with a light, slightly cool purple made from a mixture of blue and red. Ultramarine was used for the brush drawing.*

2 *Normally the forms would be built up by using cooler colors for the shadowed side of the face, but here the modeling has to be primarily tonal. The flesh tones are laid on broadly and blended with a finger to create a soft gradation.*

This area could be translated as either warm or cool

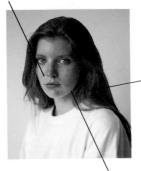

The red-brown hair color was easy to achieve with the warm palette

The subtlety of color here would normally require a mixture of warm and cool colors

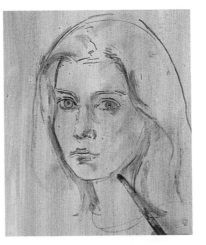

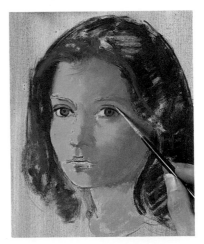

Using the cool primaries

1 *To contrast with the overall cool colors and help them to show up well, the ground color used here was relatively warm – a diluted sienna. The drawing is made with a blue-black mixture, and the artist begins to build up the forms immediately in tone.*

2 *He has achieved a remarkably realistic impression of the skin colors, although the alizarin crimson used in the mixtures is considerably cooler than cadmium red. The hair, which is painted with mixtures of black and crimson with a little blue and yellow, also gives a good impression of red.*

3 Having built up the dark and mid-toned skin colors, the artist adds highlights to bring the face into focus and establish the full tonal range. Since white is a neutral color, mixing it into the flesh colors does not alter the overall temperature.

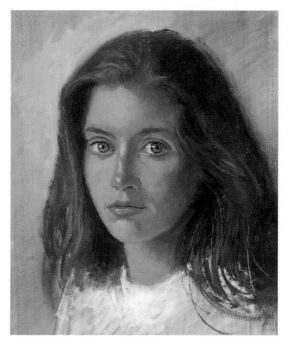

4 The main difficulty with the warm palette was in the shadow colors, where a touch of blue or green would have been preferable to black. Also the background could have been slightly cooled to create more impression of space.

▲ **Warm palette**
Using a limited palette of primary colors is a good way to acquire color-mixing skills. This palette includes cadmium red, cadmium yellow and ultramarine, plus white and black.

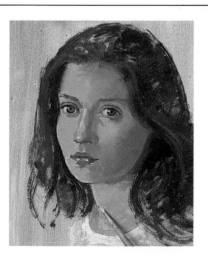

3 As in the first painting, highlights were added in the final stages, when the tones and colors were well established. Notice the difference between the color of the eyes here and in the first painting; phthalo blue cannot match the cornflower blue of the model's eyes.

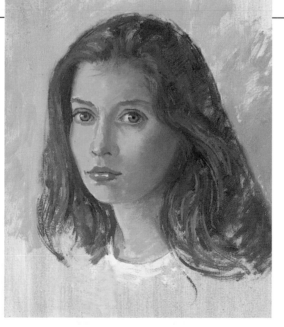

4 Although the skin colors are perceptibly cooler than in the other painting, the artist has been able to warm them slightly by contrast with the even cooler background, touches of which he has also used on the T-shirt. It is important to remember that we do not see colors in isolation; they are altered by juxtaposition.

▲ **Cool palette**
Here the primary colors are alizarin crimson, phthalocyanine blue (sometimes called phthalo blue) and lemon yellow. These are less suitable for conveying the overall warmth of skin.

4

Pale skin

Pastel is a very attractive medium to use, direct and easy to handle, but it does have one major disadvantage in that colors cannot be premixed as paints can. Because pastels are opaque, both color mixtures and modifications of tone can be achieved by laying one color over another on the paper, but there is a limit to how much of this you can do before the surface becomes clogged and unworkable. For this reason, most pastel painters have a large selection of colors, which include several different tones (known as tints) of the same color. In order to choose the right pastel stick for your first and subsequent colors, you will have to look hard at your subject. Thus pastel painting is a useful exercise, encouraging the analytical approach essential for skin colors.

Materials used

•

Gray pastel paper

•

Soft pastels:
Cadmium tangerine, Indian red, Olive green, Sap green, Burnt sienna, Blue gray, Black, White

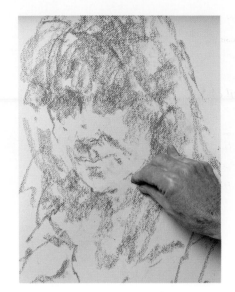

1 *The drawing for a pastel painting should never be done in pencil, as graphite is slightly greasy and repels pastel color. The artist begins with black pastel, using the side of the stick to make light, broad strokes.*

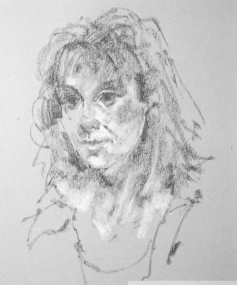

2 *He likes to plot out the full drawing and basic tonal structure before he begins to lay on color. He is working on gray paper, and has added some touches of white to establish both extremes of the tonal range.*

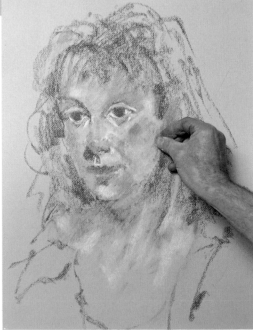

3 *Still using the side of a short length of pastel, he begins to add color over the black-and-white drawing. The deep orange-red for the lips has been put on at an early stage to provide a color key for the skin.*

4 *Although these pastel sticks are thick and soft, surprisingly fine detail can be achieved by using the edge, and here delicate drawing is done around the mouth with black.*

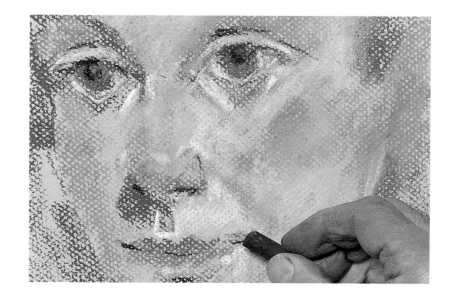

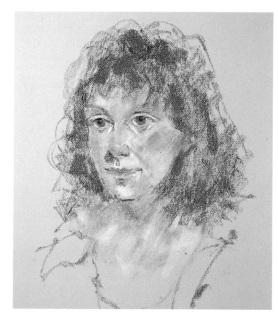

5 *Having blocked in the skin tones lightly, the artist has now added dark color to the hair, bringing the face into sharper focus.*

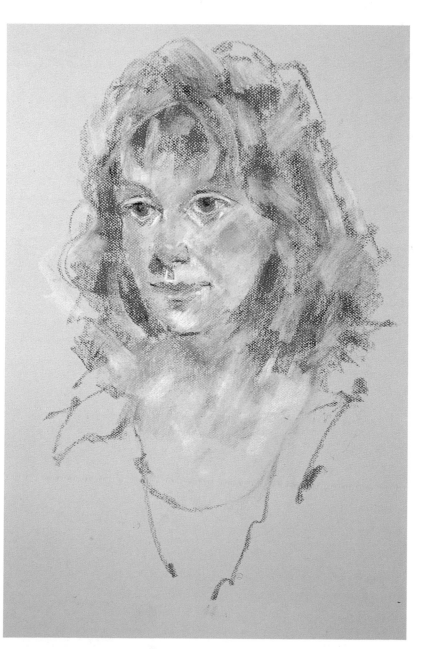

6 *With some lighter color laid onto the hair, the head is already beginning to look solid and well-established, with only the bare minimum of color.*

7 *The light and dark colors of the hair are fused together by laying light over dark. They could be blended together with a finger, but the artist prefers the pastel strokes to remain firm and strong.*

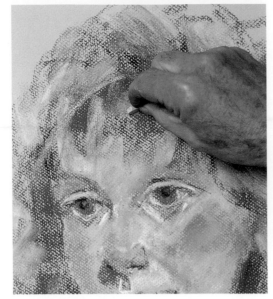

8 *At this stage the artist carefully assesses the portrait to decide which colors and tones will need to be strengthened.*

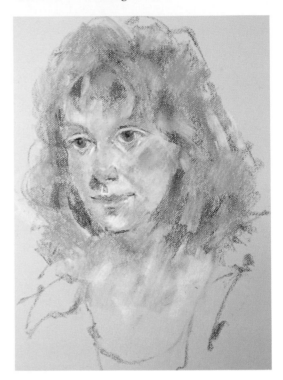

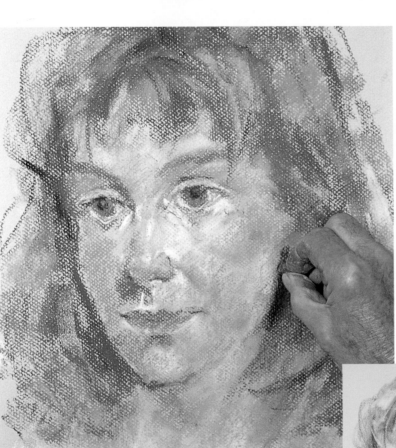

9 *The skin colors are now taken further, with blue-gray introduced on the shadowed side of the face. The gray paper provides a cool contrast to the warm pinks and yellows of the skin.*

10 *The character of the sitter is beginning to emerge, and the hair has been brought into focus by defining the shape and style.*

11 *Linear touches of white define the eyes, nose and mouth. Again the side of the pastel stick has been used for the highlights on nose and upper lip, and here a blunted point makes a softer, rounded highlight.*

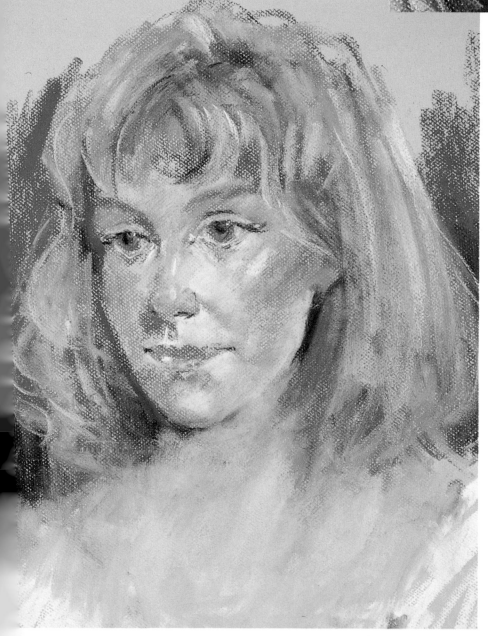

◄ **Victoria**

A relatively small selection of pastel colors have been used – no more than six, plus black and white, with the gray paper providing a further color. KEN PAINE has not attempted to blend the colors, but instead has covered broad areas which are subsequently modified either by overlaying or by adding adjacent colors to change the effect. The final portrait has a strong presence and gives a convincing rendering of the skin colors. Notice also the way the textured paper breaks up the pastel strokes in places, giving an attractive sparkle.

Working from photographs

In an age when almost everyone owns a camera, artists should never be without source material – at least in theory. In practice it is not as simple as that, because photographs are seldom a good substitute for reality, particularly when it comes to the human face and body. Photographs often provide either inadequate information or the wrong kind of information, whereas when you draw and paint you select only what you need for your picture. However, making tone and color studies from a photograph can be a good exercise. If it is a poor one you will have to draw on memory and experience to fill in the gaps; and if a good one you will have to decide how to select from over-abundant information.

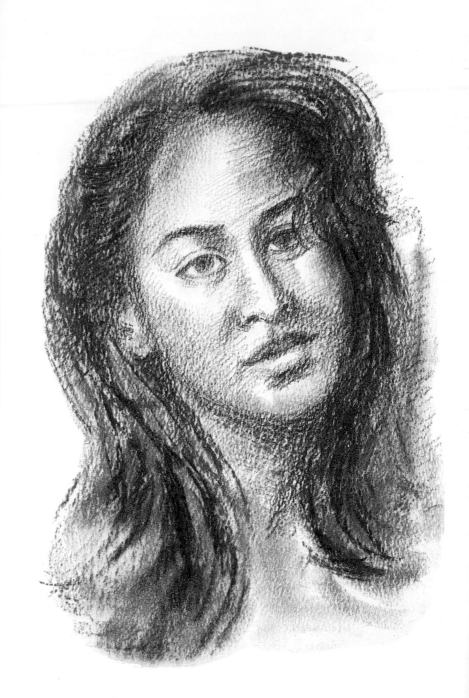

The hair is over-detailed. In both the drawing and the color study it has been simplified into a broad area of dark tone

The white background, while acceptable for a drawing, is not promising for a color study, and the artist has invented a mid-toned background

The highlights in the photograph are mid-toned; in the drawing they have been left as white paper

▲ Tonal study

The white background in the photograph has had the effect of making the skin tones look darker than they otherwise might. Thus some restraint was needed to avoid making the charcoal drawing look unnaturally dark and heavy. By keying the whole drawing to the highlights, here left as white paper, the artist was able to build up the forms of the face with relatively light shading.

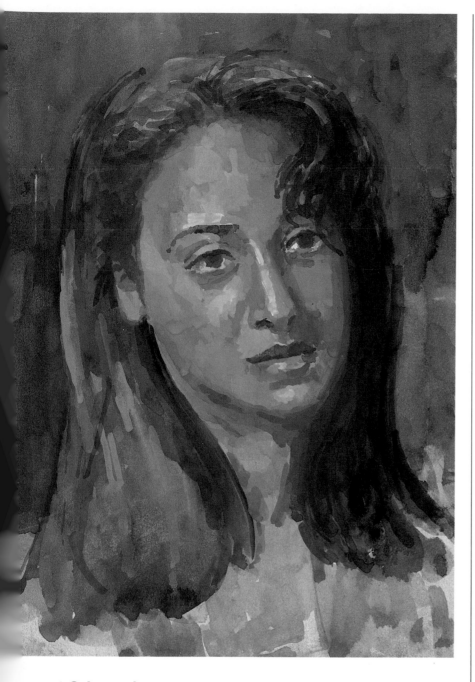

The hair registers immediately as the darkest tone, which puts the others into perspective

These little patches of light and dark are confusing and hard to read; they have been much simplified in the drawing

The ridge formed by the long muscles at each side of the spine is important to the structure

▼ Simplifying tone

The artist's experience in life drawing has helped her to spot the important areas of tone that define the forms, and she has laid these out in simple masses, avoiding becoming caught up in the minutiae of muscle structure. To strengthen the line along the light side of the body, she has used a mid-tone in the background.

▲ Color study

This gouache painting shows considerable ingenuity. The skin tones are close to those in the photograph, though the colors are richer and more varied, and the edge between face and hair has been softened to give a gentler transition into the shadow area. It is the dark background, however, that really makes the skin colors sing and brings the picture to life.

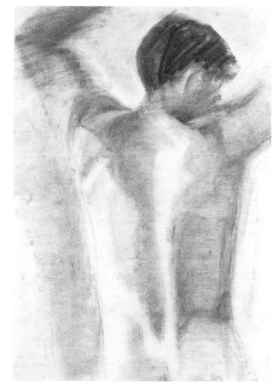

Mid-toned skin

Acrylic has been chosen for this portrait, as this medium is well suited to the glazing techniques the artist frequently uses in the later stages of a painting. The working surface is canvas, and the technique is similar to that of many oil-painters, with a gradual progression from thin to thicker paint. The artist has deliberately restricted himself to a small palette of colors.

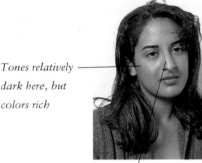

Tones relatively dark here, but colors rich

Highlights are stronger than on pale skin, making forms easier to read

Materials used

Canvas
•
Acrylic paints:
Yellow ochre, Napthol crimson,
Raw umber, Ivory black, White
•
Bristle and sable brushes

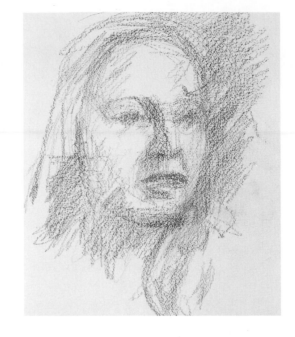

1 *As a preliminary, a quick sketch is made in soft pencil to establish the placing of the head. The proportions of the paper used are similar to those of the final canvas.*

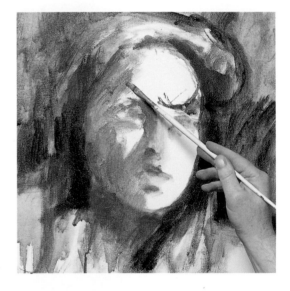

2 *The artist's approach is largely tonal, and rather than making a linear under-drawing, he begins to establish the tonal structure immediately. The dark and middle tones are blocked in with well-diluted paint.*

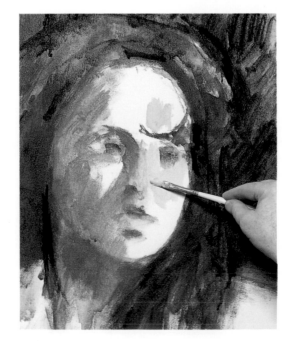

3 *He can now assess the tone and color needed for the lighter side of the face. He uses pure yellow ochre, applied slightly more thickly than in the shadow areas.*

4 With the form of the head now solidly defined, work can begin on the individual features. First, the model's upper lip is delineated with a fine sable brush.

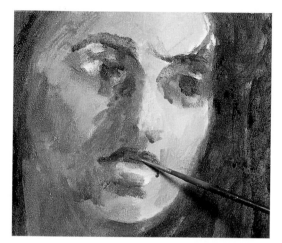

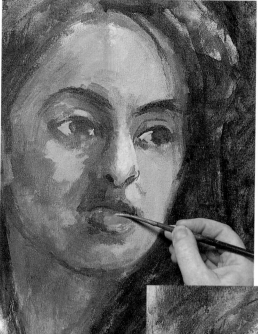

5 Care is taken not to develop one feature more fully than another. The brilliant pink for the highlight on the lips is left until the eyes and nose are relatively well defined, and the overall tonal balance firmly established.

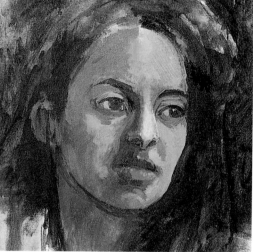

6 The face is now convincing in terms of tonal value, and hence form, but the skin color is insufficiently warm and the hair has still been treated only sketchily.

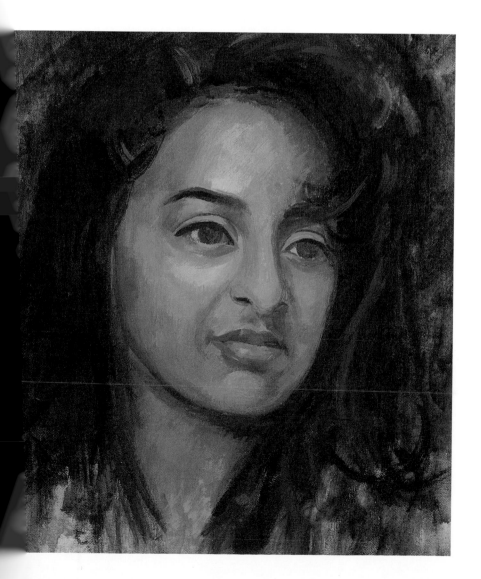

◄ **Maleni**

In the final stages BRIAN DUNCE has added a little more detail to the features, and has warmed the skin color by laying an all-over glaze of thinned yellow paint. The hair has been darkened and given more shape, but deliberately allowed to merge into the dark background, thus focusing attention on the rich golden colors of the skin.

Tone and color

These exercises will help you to identify the tonal values in the subject, the relationships of color and tone, and the interaction between skin tones and background. The pencil study concentrates on tone; the watercolor explores color and tone, while the chalk drawing shows how you can find common areas of tone between different skin types.

The forehead is gently rounded, so the transition from light to dark is gradual

The color of the skin does not vary a great deal, but this area is considerably lighter in tone than the shadowed side of the face

Light catches the bottom of the nose, defining the two different planes

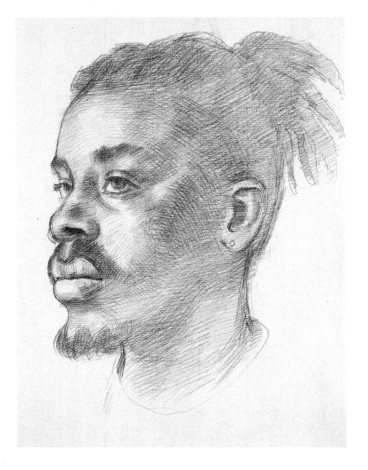

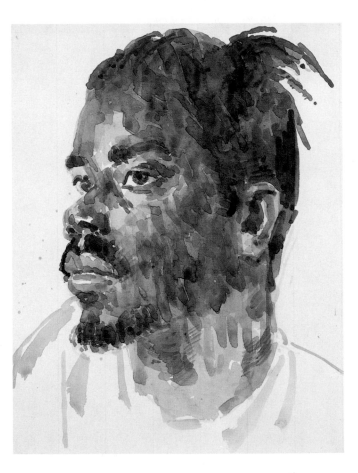

▲ Exploring the pencil range
Using different grades of pencil helps you to build up the tonal structure of the face and head. Here three were used: 2B, 4B and 6B, a gradation from soft to very soft. The drawing was laid out with the hardest one, the 2B; the basic tone was added with the 4B, and the 6B was used for the darkest areas. The pencils were kept well sharpened to give clarity to the shading.

▲ Exploring color and tone
It is often helpful to begin looking at color and tone immediately, without the added complication of a preliminary drawing. Using a medium sable brush, watercolor was put on rapidly in large blocks, with highlights reserved as white paper. The features were defined as the work progressed, but the brushwork remained loose and free throughout.

▼ ▶ Simplifying tone

It is easy to become caught up in trying to reproduce each tiny variation of tone, but this can sometimes weaken the impact of the picture. If you deliberately restrict yourself to a few tones by using three colors of chalk, you will need to simplify and will have to look hard at the subject to identify the important tones.

The lightest areas here are similar in tone to the dark areas of the white face

The gradations of tone are subtle, but have been simplified in the drawing

1 Three different chalks (hard pastels) are used for this drawing – black, red and white, with the gray paper providing a mid-tone. The artist has begun with black, making a straightforward line drawing.

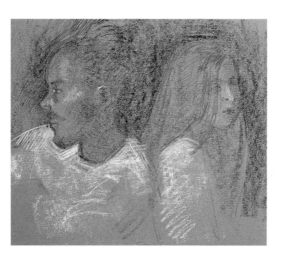

3 Two areas of common tone have been identified, and white used for both the skin highlights and the models' T-shirts.

2 Tones are built up gradually. After a light covering of red and black, the artist now applies highlights, using the chalk very lightly at this stage.

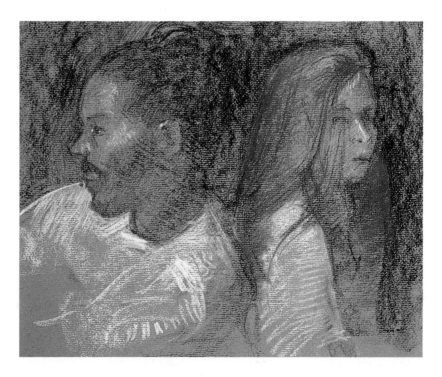

4 In spite of the simplification, the rendering looks convincingly realistic, and the painting works well because the common tones unite the two different skin colors. Working on a mid-toned paper is helpful because it provides a key for judging both the light and dark tones.

PROJECT 6

Dark and light skin

This project presented potential problems. The dark background chosen in order to contrast with the girl's coloring made the man's dark skin potentially hard to handle, as it appeared to blend into the background. However, it proved an exciting challenge, providing an opportunity to learn not only about different skin types but also the relationship between them and the color similarities between dark face and background. Note how the highest color on the man's face is just about equal to the darkest on the girl's.

Head merges into background, but highlights on face and ear stand out well

Materials used

Gray paper
●

Gouache paints:
Cadmium yellow, Lemon yellow, Naples yellow, Cadmium orange, Red ochre, Flame red, Parma violet, Ultramarine, Winsor blue, Lamp black, White
●

Sable brushes
●

China plate (palette)

1 *As in Project 4, the artist is working on a mid-toned gray paper, and he begins with a careful brush drawing in burnt sienna.*

2 *The drawing is now complete and ready for color. The amount of detail required for a preliminary drawing is largely dictated by the subject, and will not necessarily always reach the same level.*

3 The first applications of color are broad. The artist's first concern was to look for similarities between dark head and background.

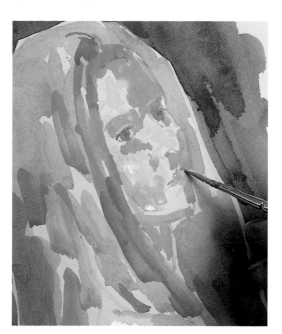

5 Having identified a range of color and tone on the dark head, the next step was to find the comparative level on the girl's much lighter face.

4 Some white is added in order to begin establishing the full range of tone and color for the finished picture.

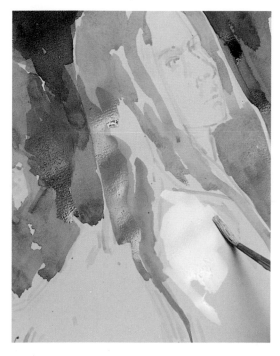

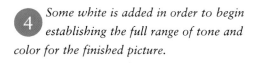

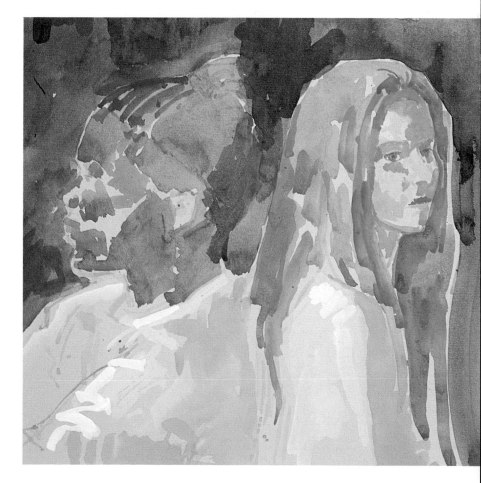

6 The double image is now beginning to shape up. The basic distribution of the restricted range of color has been established, and as an arrangement will not alter much.

7 Here you can see how similar the tone of the head is to the background. The darkish pink highlight being put in was rather unexpected both as a color and as the highest tone.

8 The purple highlights on the dark head closely resemble the dark side of the girl's head. The artist should always be on the lookout for such correspondences.

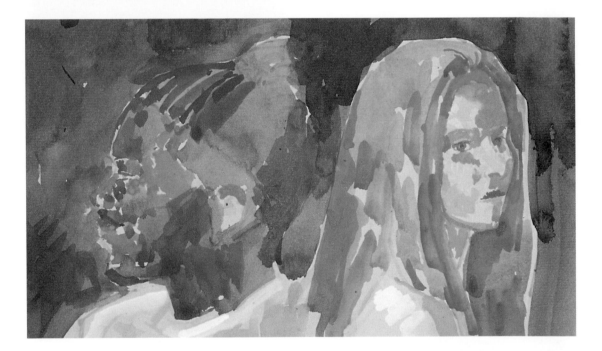

9 The girl's hair was a particularly attractive aspect of this double portrait, and as a color formed a very important part in the composition.

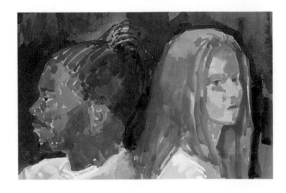

10 The painting is assessed for balance and arrangement of colors before any finishing-off work is done.

11 *The two heads work well together in the general sense, but some further definition is needed, such as refining areas on the girl's face to bring her into focus a little more.*

▼ **Sadie and Marcus**

The finished painting shows an arresting contrast between the two heads, but JAMES HORTON *has made a coherent and harmonious statement in terms of painting, with many similarities observed and recorded.*

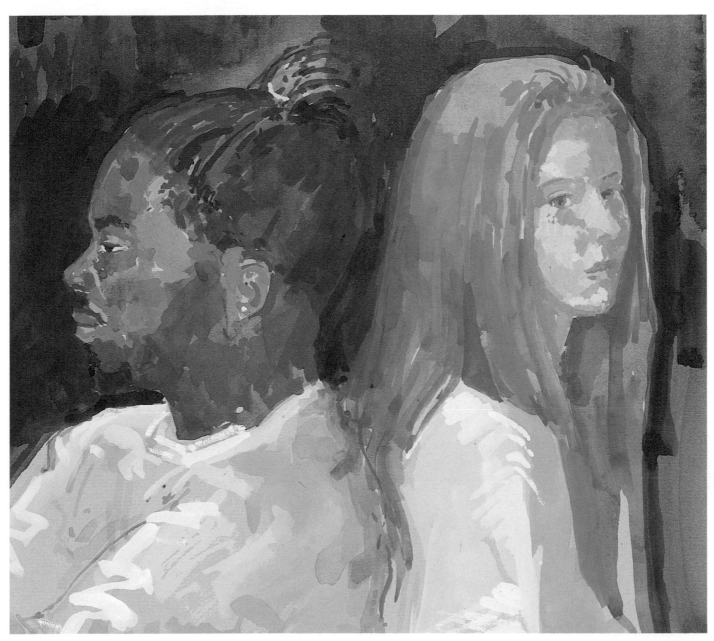

Lighting & tonal values

It goes without saying that the direction and quality of light are of fundamental importance to an artist. The way in which a subject is lit will determine the whole mood and atmosphere of a painting, a fact which is well illustrated by the paintings shown in this section of the book.

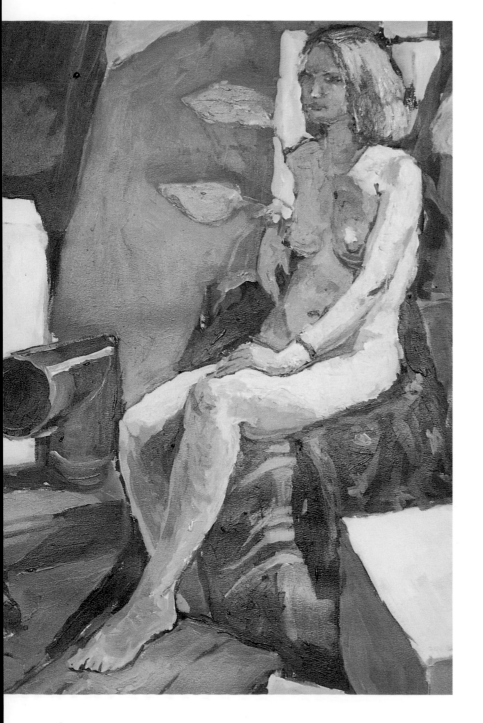

Interestingly, the way in which artists have treated light has changed over the centuries. Painters of the Renaissance – who were often sculptors as well – were mainly concerned with portraying people and buildings in as solid a fashion as possible. They generally chose a straightforward, uncomplicated lighting which, as often as not, was invented to suit the painting. They were not interested in particular light effects, but as time went on, particularly after photography had been invented, artists began to be fascinated by the peculiarities produced by unusual sources of light. The Impressionists led the

◀ **Karen: Seated Nude Study**

Here side lighting has provided an exciting tonal pattern as well as creating subtle and intriguing colors on the shadowed side of the body. The painting, by DANIEL STEDMAN, *is in acrylic.*

Shadow cast on the background creates tonal contrast

Strong light makes an elegant pale shape down the side of the body

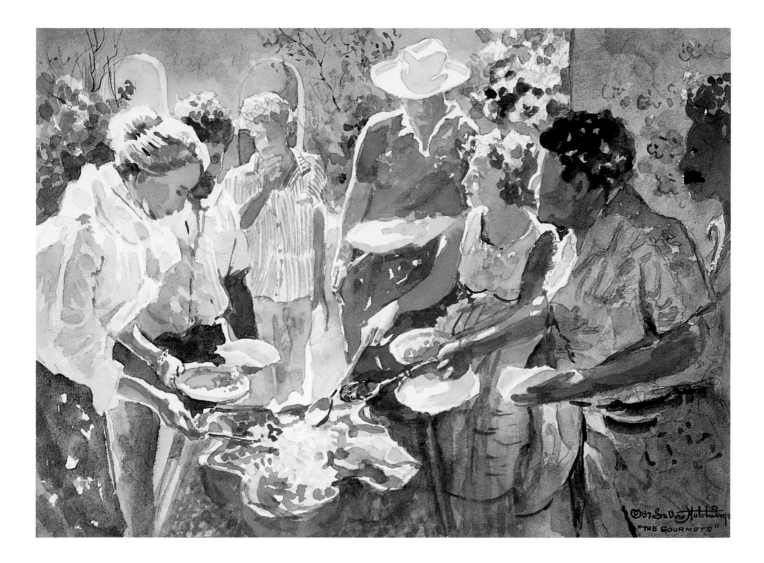

way in the exploration of natural lighting, and artists like Degas and Sickert both exploited the effects of artificial lighting in paintings of cafés and theaters.

The way tonal values are perceived has also changed as painting has developed. At one time, oil paintings were begun in tone alone: the artist made a full monochrome underpainting, over which the color was applied in the final stages. Most of these paintings were on a large scale, and done in the artists' studios. The Impressionists, who worked out of doors directly from the subject, rejected this practice, making no underpainting, and putting down each color as they saw it.

Since their time the idea of color as a reinforcement to a tonal structure can no longer be seen as valid. However, the distinction between tone and color is still made,

▲ The Gourmets

In LAVERE HUTCHINGS's *lively watercolor of an outdoor scene, sunlight from above and behind the figures has created an attractive halo effect and strong contrasts of tone.*

Tones carefully handled, with white highlight and dark shadow separating the two faces

Strong contrasts of tone in central area reinforces focal point

Backlighting turns flesh color very dark, but highlights profile

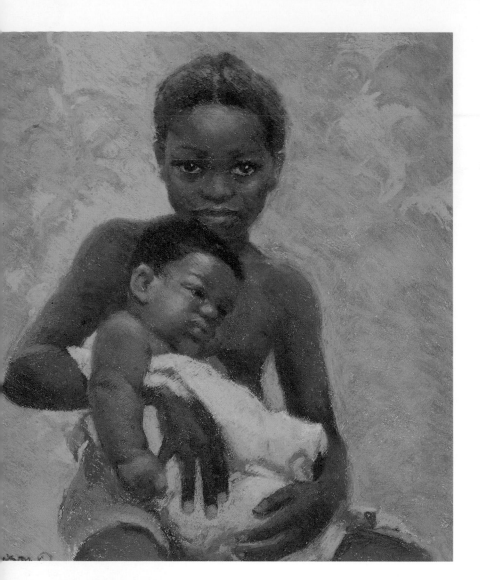

and one sometimes hears artists being described as either a tonal painter or a colorist. Such terms can be confusing, but basically a tonal painter is someone who controls the picture surface by a strict tonal hierarchy, so that if the picture were seen as a black-and-white reproduction it would still make pictorial sense. Such a painting is not necessarily monochromatic; indeed it can be very colorful but still conform to a tonal pattern. A colorist, on the other hand, will use color purely to create effects that work in an interactive way with one another.

Tone and mood

Whichever of these categories you feel you may fit into, it is necessary to come to grips with the question of tone, not only because paintings need to hang together in terms of light and dark, but also because tone can be used in a deliberately planned way to make your paintings more expressive.

Artists often use the phrases "high key" and "low key" to describe paintings with a predominance of light and bright, or dark and somber colors respectively. In general, light colors – and hence tones – convey a relaxed and cheerful feeling; these are probably the colors you would instinctively choose for a portrait of a child, and you would keep tonal modeling to a minimum in order to convey the delicacy of the skin.

But for an adult or older person you might want to put across a feeling of seriousness, strength, or perhaps even sadness, in which case you could choose a low tonal key for the picture, as we tend to associate dark colors with stability as well as with gloom. And for dramatic effects, try strong contrasts of tone, perhaps posing your sitter by a lamp or a window so that half the face is brightly lit and the other in deep shadow.

As we have seen, the tonal variations in any color are produced by the fall of light, so in order to manipulate the tones in your subject you will need to consider how best to light it. This is important for the descriptive as well as the emotional content of your painting; the lighting must enable you to see

Lighting from in front and slightly above creates centralized highlights. Here the artist has introduced some of the light green used for the background

The light-toned turquoise garment silhouettes the dark hand. Notice also how the pink of the skirt is repeated on the fingernails

▲ Children of the Suriname Rainforest

The combination of tonal contrast and the direct gaze of the older child gives pictorial drama and emotional impact to DOUG DAWSON's pastel painting. There is also a strong pattern element in the interplay of sinuous dark shapes against the brilliant background.

◀ ▶ **Self-Portrait**

This painting has a strong tonal organization which is in part due to the careful use of lighting, which illuminates half the face, the shoulder and hand as well as the screen behind the artist's head. JOHN WHITTALL *has orchestrated a muted color scale throughout, which allows the subtle color values in the face to register prominently.*

Subtle color values in the face work well against more somber background

Light striking hand creates touch of tonal contrast in that area

▼ **Portrait of Helena Cook**

SUZIE BALAZS's *pastel painting, like Doug Dawson's opposite, has a strong tonal structure, and employs a similar frontal lighting. A full-on view of a face is unusual in portraiture, but here it is very effective, as it places the emphasis on the interplay of shapes and tones.*

the forms clearly. Light coming from directly in front of the sitter is best avoided, as this flattens the forms and minimizes color variations. The commonest form of lighting in portraiture is known as three-quarter because it illuminates three-quarters of the face and shows up the structure well, but it is also worth experimenting with lighting a head or figure from behind. Backlighting, a favorite with photographers, creates a lovely halo effect, and the skin colors seem to glow in soft shadow.

Opacity and translucency

Apart from the tonal structure of the painting, there is another aspect of tone that is particularly important. This is the quality of translucency. All skin, but particularly pale skin, is translucent to some extent, which means that what happens under the skin will, depending on the light, register on the surface. Veins and bones close to the surface are particularly noticeable. This introduces

Light area of background echoes white of dress. Pastel is applied lightly so that paper color shows through

The skin color has been repeated on the pattern; introducing further colors would have reduced the impact

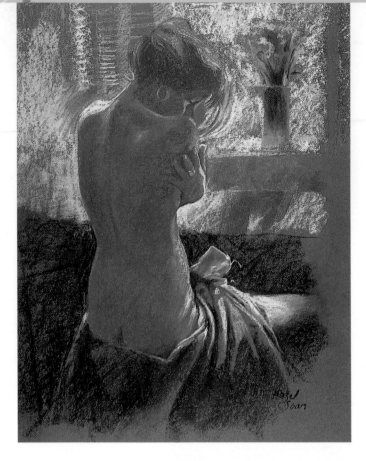

◄ Caress

Natural light coming through a window has been exploited by HAZEL SOAN *in her lovely pastel study. This has semi-silhouetted the figure, so that most of the skin is dark, with the occasional linear highlight around the edges of forms and in the hair.*

This patch of light on the shoulder indicates another window only hinted at in the painting

The vase of flowers provides a balance for the dark tones at the bottom of the painting and the mid-tones of the figure

The light striking the drapery creates a pattern of light and dark balancing that of the hair

The low lighting has given more prominence to the eyes than would be possible with conventional lighting

The light mainly strikes the other side of the face, but here has caused a touch of blue to be reflected from the sitter's shirt

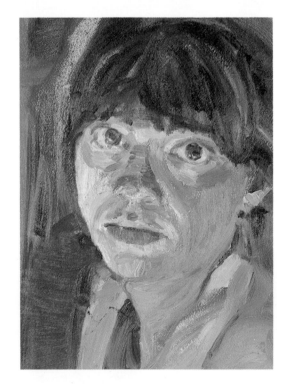

▲ Self-Portrait

Painting a self-portrait allows you to experiment with lighting. For this oil painting KAREN RANEY *lit her face slightly from below, thus casting shadow above the cheekbones and upper lip.*

an extra element when attempting to gradate skin tones, and can be hard to emulate in paint, particularly if you are using an opaque medium such as oils or acrylics.

The Old Masters, whose techniques were rich and varied, often overcame this problem by using a blend of opaque and transparent paint. Rubens, for example, would make a fully resolved underpainting and then glaze thinly over certain areas. The edges of the form, where they turn from light into shadow, were allowed to shine through as thin layers of paint in much the same way as veins show through skin.

This particular technique relies on resolving the tonal structure in the early stages, a practice which many painters today do not favor as they feel that it compromises spontaneity. This is to some extent true, but we have perhaps come to attach undue importance to the idea of spontaneity, confusing it with artistic merit. Degas, whose paintings are among the most spontaneous-looking ever, in fact planned his compositions with laborious care. "No art was ever less spontaneous than mine," he said.

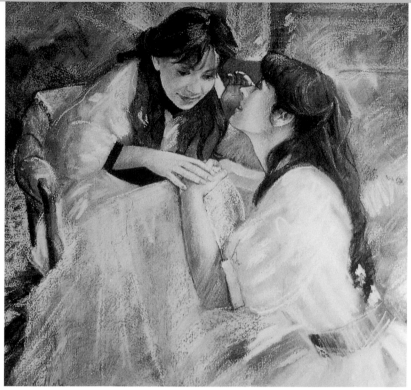

*Dark area of
background pushes
chair and figure
forward in space and
provides balance for
dark hair*

*The black shape makes the
outline of the wrist and hand
stand out strongly. The
hands are important in
this painting*

▲ **Private Conversation**

*This delightful painting, with its atmosphere of
quiet intimacy, shows a skillful handling of tonal
contrasts. The work is almost monochromatic;
notice how GLYNIS BARNES-MELLISH has played
down the skin color to preserve the unity of the
picture. She has also exploited contrasts of
texture, using a dry-brush technique for the
dresses and background, and smoothly blended
paint for the faces.*

MASTER WORK *Sargent was one of the
most gifted and fluent
portrait painters the world has known. His way
of rendering character was intrinsically linked to
his technique as a painter. He used a very
straightforward palette containing several earth
colors, and had a perfect sense of color pitch and
tonal values. In this portrait, the dramatic
lighting, somber colors and overall dark
tonalities combine with the breathtakingly
economical use of paint to produce a powerful
impression of the sitter.*

Albert de Belleroche JOHN SINGER SARGENT
(1856–1925)

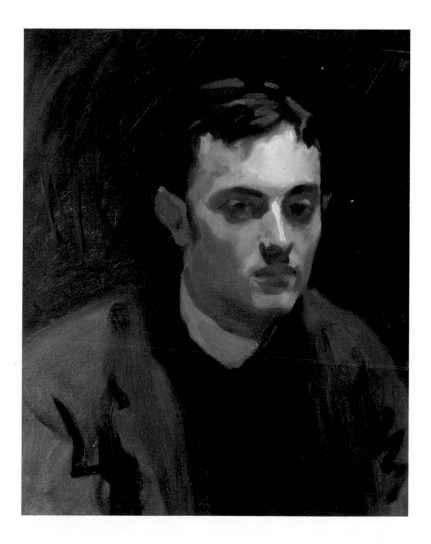

EXERCISES

Skin and clothing

No one color can be seen in isolation, and skin is no exception. A mid-toned skin will seem darker against white, and an "olive" skin may take on a distinct greenish tinge if juxtaposed with red. The colors of clothing or an adjacent wall or curtain will also reflect onto the skin, causing interesting but sometimes puzzling color permutations. To study these reflected-color effects, several photographs have been taken showing models in different clothing colors. The point of the exercise is to exaggerate one or more of these, working back from the clothing color, as the artist has done in the paintings opposite.

1	2	3
4	5	6
7	8	9

Reflected-color effects

1 *The effect of the yellow T-shirt shows quite distinctly around the jaw, particularly on the shadow side of the face.*

2 *The white T-shirt illuminates the shadow beneath the chin, giving a bluish cast.*

3 *Little obvious effect from the white T-shirt, although the dark side of the chin shows a light edge, and the white has lightened the shadows.*

4 *A strong yellow streak can be seen on the shadowed side of the face and in the eye sockets.*

5 *A slight touch of turquoise is detectable on the model's chin but the dark tone of the T-shirt prevents much light being reflected.*

6 *Blue can be seen in the shadows, but the dark*

skin prevents obvious color reflections.

7 *The blue shirt reflected on the pale brown skin produces a greenish shadow around the jaw.*

8 *There is little obvious color effect, but the blue has darkened the shadow beneath the chin.*

9 *On either side of the beard there is a strong yellow cast caused by reflection from the T-shirt.*

▶ **Turquoise ground color**
The artist has used the color of the T-shirt (above) as a starting point, laying this at full strength all over a piece of watercolor paper. She has then worked on top with pastel, gradually building up the predominantly warm skin colors over the cool cerulean blue, which has been allowed to show through in the shadow areas.

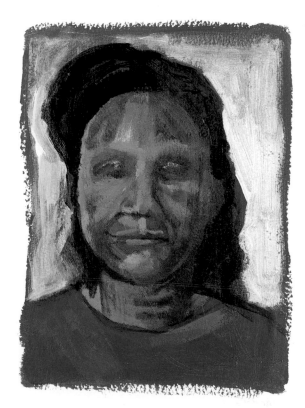

▶ **Deep blue ground color**
The same method has been employed here, except that acrylic has been used for both the underpainting and the subsequent colors. The deep ultramarine (above) works well with the dark skin, which in any case often appears to have blue or violet colors within it. Although the effect is exaggerated, it is sympathetic to the general skin colors, and works well.

7

Reflected colors

The aim of this project was to identify reflected colors and exploit them in a meaningful way in the painting. The model's bright T-shirt caused striking reflections under her chin and along the sides of the jaw. A blue background was chosen to provide a good contrast for the yellow shirt and blonde hair. The painting was done in watercolor, and as is always the case with this medium, the ongoing problem was preserving the effect of the white paper showing through the applied colors.

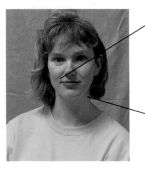

The yellow T-shirt casts an overall glow on the face

The effect of the reflected color is obvious here

Materials used

Watercolor paper

●

Watercolor paints:
Cadmium yellow, Cadmium orange, Lemon yellow, Yellow ochre, Cadmium red, Alizarin crimson, Rose madder, Ultramarine, Monestial blue, Viridian, Burnt sienna, Burnt umber, Raw sienna, Raw umber, Sepia, Black, Payne's gray

●

Sable brushes

1 *The artist begins with a careful pencil drawing, keeping the lines as light as possible so that they do not show through the watercolor.*

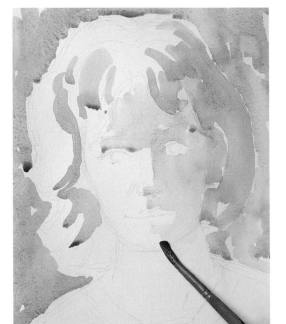

2 *Preliminary washes of color are applied, first on the background and then on the face and hair. A little yellow was used in the mixture for the skin color to provide a basis for the reflections.*

3 *A rich yellow is used for the T-shirt. This will be strengthened in places later on, but to avoid too much overlaying of colors, which can muddy the paint, it is best to establish strong colors at an early stage.*

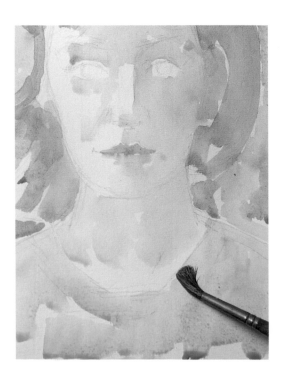

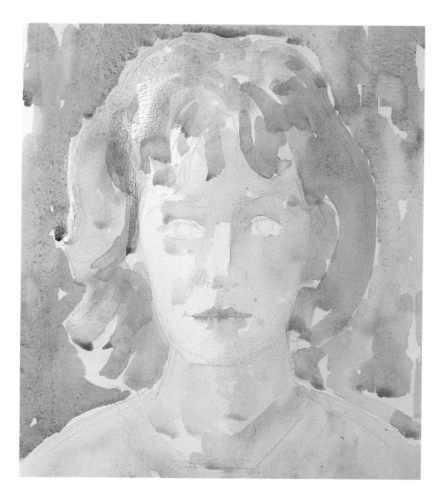

4 The initial blocking in of colors is now complete, with broad washes laid all over the paper except for the areas to be reserved as highlights.

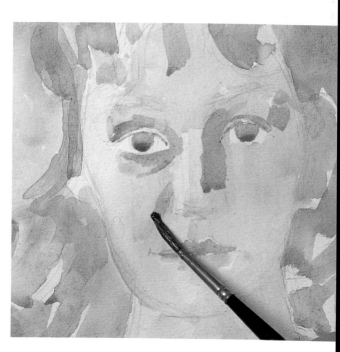

6 With the eyes now defined, together with some suggestion of structure in the eye sockets, nose and cheeks, the face begins to come into focus.

5 The artist gradually builds up the image, working very lightly to retain the delicacy of the skin colors.

7 *Before deciding on the tonal range of the face, the artist establishes the tone and color of the hair, laying a darker wash over the original one for the shadow area.*

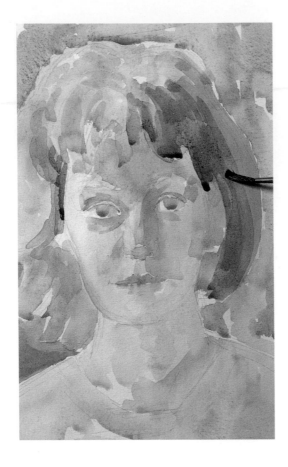

8 *He then returns to the face, building up the shapes with darker washes but at the same time taking care to avoid going over the lighter areas of reflected color.*

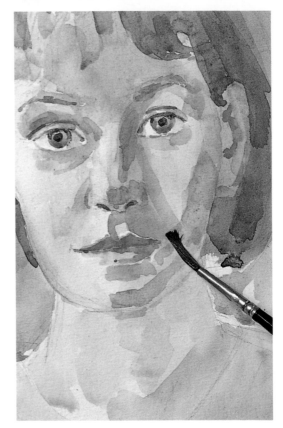

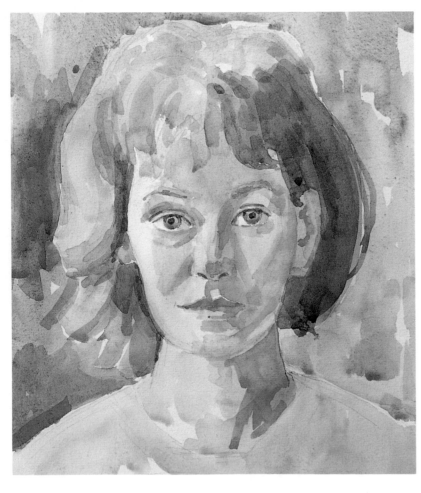

9 *The painting is now beginning to look convincing in terms of form and color, and the way the yellow reflection under the chin is sandwiched between two darker tones works well.*

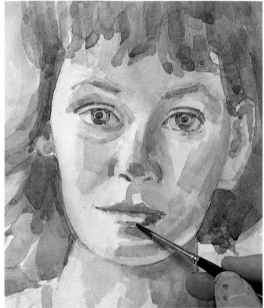

10 Fine detail is added to the mouth to bring it up to the same level as the eyes and hair. No attempt has been made to blend the colors on the face; the separate brushstrokes, overlapping in places, give the painting strength and vigor.

11 The painting is almost finished, but the shape of the chin in relation to the curved line of reflected yellow needs further refining. Again, care is taken not to overwork the paint.

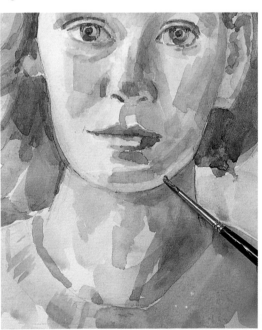

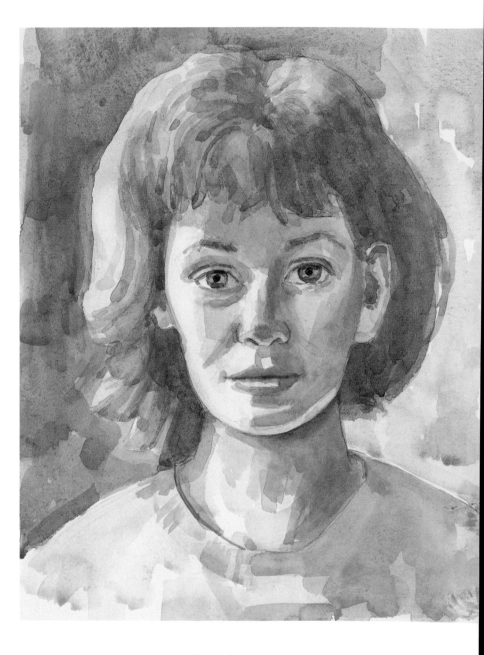

▲ **Victoria**

As a final touch, JAMES HORTON warmed up the shadow areas on the face and neck with a wash of burnt sienna, and also modified the outline of the hair with the background blue. The highlight areas of the face were left as they were in the first stages, just off-white. This prevented the general tonalities becoming too dark and muddy, although there are some quite strong contrasts of tone in the face.

Exploring lighting

Without light, nothing has a visual existence. This sounds very obvious, but it is easy to forget the extent to which the direction and intensity of the light affects your painting subject. The project on the following pages explores natural light striking the body in different ways, while here studio lighting is used. The object is to look not only at the way light describes the forms, but also at how a particular lighting effect can transform an ordinary subject into one which is full of contrast and exciting patterns of light and dark. You can experiment with this idea in your own home; you don't have to use a nude model, and any movable lamp can stand in for studio lighting.

▼ Charcoal drawing

The artist has worked quickly because this was not a pose that could be held for long. She has identified the main masses of tone and blocked them in using the side of the stick, smudging with her fingers to soften the edges.

Light catches the edges of shoulder blades and muscles, almost "drawing" the forms

Lines of light along tops of thighs continues the tonal pattern seen on the model's back

Body throws legs into shadow, creating a hard-line edge at top of shoulder

◀▼ Pencil drawing

Here, the forms have been built up by light hatching and crosshatching. The artist has used only a suggestion of detail on the back, as she wanted this area to stand as an elegant pale shape against the dark background.

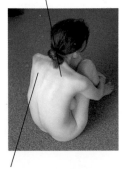

Light catches edge of spinal ridge and top of shoulder blades, but whole of back remains predominantly light-toned

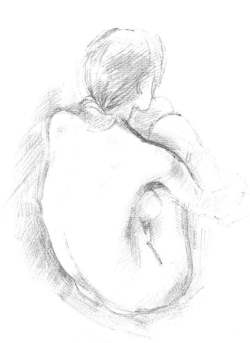

Light running down the whole length of the body emphasizes the model's slenderness and precisely defines the shape of the hip

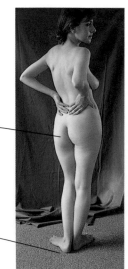

Light strikes the foot, showing the flat plane and making the complex form easier to read

▼▶ Pastel drawing

For this study, the artist has used soft pastel on a contrasting pale blue-gray paper. Because she has used color she has not needed to emphasize the tonal contrasts so much as in the other drawings, instead using cooler colors (blue-grays) for the shadows and turns of form.

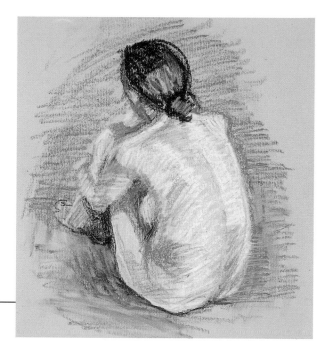

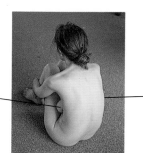

Dark shadow outlines the breast, making sense of a form that might otherwise have been hard to read

As in the earlier similar pose, light strikes the back, creating a pale curving shape

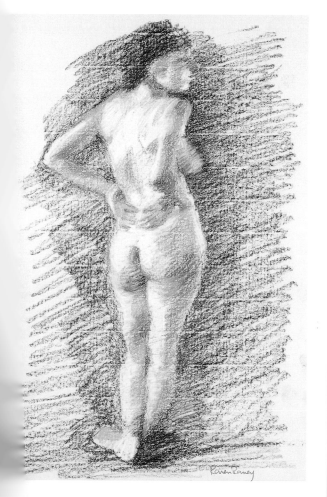

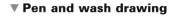

◀▲ Pastel on toning paper

Like the drawing above, this is in soft pastel, but instead of using a contrasting color of paper, the artist has chosen a cream close to the overall skin color. Again she has used warm and cool colors to describe forms.

▼ Pen and wash drawing

This drawing has been made with quill pen and diluted ink, a medium which Rembrandt exploited in many of his drawings. It was done quickly, and although the feet are not defined in any detail, there is a strong feeling of mass and gravity in the sketch.

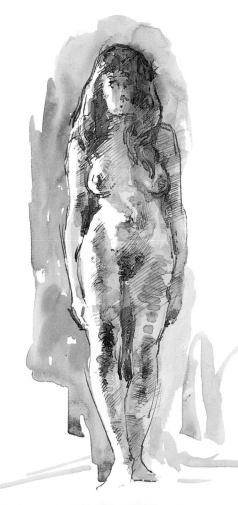

Reflected light outlines the lovely soft curve of the hip

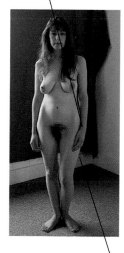

Three-quarter lighting makes it easy to read the plane between waist and top of buttocks; this is emphasized by the position of the hands

Color and light

The way in which light falls on a subject will always affect the color. The aim of this project is to observe how light affects the skin color by rotating the model through 180°, thus creating three different views in the same room. Because of the translucent nature of skin the progression from light through to dark is not always as logical as it might be with other solid objects. Skin tones can appear to jump from warm to cool quite rapidly, varying even more with a fluctuating light. Also, in the case of light skin, reflected light plays an important role, as it will tend to pick up touches of surrounding colors.

Materials used

For the monochrome studies:
•
Diluted ink
•
Quill pen

For the color studies:
•
White and tinted paper
•
Gouache paints:
Cadmium yellow, Lemon yellow, Naples yellow, Cadmium orange, Red ochre, Flame red, Parma violet, Ultramarine, Winsor blue, Lamp black, White

Monochrome studies

These quill pen and wash drawings were made as an exploration of light falling from different directions. Tones can be built up rapidly by using broad washes. Studies of this sort are useful for determining the amount and value of a highlighted area, and also for understanding the tonal balance before translating it into color.

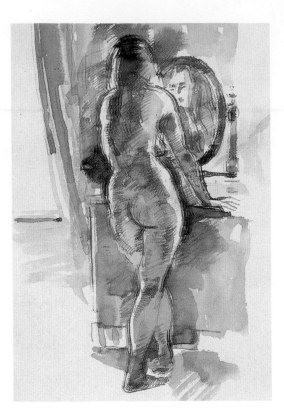

▲ *Light from the window in front of the model creates a rim effect on both sides of body.*

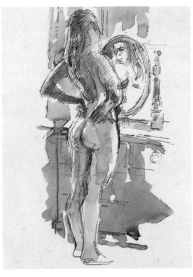

▲ *The same lighting but a different pose. Notice the strong line of light down the left side of the body.*

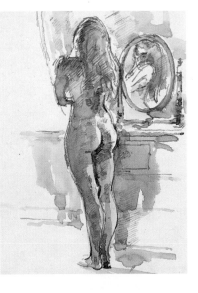

▲ *With the body now turned slightly away from the light, the left side is cast into shadow.*

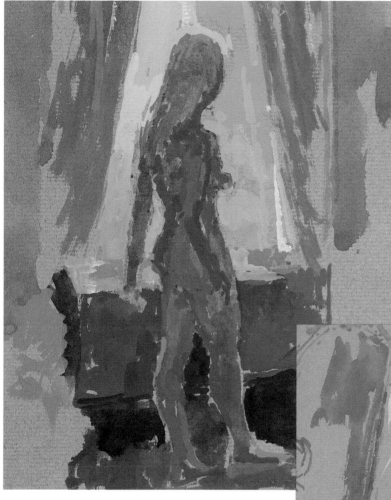

◀ **Against the light**

In this first color study the figure is backlit, appearing almost as a silhouette framed by the light from the window. There are color variations, however, with the upper half of the body being warmer in color than the cooler, pinker legs. As an initial statement it was important to identify this basic difference in the particular individual.

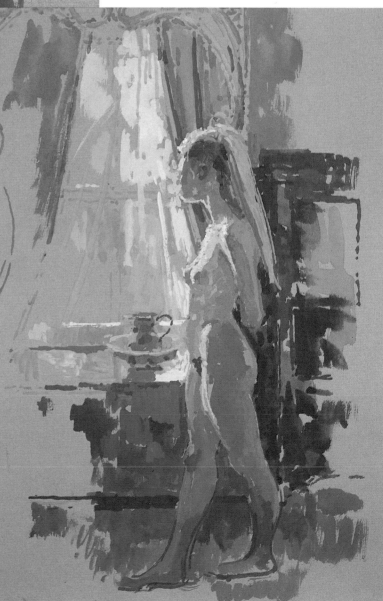

▶ **Highlight effect**

Strong light from the left catches the edges of the arms, torso and legs, with the rest of the body dark in tone, giving an opportunity to explore the transition from the warm greenish yellows of the upper torso to the more purplish nature of the lower legs. Notice also how figure and background merge tonally, which gives special emphasis to the head and chest highlights.

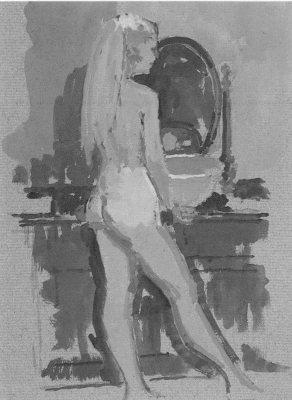

◄ **Full light**

With the light now striking the figure full on, the most obvious change is that almost the whole of the body is lighter than any part of the background. Also, shadows cast from the figure onto the background are quite prominent, emphasizing the model's shape and contour. The color has been applied very simply and almost flatly, as the lack of strong modeling of forms is a characteristic of even, all-over lighting.

► **Increased shadow**

Positioning the model on the other side of the mirror has created a little shadow on the edge of the figure merging into the background. Cast shadows are still much in evidence, and so too is the contrast of the rich, mahogany furniture against the pale flesh. Interestingly, the reflection in the mirror acquires the same tonality as in the study by the window, but because of the light absorption the colors on the torso have a cool greenish-gray nuance.

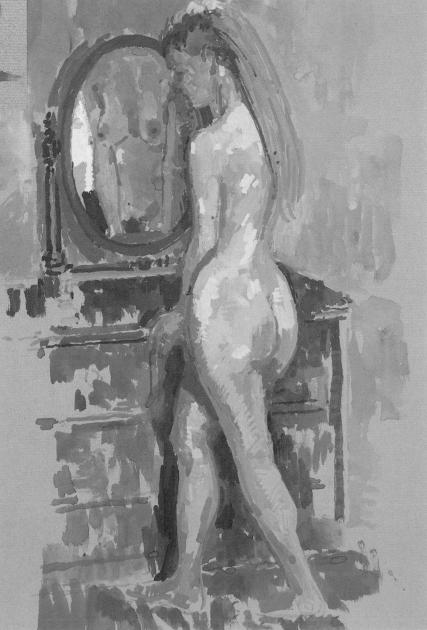

▶ **Side light**

Placing the model sideways to the light source achieves considerable contrast between figure and background. The warm–cool contrast between the colors of the upper torso and the legs is still apparent, and has been consistent throughout following the changes of position and lighting. This study shows how the head, torso and legs of the model are very close in tone but quite different in color.

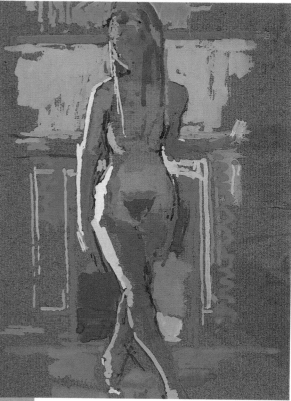

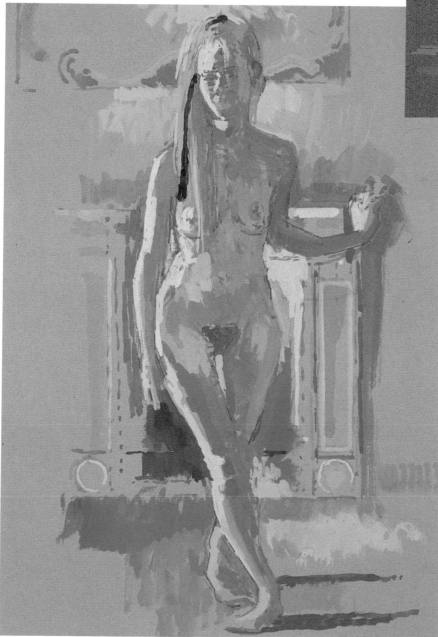

◀ **Tonal relationships**

The relationship of the figure to its surroundings was explored further here. As in the previous pose, the illumination from the left picks out a continuous light edge along the figure but throws the far side of the torso into shadow so that it registers as dark against a lighter background. Great care was taken to keep the color fresh and clean: in order to convey the colors in skin tones it is important to apply paint mixes decisively, as on the shoulder and the forward leg.

Underdrawing in charcoal

The project on the following pages shows the classic technique of underpainting in monochrome before building up the painting in color. Here we look at another method of beginning in tone – drawing in charcoal and then laying two separate layers of color on top, one of acrylic and another of oil. Some pastel painters employ a similar method, making preliminary tonal drawings in charcoal. Underpainting is a useful discipline when you are exploring different skin types because you have to begin by analysing the tonalities – one of the most problematical aspects of painting skin.

	Photograph of model	Charcoal underdrawing	Acrylic underpainting	Oil glazes
Fair skin	1	2	3	4
Mid-toned skin	1	2	3	4
Dark skin	1	2	3	4

These exercises show how the basic technique of charcoal underdrawing can work with different skin types. Beginning with a photograph of the model, each exercise uses the same series of steps, building up through charcoal, acrylic and oil. Follow each sequence from left to right.

1 **Fair skin**
The model's face has overall light tones, but is quite dark in the shadow areas.

2 *A charcoal drawing has been made on oil sketching paper – you can use any surface suitable for oil painting. This immediately establishes the tonal values.*

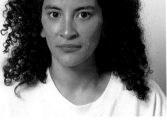

1 **Mid-toned skin**
Here, tones in the highlight areas are slightly darker, but there is little difference in the shadows.

2 *As with light skin, a charcoal drawing was made using a full range of tones.*

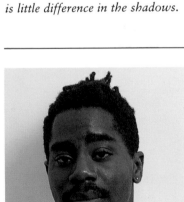

1 **Dark skin**
A marked difference can now be seen in overall tonality – note the contrast between the highlight areas and white shirt.

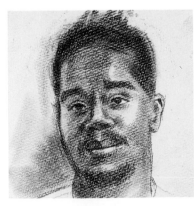

2 *As in the previous studies a comprehensive charcoal drawing was made, and the drawing was fixed.*

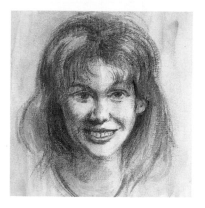

3 The drawing was sprayed with fixative and a wash of well-watered burnt umber acrylic paint applied. A clean rag was used to rub out the highlight areas.

4 A single flesh tone of thinned oil paint (cadmium red, cadmium yellow and white) was worked across the face. It was not necessary to gradate the color, because the charcoal still shows through to create a darker tone. The same method was used for the hair.

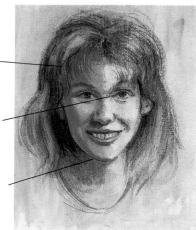

Hair is only thinly covered with color

Demarcation line shows how transparent the glaze is

Shadow created by thin glaze over under-painting; this is known as an optical gray

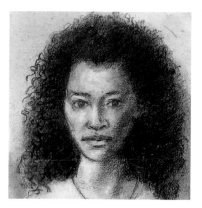

3 As before, the drawing was fixed and a rag used while the paint was still wet to wipe out the highlights.

4 The final flesh color, again in oils, was a mixture of cadmium red, yellow ochre, burnt sienna and white, applied as a thin glaze. The flesh color was varied slightly with additions of burnt umber in the shadows, but always applied thinly to let the underdrawing show through.

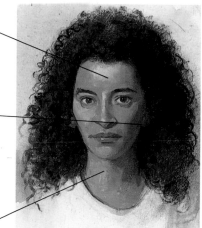

Highlight on the forehead, a mix of yellow ochre and white, is quite thick

Shadow side of the face has been created with just one color, as tonal structure is already in place

Thin glaze of flesh color here, resembling watercolor, shows the translucent technique very well

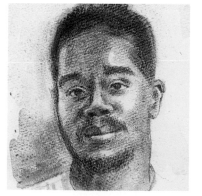

3 The color chosen for the second stage underpainting was blue-black because this would suit the dark skin. Very little wiping out was needed.

4 The colors used for the overpainting were ultramarine, cadmium red, yellow ochre, burnt umber, black and white – a basic palette. The highlights were thin glazes using the tone of the under-painting; it was not necessary to add white in this case, as the "highlights" were quite dark.

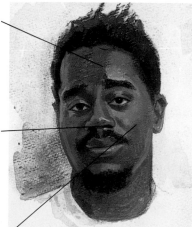

Top color in this area is all semi-transparent, with underpainting color showing through

A small touch of white mixed with the glaze was needed to create the highlights on the nose and lip

Highlight on the cheek is thin and transparent, enhanced by the ground

PROJECT 9

Tonal underpainting

The method of building up a painting with layers of thin, transparent color laid over a monochrome underpainting was once the normal one for all oil paintings. Although less used now it is still a valuable exercise, allowing you to establish a tonal structure before dealing with the complexities of color.

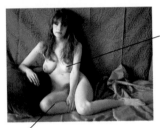

Strong side lighting models the forms very clearly

Subtle colors of shadows can be built up when tonal structure is established

Materials used

Pre-toned canvas

•

**Acrylic paints (underpainting):
Burnt sienna, Black, White**

•

**Oil paints (glazes):
Cadmium yellow, Lemon yellow,
Yellow ochre, Alizarin crimson,
Indian red, Vermilion, Cerulean
blue, Ultramarine, Burnt sienna,
Burnt umber, Black, White**

•

**Linseed oil, Damar varnish,
Turpentine**

•

Bristle and sable brushes

① *Working on a canvas pre-toned with burnt sienna, the artist begins with a line drawing, using diluted acrylic paint.*

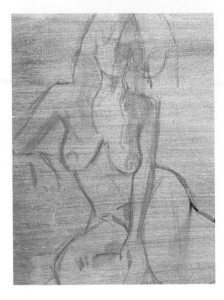

② *Tone is then added in order to begin the gradual process of building up solid form.*

③ *A mid-toned surface gives more flexibility than white, as both dark and light tones will show up. White acrylic is added to create highlighted areas.*

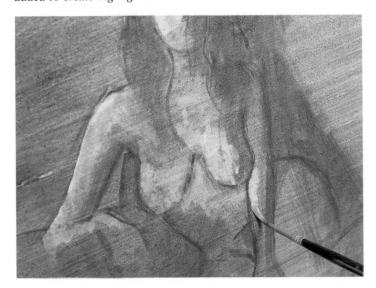

4 The artist now gives some detail to the head and features. Because some parts of the underpainting will show through, as much care must be taken at this stage as during the later ones.

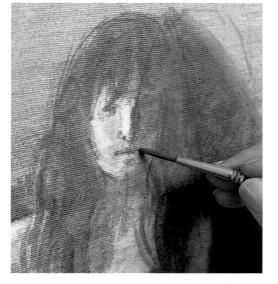

5 Further applications of white acrylic give the form maximum solidity. Small highlights such as this play an important role in describing form.

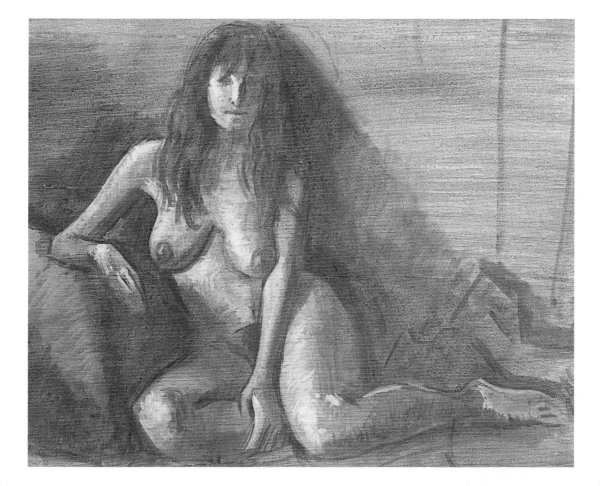

6 The underpainting is now complete, and ready for oil paint to be applied on top. Any water-based medium can be used for underpainting – the traditional one was tempera.

7 The first oil colors have now been applied – the background blue and the first thin layer of a pinkish flesh tone. The paint is thinned with a mixture of linseed oil, varnish and turpentine.

8 Here we can see the effect of the thin glaze of oil going over the top of the burnt sienna under-painting. This produces what is known as "optical gray"; new color incompletely covers the underlayer so that the two mix in the eye.

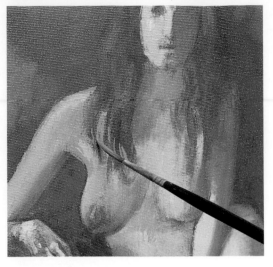

9 Pale skin colors continue to be applied thinly with great care taken to preserve the translucency of the color in shadow areas.

10 Thicker flesh color is applied to the area of the knee. As this part of the model is in full light, the color can be denser. Traditionally, thin color is used for shadow and thick for highlights.

11 This detail shows the gentle transition from light to dark shadow on the leg. But although the boundary between the two is almost imperceptible, this edge nonetheless carries the form adequately into shadow.

12 One advantage of working with thin glazes is that the paint film remains workable for quite some time, allowing manipulations such as rubbing with a finger. This not only softens edges but also increases the luminosity of the underpainting by rubbing the glaze out to almost nothing.

▼ **Nude on Blue Background**

JAMES HORTON's painting shows that an effect which is both colorful and convincing can be achieved with very little color. The glazing technique can be taken a very long way with the build-up of layer over layer. With oil, of course, drying time would have to be allowed for, but acrylic, which is fast-drying, can be used for the whole process, which is not unlike tinting a ready-made black-and-white photograph.

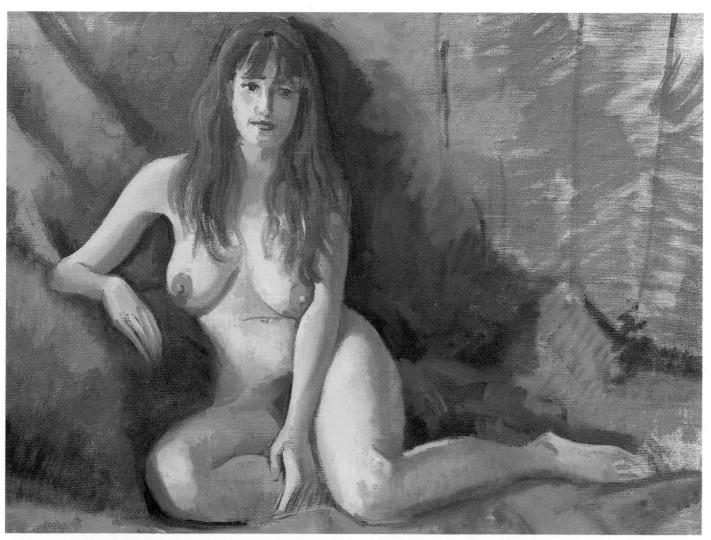

Texture &detail

In some ways, painting is a kind of juggling act, with the artist having to keep several balls in the air at the same time. Sometimes you find you have achieved what you want to in one area of the picture, but only at the expense of another. This is particularly prone to happen when all your concentration goes into a certain part of a picture, and you have failed to see it as a whole. So far we have looked at various ways of using tone and color to create a solid object with a resemblance to life. But there is still the question of detail. This is an aspect of painting that often causes concern to the inexperienced painter. When dealing with a face or body, it can frequently be hard to decide exactly how much detail is needed.

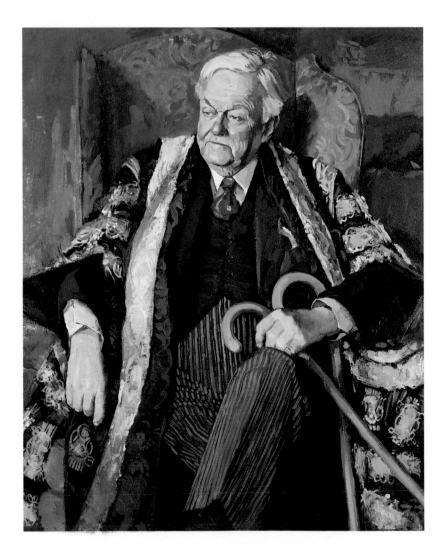

F or many people, the idea of likeness to life is linked with that of almost photographic detail. But it is important to understand that detail on its own is of little consequence if the underlying construction is not strong. The best way to think of detail is as a logical development of

◀▼ The Rt Hon Lord Hailsham
of Marylebone

In an official portrait such as this oil painting by TREVOR STUBLEY, the sitter's clothing is important and must be treated in detail. The same degree of attention must therefore be given to the face. However, as can be seen in the detail below, the artist has rendered the face with skillful economy, using broad brushstrokes.

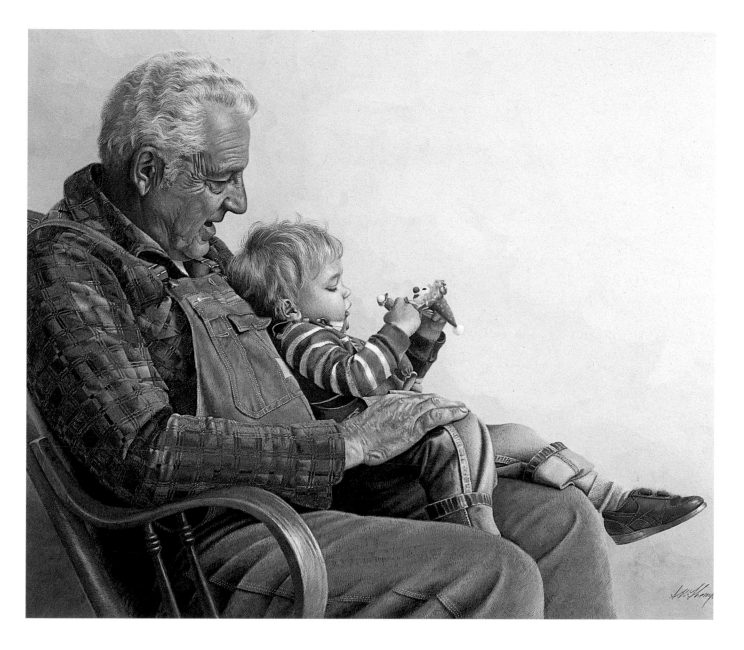

the drawing, tonal and color values; if the piece of work does not read well in these terms, no amount of added detail or linear definition will improve it.

How much is enough?

This still leaves the question of how far to take the final stages of development – or quite simply, of knowing when to stop. There is no easy answer to this, because it largely depends both on the picture and on the artist's individual interests. To some extent the nature of the subject will give some guidance. With children, for example, a high degree of detail is often inappropriate

▲◄ Grandpa's Pride and Joy

STEPHEN MARK THOMPSON *has fully explored the detail in the subject simply because this is the way he likes to paint. His medium is egg tempera, which cannot be laid on in broad brushstrokes like oil paint or acrylic, and thus encourages a minute approach. You can see the smooth effect, with barely visible brushstrokes, in the detail.*

because of the soft shapes and smooth skin texture. Older people provide an opportunity to engage with skin and hair textures, and wrinkles and lines that help to build up the person's character, but even so, such details must always be seen in the context of the overall structure of the head.

Hands, too, can give problems, and it is always wise to begin by simplifying the hand into an overall shape before beginning to define individual fingers. In some portraits, the hands are left with little or no definition,

because a hand treated in too much detail can steal attention from the face, which is the center of interest. In others, however, hands are treated with a great deal of care, as they are seen as important in helping to describe the sitter's character.

The amount of detail you include in your work is of course a personal matter. What it really comes down to is what you as the artist are most interested in, and before you embark on a painting you should always ask yourself what it is you particularly like about the subject. If it is the detail that fascinates you, then go for it, and make your painting as full as you can. There is much enjoyment to be gained from developing a work as far as possible, and you can learn from it too. Once the picture is finished, look at it critically in order to assess it. You will quickly be able to see whether you have included too much detail and have thus reduced the impact, or perhaps the detail has weakened the underlying structure.

▼▶ Dressing the Model

This oil painting, with its wealth of lovingly described detail, touches on many aspects of painting other than skin tones. The pictorial relationship between the two women and the lay figure is intriguing, and JOHN WARD *has emphasized this through the rather ghostly coloring used for the tall woman's face.*

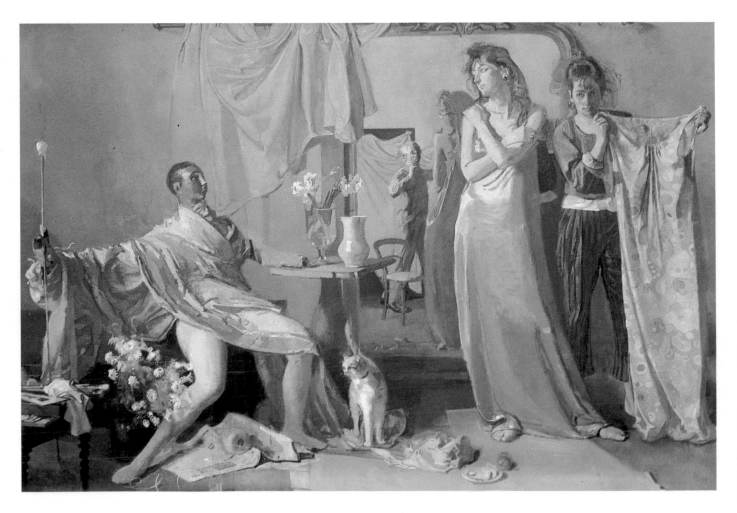

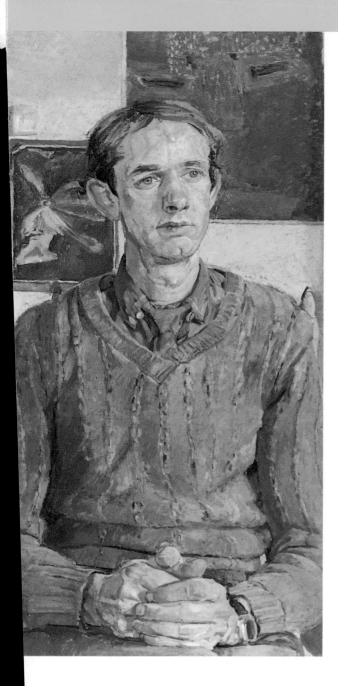

◄ ► Trevor With Mary's Pictures

There is a good deal of detail in DAPHNE TODD's oil portrait, as well as some suggestion of texture – the difference between the skin and the rough wool sweater is obvious. Yet the artist's approach is bold throughout, with a minimum use of line. The fingers, for example, are rendered mainly with broad brushstrokes, with a small brush used only for final definition.

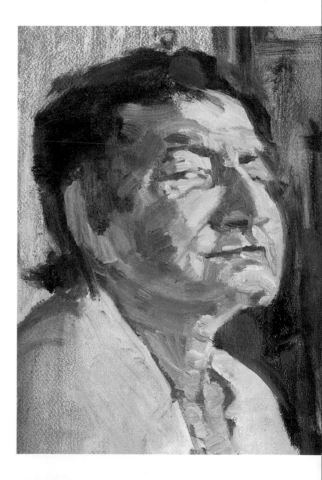

► Gertie

Small details would be out of place in this boldly impressionistic painting done in oil on paper. Nevertheless, the head is firmly constructed, and the features accurately placed and described with conviction. Notice how KAREN RANEY has used her brushstrokes to suggest the forms; around the eyelids the brush has followed the curve, while flatter strokes have been used for the cheek.

If you answer your own question in a different way, and say that you are mainly interested in the contrasts of color, the play of light on the skin, or the overall shape or posture of the person you are painting, you will not want to dwell on small details, and you should try to keep the treatment broad throughout. Sometimes you will see portraits or figure paintings in which facial features and hands are merely suggested in the final stages with one or two flicks of the brush, and yet are completely convincing in the painting's own terms. A strategy sometimes used by artists who want to avoid getting bogged down in detail is to use larger brushes than they normally would – this is

worth trying, as it can help you to concentrate on the real essentials.

But just as it is tempting to put in details simply because they are there, it is equally tempting to stop too soon because you are pleased with the early stages – a remark often heard in painting classes is "don't go on; you may spoil it." In fact, this is sometimes the case, but you should always take a work to the point where you personally feel it is finished.

Texture

Texture is a little different from detail, as you must consider from the outset how you can manipulate your chosen medium in order to convey it. You cannot easily add texture in the final stages of a painting in the same way as you would define eyes and lips to bring a face into focus. But again you must make a decision based on your particular interests; you do not have to make a feature of texture at all – if you wish you can treat skin, hair and clothing simply as broad masses of color and tone.

The importance of capturing the texture, color and fall of hair, and making it work sympathetically with the skin color, should not be overlooked. There are various ways of linking skin and hair together. One method is to use the same shadow and highlights for both skin and hair; another is to use the "base" skin color as a first blocking for the hair then build up the other colors.

Skin textures vary as widely as do skin colors, and often are an important aspect of the business of achieving a likeness. In Rembrandt's portraits of old people, the wrinkled, leathery skin texture is conveyed through the use of thickly applied oil paint. This would not be a suitable approach, however, for portraits of children and young people, where smoother brushwork and subtly blended colors would be more suitable. Whatever medium you use, think about how you can best suggest these qualities, while bearing in mind that they must conform to the overall structure of the head and face.

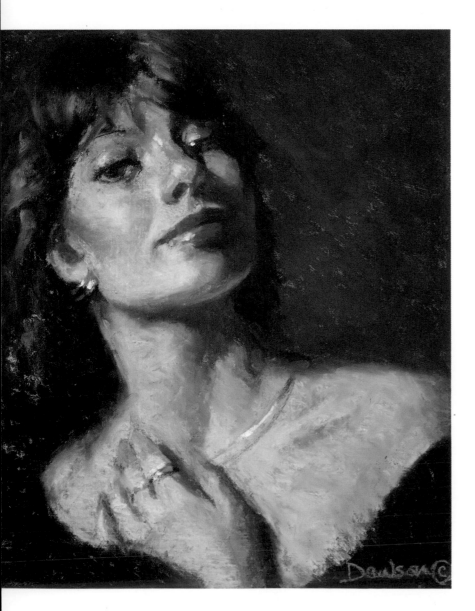

◀ ▼ Kent's Lady

In DOUG DAWSON's *pastel painting, the face is brought into focus by the highlights on lips, eyelid and earring. In the detail, notice the careful placing of shadow beneath the nose.*

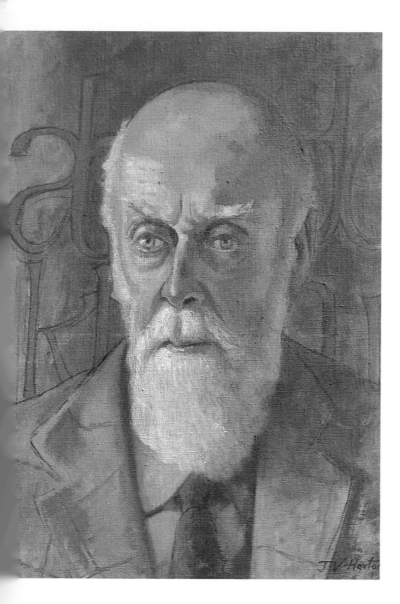

◄ ▲ David Kindersley

It is natural to give more attention to detail when painting an older person, because the lines and wrinkles of the skin are part and parcel of the person's face and character. In this sensitive oil painting, JAMES HORTON *has carefully described the deep-set eyes and bony ridge of the nose without losing sight of the head's overall structure and shape.*

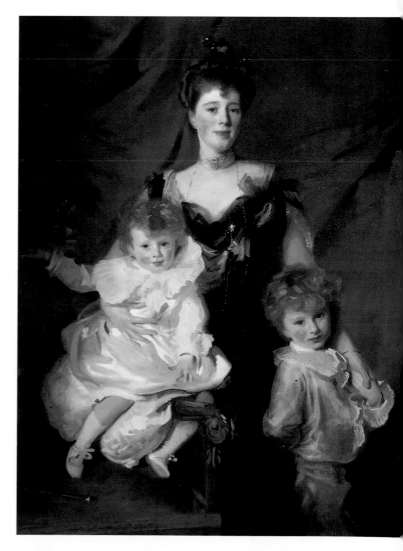

MASTER WORK *Sargent was always in demand as a society portrait painter because he could make his sitters look attractive without compromising his artistic beliefs. Notice how skillfully he has conveyed the delicate texture of the skin, the liquid shine of the eyes, and the subtle difference in color between the children's faces and the mother's. The painting is full of detail, but always only lightly suggested with no more than the deft flick of a brush.*

Mrs Cazalet and her Children (detail)

JOHN SINGER SARGENT (1856–1925)

EXERCISES

Detail and age

In general, detail is more important when you are painting an older person than a younger one. The angular planes, lines and wrinkles of the face help you to convey a true likeness and are also interesting in pictorial terms; there is more to "get hold of" than in a young person. Try to familiarize yourself with the subject by making sketches whenever possible, looking for the characteristic lines of the face. Observe posture too. Then try a painting in which you use as little detail as possible but still convey the impression of the person's age, as the artist has done in the portrait opposite. In this way you will learn how much you can safely leave out.

▼ ▶ **Exaggeration**

These sketchbook studies convey a remarkable impression of the various people's ages and characters. They verge on caricature, but this kind of exaggeration is no bad thing, as it relies on being able to spot the most characteristic elements in a face or body. This is a vital skill in "serious" portraiture.

Wrinkles above mouth typical of ageing people

Shoulders tend to become narrower, and heads sink into neck

Proportion of head to body well observed; bodies tend to shrink in age as well as changing shape

Beak-like nose and small mouth convey age of subject

Glasses help build up impression of woman

Cap and clothing hints at lifestyle and type

Stubble and unkempt hair provide clues about person

Shape of head and drooping mouth are key points here

Characteristic posture, with hand over stomach

◄▲ Different approaches

The point of this exercise was to make a drawing exploring the full range of detail in the face and then to produce a broader statement in color. By focusing on the most important aspects in the painting, such as the deep-set eyes and the shape of the nose and mouth, the artist has produced a fine likeness with very little detail. He has hinted at the wrinkles on the forehead and corners of the eyes, but more detail would have weakened the effect.

Area around eyes much simplified in painting

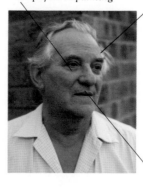

Wrinkles on forehead described in detail in drawing but only lightly suggested in painting

Line formed by edge of cheek is important in defining forms, and features in both drawing and painting

PROJECT 10

Character

Children and young people can be tricky portrait subjects, as it is difficult to pinpoint the physical character of their faces, but as people grow older their faces acquire more character and have a greater "lived in" quality. The subject here, although far from old, has a well-established character which becomes more obvious the longer the face is studied. The gentle slope of the eyes and the half-smile are both quite pronounced, and should be reflected in the portrait. A successful portrait goes beyond merely recording facial features.

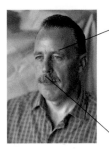

Definite sloping line made by lower plane of brow is an important feature

Mustache follows line of upper lip to define plane

Materials used

Primed canvas

●

Oil paints:
Pale cadmium yellow, Cadmium red deep, Ultramarine, Titanium white

●

White spirit

●

Bristle and sable brushes

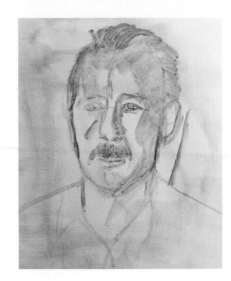

1 *The artist has begun with a brush drawing, using oil paint diluted with white spirit. The placing of the head is established immediately.*

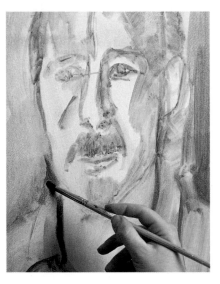

2 *She continues with the drawing, still using thinned oil paint to establish the main planes and the general tonality.*

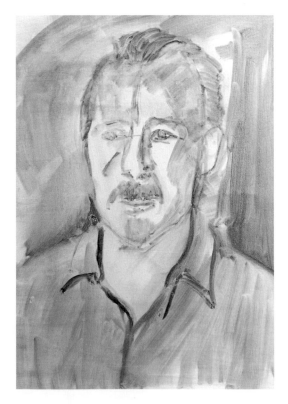

3 *Some artists will draw in monochrome only, but in this case some color has been introduced from the outset.*

4 The basic skin color is established early on, with paint applied relatively flatly to the light-struck side of the face.

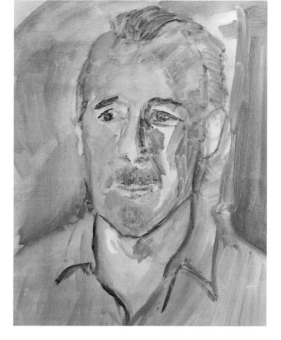

5 Still using thin paint, the artist continues to build up the highlight areas. She is working larger than life size, so there is a good deal of filling in to be done.

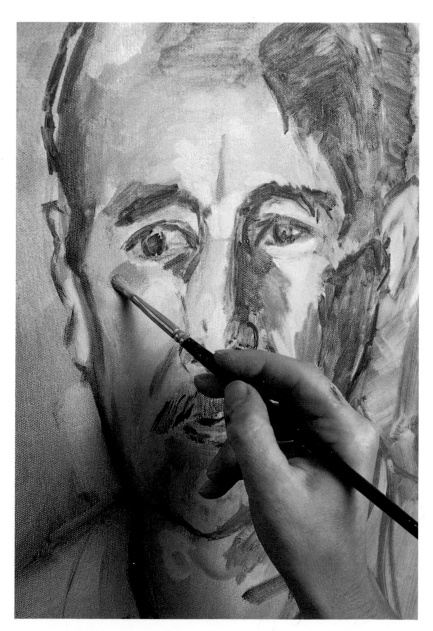

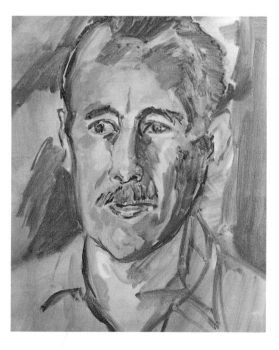

6 Although quite strong color is present on the face the painting still has an overall monochromatic feel about it.

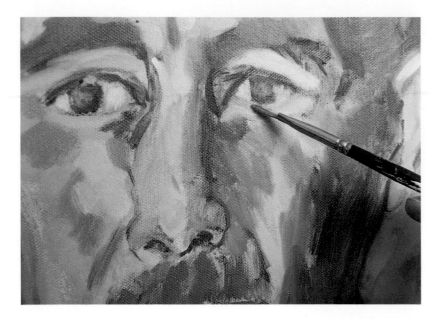

7 *Having built up the main planes of the head, the artist now begins to define the eyes. Notice the greens among the conventional flesh tones on the far side of the face.*

8 *Here again we can see how color is beginning to override the initial strong drawing, and is now being used to construct the forms without the limits of linear drawing.*

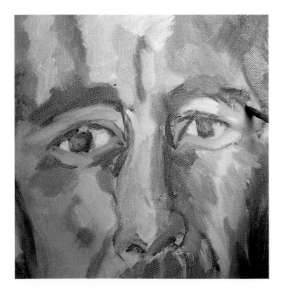

9 *The use of color becomes increasingly bold as the painting progresses, with a variety of colors used on the neck, including blues reflected from the shirt.*

10 *The character of the face, and the textures of skin and hair, are now well established, with the color values playing a dominant role.*

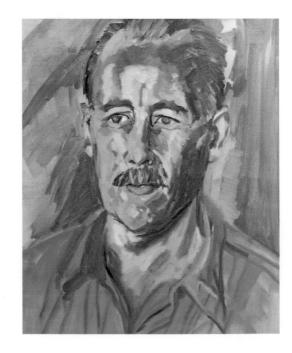

11 This close-up shows detail being added around the mouth and mustache. In this area, too, you can see a lively and intricate network of color patches.

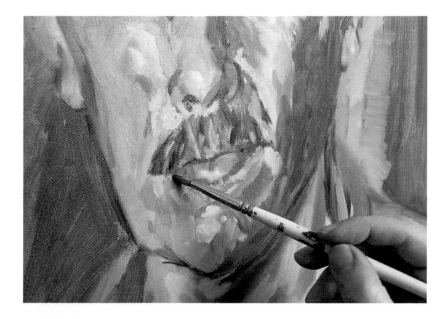

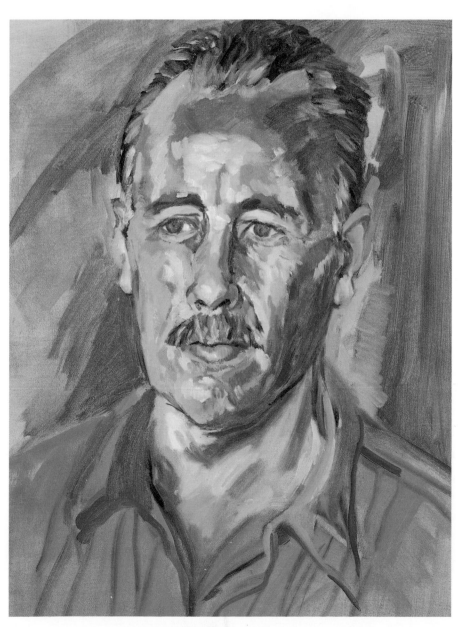

◀ Portrait of John

The final painting, by RIMA BRAY, shows a robust use of color which describes the sitter's character very well and contains sufficient interest in each area to hold the viewer's attention.

Older skin

These two studies, in gouache and watercolor, make an interesting comparison in terms of technique. The gouache allowed the artist to manipulate the paint and to modify colors as the work progressed. In the watercolor, however, more care had to be taken in the early stages to avoid overworking later, and thus losing the luminosity of the paper.

As people age, bone structure becomes more clearly visible

The skin takes on more texture, with lines and wrinkles forming

Materials used

Watercolor paper

●

Watercolor paints:
Aureolin, Cadmium yellow, Cadmium red, Permanent rose, Cerulean blue, Ultramarine, Indigo, Cobalt green light, Cobalt green violet, Raw umber, Red earth

●

Gouache paints:
Cadmium yellow, Yellow ochre, Cadmium red, Violet, Indian red, Cerulean blue, Ultramarine, Indigo, Viridian

Bristle and sable brushes

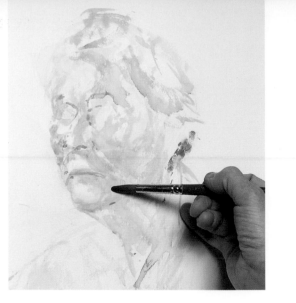

Watercolor portrait

1 *The artist begins in paint immediately, establishing the basic shape and form of the head with blocks of color and little linear definition.*

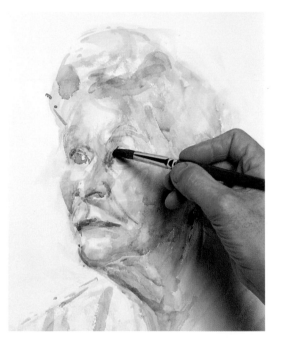

2 *Colors have been built up with a series of over-laid washes, and linear brush strokes are now used to hold them together.*

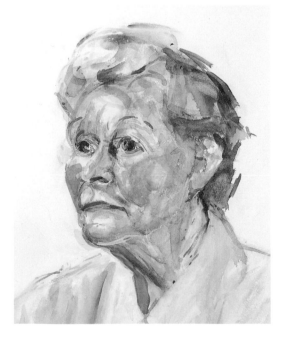

◀ **Dorothy: watercolor study**

The final painting uses the transparency of watercolor in successive layers to portray the feeling of textured skin. Broad but carefully placed washes combine with more controlled linear marks which give DAVID CARR's study great strength.

Gouache portrait

1 *No preliminary drawing is made; the artist begins with color immediately, using the paint thinned to lay broad, transparent washes.*

2 *He uses relatively strong colors in the early stages because they can be modified later with opaque paint.*

3 *Working wet-in-wet, more color is added to the background and neck.*

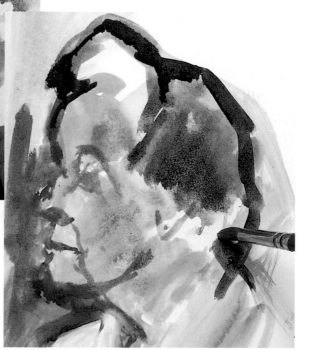

4 *He now begins to define the head, using a dark but still fluid wash to establish the hair. The same color has been used on the background, taken around the brow, nose and chin.*

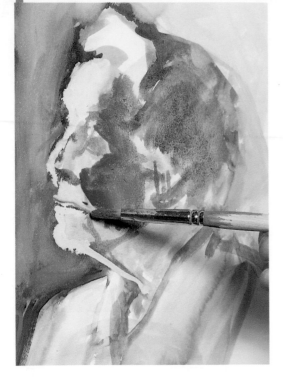

5 Gouache permits the use of quite strong color in the early stages, and here red and green are used boldly.

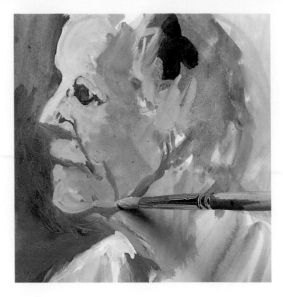

6 Gouache used thinly becomes much lighter as it dries, so more dark color has been added to the hair. Thicker, opaque paint is now used to build up the forms of the face.

7 The brushwork is still vigorous, and the artist resists the temptation to begin detailing the texture of the skin. Instead, he continues with a solid build up of form and color.

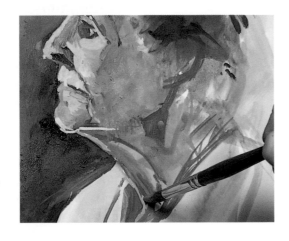

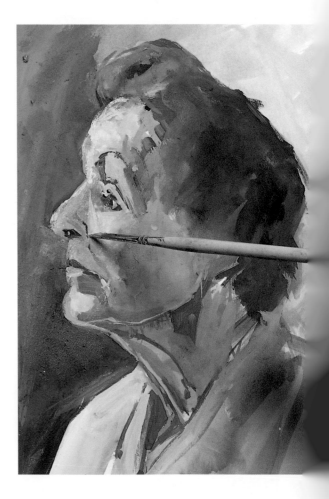

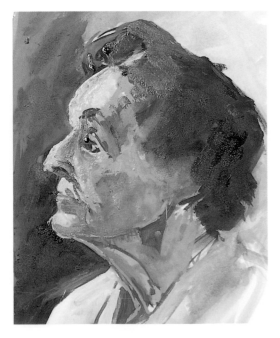

8 The particular character of the sitter is beginning to emerge clearly, and the forms are strongly modeled.

9 With the structure of the face and head firmly established, the artist uses small patches of color and firm lines to build up detail in the features.

10 *Thick, opaque paint is used for the forehead, which is strongly illuminated. The combination of bold colors and subtle gradations of tone and color gives the work a highly painterly feel.*

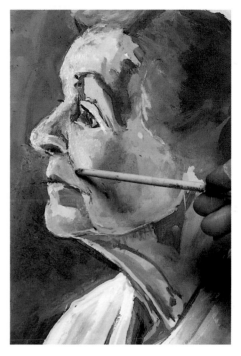

11 *In gouache painting it is best to work from thin to thick, and the full opacity of the medium is again used to add strong color to the cheek.*

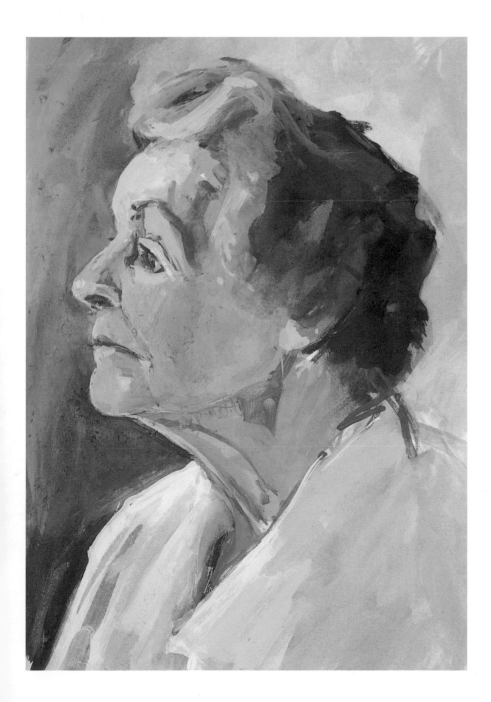

◀ **Dorothy: gouache study**
The final painting shows an excellent match of medium to subject. DAVID CARR's robust brushwork conveys the character and bone structure of the model perfectly.

Exploring the media

Drawing and painting young people presents a whole new series of challenges. One problem, of course, is that children do not pose willingly, so you usually have to work faster than you would with an adult model. Another is that it can be tricky to convey the soft roundness of the forms and the gentle modulations of tone and color – too many sharp contrasts or areas of insufficiently blended color will add years to your subject. You may find it helpful to experiment with a painting medium that allows you to work both rapidly and delicately – pastel, for example, is excellent for studies of children, and so is watercolor as long as you restrict yourself to sketchy treatment.

Pencil shading over a wet wash helps deepen the tone and creates texture

Pencil used carefully on top of watercolor to define the features

Hair is modeled with firm brushstrokes of watercolor

Color sketches

These drawings were all made with pencil and watercolor, with some additional black ink in the case of the boy. The artist began in pencil, adding watercolor as soon as the few basic lines were established, and then used pencil and watercolor together, drawing into a wet wash.

The brown of the forehead is fused with the dark hair to avoid a hard line between hair and face

Pencil hatching over a wet wash creates texture in the hair

Pencil crosshatching used here on top of the base wash to create another tone

Fine pen line used where a strong line and deep tone was needed

Side of face is modeled with overlapping brushstrokes in gradated tones

Highlights on the dark skin are left as plain paper

▼▶ Working with gouache

The background lends itself well to a painterly interpretation. The general tone makes the skin colors stand out, but it is interestingly varied

The creaminess and opacity of gouache was well suited to this subject, as it can create extremely fresh and pure color mixes. The painting was begun with paint diluted to a watercolor consistency and drawn freely with a brush; the paint was gradually thickened as the picture progressed. Although the artist has conveyed the smooth texture of the skins very successfully, the treatment is quite vigorous.

▼▶ Working with pastel

Highlights are more obvious on dark skin, and the artist has made a feature of them in the painting

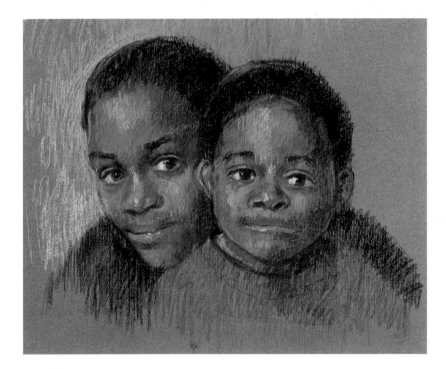

Pastel was a good choice here, as it allowed the artist to complete the portraits in one short session. He used a large box of pastels, choosing a selection of colors closely approximating those in the subject, but he has also mixed colors on the paper surface by crosshatching. The paper chosen was dark, in keeping with the overall tonalities. This also had the advantage of allowing highlights to be added at any stage, as they could be immediately assessed against the paper.

PROJECT 12

Young skin

Painting children is always a challenge to the artist; young skin has a translucent quality that can be hard to capture. Also, because the forms are softer and gentler than in adult faces, the tonal transitions are more gradual, requiring careful handling and an understated approach. Any sudden jumps of tone or color or hard lines will tend to make the subject look older. The artist has chosen to work in watercolor, keeping the skin colors in a high pitch to avoid overstatement.

Although in shadow, this area is still quite pale

Care must be taken not to overdo the shadows beneath the eyes

Materials used

Watercolor paper
•
Watercolor paints:
Naples yellow, Orange, Yellow ochre, Cadmium red, Violet alizarin, Cobalt blue, Cerulean blue, Burnt sienna
•
Pencil
•
Sable brushes

1 *Watercolor is not easy to correct, so it is vital to make a careful preliminary drawing. The artist has used outline only, so that the applied colors stay clean and pure.*

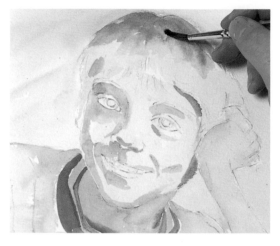

2 *He begins by placing light washes, keeping the colors inside the lines. He is careful not to let the pink flow into the eye.*

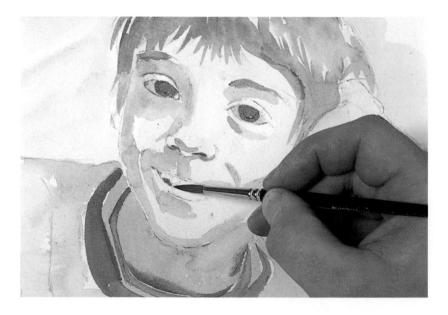

3 *The uneven teeth and cheeky smile are important in conveying the child's character, so this area is treated in detail. Dark color is added around the teeth with a pointed brush.*

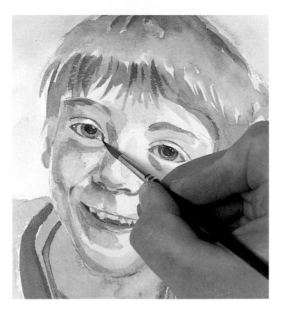

4 The eyes are always the focal point in a portrait, and are treated with equal attention to detail. Notice, however, that the forms of the face have been well established before these fine lines are added.

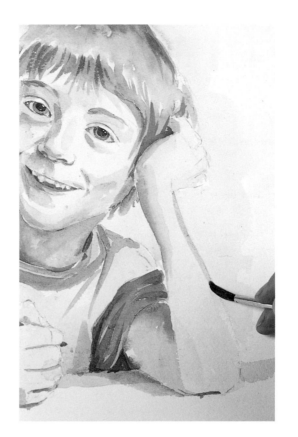

5 The head and body are now complete, and the final touch is to bring the arms up to the same level. Because this arm is in the foreground as well as supporting the weight of the head, it needs to be firmly defined.

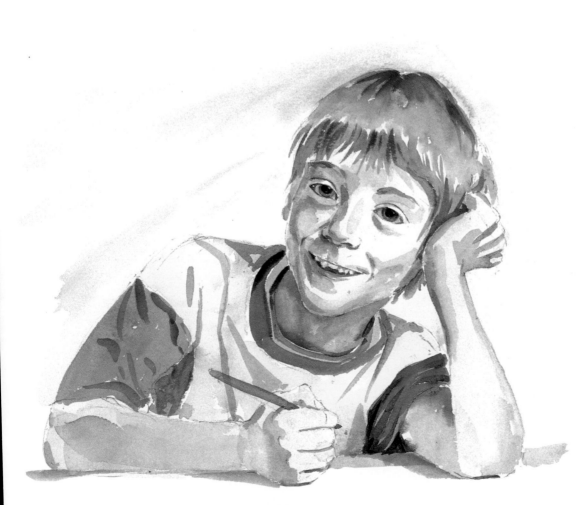

◀ **Matthew**
The fresh appearance of the skin has been retained through a clean and careful application of paint. MARK TOPHAM has kept the tonal contrasts to a minimum and has avoided laying too many colors over one another, which can destroy the translucency of the watercolor medium.

Bringing it all together

Although there are some artists who work mainly by instinct, most good paintings are the result of intellectual effort as well as technical skill. The artist must make decisions at each stage of the work, and at the same time must remain in control of all the elements involved, constantly assessing the composition, the drawing and the balance of colors and tones.

Although there is no single recipe for success in painting, there is one practice that painters have always used, either consciously or unconsciously: they make comparisons. The process of comparing one color to another or one tone to another is essential if you are to keep overall control of the development of a painting. By constantly checking relationships in this way you will develop a sense of

◄ **Aunt Emma**

This haunting pastel portrait by KEN PAINE *is an example of how the artist can edit the subject to create a more powerful effect. Treating the clothing and background in a loose and non-specific manner focuses all the attention on the face. The portrayal of fragile old age is enhanced by the strange greenish lighting.*

The background area creates interest but does not interfere with the focal point

Loosely scribbled lines successfully describe the forms beneath the clothing

balance which will help you to develop the painting as a whole rather than as a series of isolated parts.

Comparison and context

This process of comparison is only an extension of something we do all the time in everyday life, often without thinking about it. If we describe someone as fat, this assessment is made in relation to a "standard model" figure, or to other people who are thin. The same is true of height. A pygmy taller than his fellows would not be tall if standing among a group of Europeans. In painting, a dark color will look less dark if surrounded by black than it will when placed next to a very pale color.

Project 6, where a black man and a white girl were painted together as a double portrait, illustrates this very well. Although the differences in the two skin types were obvious at first glance there were also interesting similarities in the colors used for both skins, which might not have been noticed had each been treated individually.

It is vital to realize that no color exists in isolation; as soon as it is placed among other colors it will interact with them and cause a particular effect. In the same way, skin tones themselves must be seen in context. In real life we never see anything in isolation, and nor do we in painting – our subjects are viewed in relation to a background. In the double portrait, this background plays a vital part in the relationship and unity of the figures; in Project 13 the girl standing against the fireplace is a good example of the way in which large areas of skin interact with a colorful background.

In the latter case the girl is seen as part of an interior, which puts the figure into context in terms of scale, lighting and space. In paintings such as this, where the setting is of equal importance to the figure, the flesh tone element is only one part of a greater whole and therefore must be treated accordingly. You may wish to give special attention to the skin colors, but they must be assessed in relation to the painting as a whole. Your

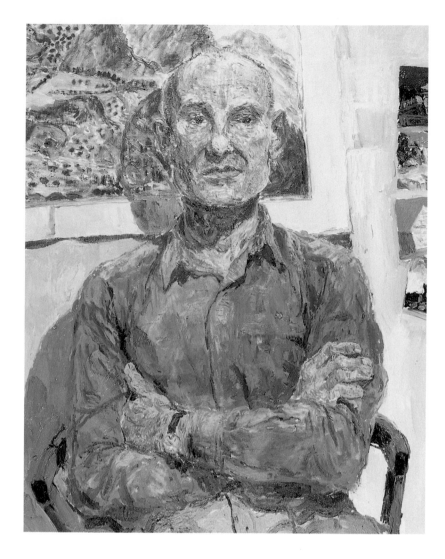

▲ **Max by Rocca Janula (Monte Cassino)**

The pose is important in portraiture, as people have characteristic ways of holding their bodies, hands and arms. In SUSAN WILSON's carefully composed oil painting the direct gaze and firmly crossed arms suggest a strong and uncompromising nature.

The energetic brushwork echoes that on the face, creating a link between figure and background

Blues repeated from the shirt suggest stubble, and also form a color link which unifies the picture

The slight sideways lean of the body raises one elbow above the other, breaking the symmetry of the figure

The pale face, balancing the light tones in the right-hand area of the picture, stands out strongly against the dark clothing and background

▶ **Sarah and Baby Sam**
Paintings such as this, where figures are seen engaged in day-to-day activities, usually have to be worked up from sketches, which enables you to work out a satisfactory composition. JANE STANTON's *pastel is cleverly organized, with the baby's face and bottle forming a strong focal point.*

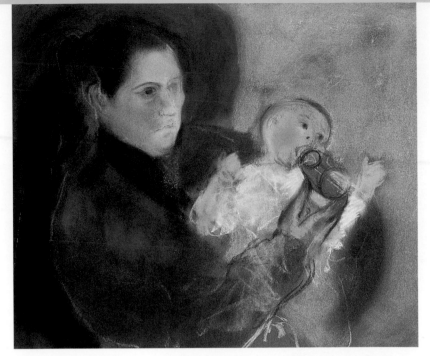

treatment may depend upon whether you are painting a portrait of a specific person or just an anonymous figure within a setting.

Practicing your skills

You will learn to paint mainly by doing it, but a large part of the practical business of painting is learning to look. I mentioned earlier how easy it is to be swayed by preconceptions and thus fail to spot the subtle and sometimes surprising nuances of color. Once you have trained yourself to identify these – which is really only a matter of believing what your eyes tell you – and gained familiarity with your materials, you will be well on the road to success. So paint whenever you can, making notes of the color mixes you use, and when painting is not possible, look at the colors around you and try to decide how you might achieve them in paint.

There may be difficulties in obtaining models for nude studies, but portraits should be no problem; most people are flattered when asked to sit for a portrait. Don't be worried about the result or what they might think; just concentrate on the work in hand, and if it does not succeed, view it as valuable practice. You will learn to paint mainly by painting, familiarizing yourself with your

▶ **Alex Yadala**
Although the majority of portraits are painted indoors, mainly for practical reasons, an outdoor setting can be appropriate for some subjects, and gives you the opportunity to explore the effects of natural light. In her mixed-media (watercolor and pastel) work DOROTHY BARTA *has created a delightfully spontaneous-looking portrait.*

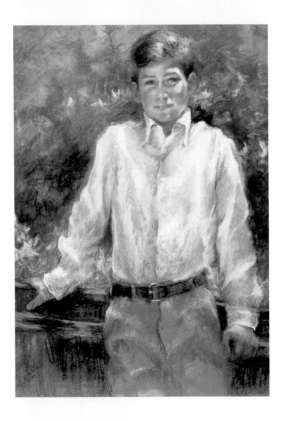

Scribbles and light strokes of pastel overlay watercolor in this area, building up a lively and intricate effect of color, light and shade

Dappled sunlight creates highlights and shadows that can confuse the forms, but here have been handled with confidence in pure watercolor

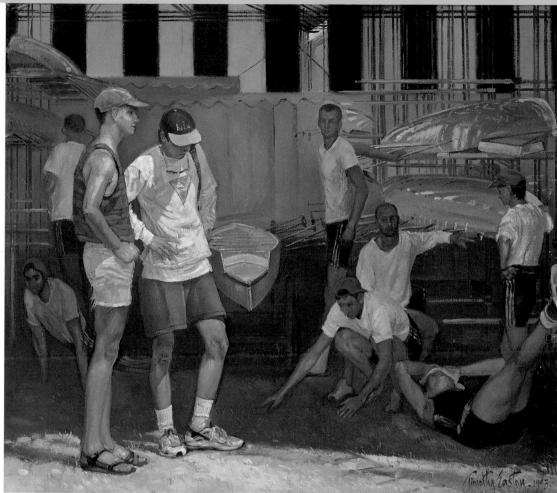

◄ **Easing Down, Henley**

In figure groups, it is important to establish a relationship between the people. The men share a common occupation, so are linked in "narrative" terms, but TIMOTHY EASTON *has also set up visual links, both by overlapping the figures, and by using a controlled palette, with colors and tones repeating from one area of the picture to another.*

materials and making a mental note of all the color mixes you use and their effects.

In the context of practice, self-portraits are of great value. Using yourself as a model allows you to attack – and hopefully solve – a whole range of problems associated with painting skin. All painters have made self-portraits at some point in their careers, and some, notably Rembrandt and Van Gogh, documented their passage through life with frequent renderings of their own faces. But initially, don't try to produce high art – use your face as a means of learning your craft and sharpening your skills. Forget preconceptions and look for the real colors – you may be surprised at how many there are.

Composing the picture

Painting a self portrait can also help you to plan your composition. This is of crucial importance; indeed, composition should be the first consideration in your decision-making

The bright colors and strong tonal contrasts initially draw the eye, but the direction of the man's gaze leads in to the other figures

Warm ochre repeats the foreground color, while the contrast of light and dark tones balances those in the middleground

process. Even before you begin to analyze the colors and work out how to mix them, think about how you are going to place the face or figure on your canvas or paper.

Unfortunately there are few hard and fast rules about composition; it is mainly a matter of balancing shapes and colors and achieving a relationship between the various elements in the picture. But there is one central tenet that is worth remembering, which is that the picture will be more interesting if you avoid total symmetry.

Take the simplest example of a head-and-shoulders portrait, which you may think does not need to be "composed." But it does,

because if you choose a frontal view with the head placed right in the middle of the picture area the effect can be very dull; symmetry is static and does not give the viewer a sense of involvement. Head-and-shoulders portraits are usually painted with the head seen at a slight angle, and placed so that there is more space at one side than the other.

You also need to consider the way in which you "crop" the head. The head and neck are one unit, so in a head and shoulders portrait the neck is always included, and sometimes part of the shoulders. In a three-quarter length, the body is normally cropped below the hands; not only because hands can form an expressive element but also because arms with no hands would look rather odd.

If you are tackling a full-length figure, whether a portrait or a nude, try to use the room setting and any props in a way that contributes to the picture. In a life class this can be tricky because there is not usually much in the way of furniture, but you may find that you can use the upright shapes of an easel as a balance to the figure, or bring in some objects on a wall, such as pictures or coats draped over a windowsill.

Painting someone in their own home or yours gives you more choice of props, and you can rearrange furniture and so on to achieve an interesting balance. But you do not have to paint faces and figures in a precise context; a device often used for head-and-shoulders portraits and standing figures is to leave the background undefined so that space behind the figure is suggested rather than described. This can create a dramatic effect because it focuses all the attention on the face or figure.

When planning a painting, it is a good idea to make a few quick sketches to try out various different arrangements. Or if you have a Polaroid camera, use this as an aid. This immediate reduction to a small-scale image on a two-dimensional surface will give you an idea of the general distribution of colors, tones and shapes. But do not be tempted to try to work from photographs; they are no substitute for real life, and will hinder rather than help you.

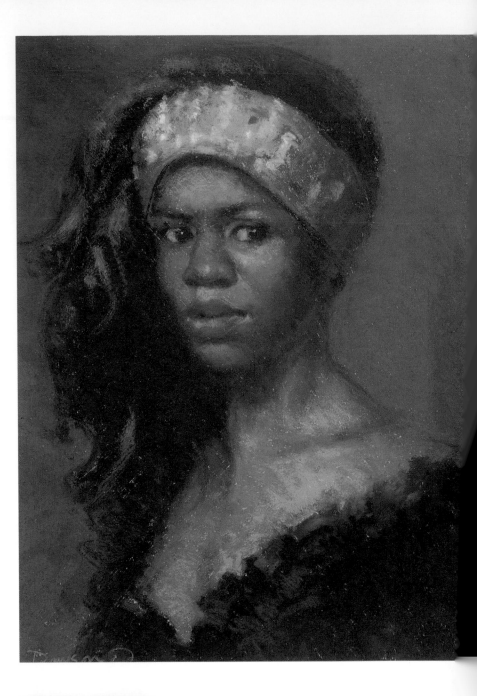

The painting has a compositional rhythm. The eye travels from the shoulder and neck, around the hair band and downward again with the sweep of hair

The dark dress balances the similar tone of the hair, and also leads our eye into the picture

▲ **Linda**

In his striking pastel painting, DOUG DAWSON *has combined a carefully planned composition with dramatic tonal contrast and exciting use of color. Notice particularly the way he has enlivened the skin colors with a paler version of the background color.*

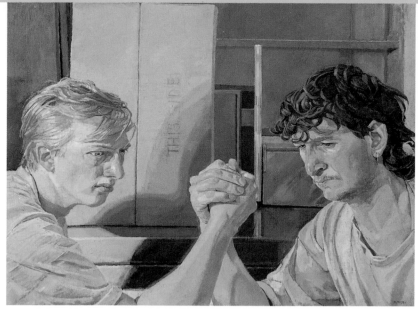

The hands are the subject and focal point of the painting, and care has been taken over details such as the shape of the fingernails

The yellowish indoor lighting contributes to the atmosphere of the painting and unifies the colors of skin and background

▲ **Contest**

Figure groups can sometimes be treated in a generalized way, but in DAPHNE TODD's oil painting it was important to convey the concentration on the two faces. This necessitated a high degree of attention to the features, and each face is a fine portrait. The way the picture has been composed focuses attention on the hands and faces.

MASTER WORK Degas turned more and more to pastel towards the end of his life, and was responsible for establishing the medium as one that is worthy of serious consideration. A superb draftsman, he was able to transform the most ordinary subjects into complex and powerful statements that rank among the greatest achievements in European art. In this pastel painting, the daring composition and sense of solidity create a presence far exceeding the subject matter. Both color and detail have been played down in order to enhance the monumental pale shape of the woman.

Standing Nude EDGAR DEGAS (1834–1917)

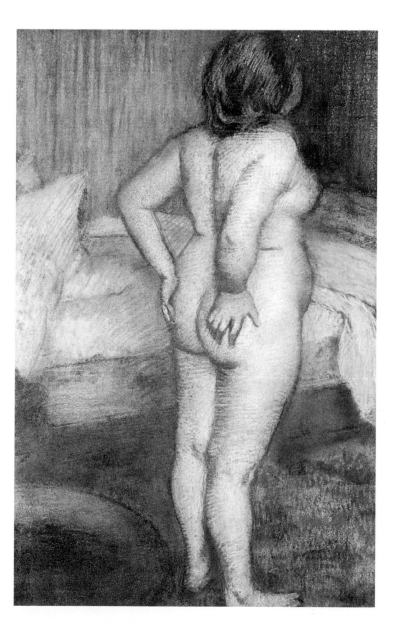

Composing the nude

The unclothed human body presents such a variety of shapes, forms and colors that you can often make a composition from this and nothing else. The project that follows shows the nude seen in a specific context, but the object here is to experiment with different ways of treating the body alone. Using any medium you choose, make some sketches to try out various compositions, sometimes showing the full figure and sometimes cropping it so that it makes an interesting shape or set of shapes on the paper.

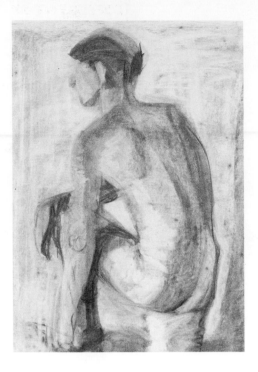

▲ Light and dark

In this charcoal study, the artist has again made successful use of cropping, establishing a strong tonal structure that defines the forms of the body as well as creating a satisfying pattern of lights and darks.

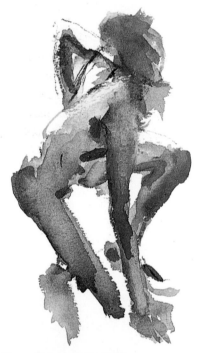

▲ Drawing movement

Here the study is essentially one of movement, which is eloquently described in loose, broad washes of diluted ink. Brush and wash is an excellent medium for rapid studies of this kind, as it forces you to avoid detail and look for the most important elements of the pose, such as the main masses and the distribution of weight.

▶ Pattern and rhythm

Like the study shown on the left, this elegant watercolor also beautifully conveys a sense of movement. Here, however, the artist has taken a different approach, cropping the subject so that the body and arms create a flame-like pattern weaving from bottom to top of the picture.

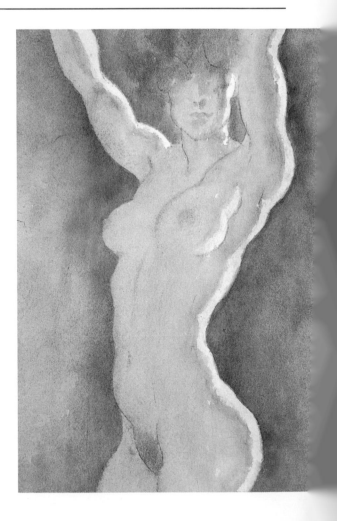

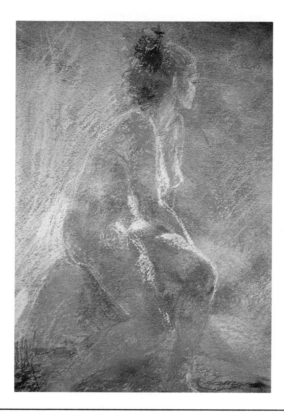

◄ **Using light tones**

The theme of this delightful pastel sketch is color and light. Although the thighs and knees are strongly modeled, there is a minimum of tonal contrast overall. Notice the way the artist has varied the direction of her pastel marks, so that the criss-crossing strokes in the background give a feeling of movement and shimmering light.

▼ **The body in composition**

This watercolor is a perfect example of the way the body can form an entire composition, with no need for "props." One leg makes a strong vertical and the other a horizontal, while the arms are opposing diagonals leading upward to the bent head. The play of light has been carefully observed, with the pattern of lights and darks contributing to the liveliness and strength of the image.

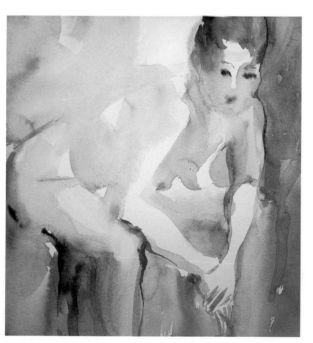

▲ **Composing for emphasis**

The fascination of this pose lies in the way the body is thrust forward, with the arms resting firmly on the knees and the head continuing the upright line of the arm. The artist has emphasized this in her watercolor sketch by taking the curve of the buttock right to the edge of the paper so that the body appears to be propelled forward.

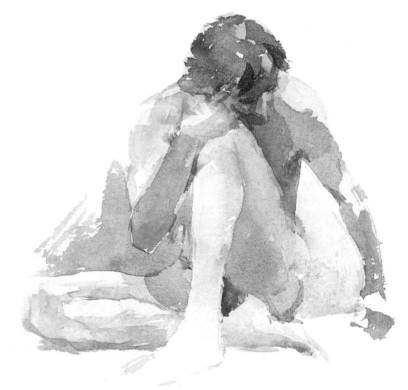

The nude in context

The attraction of this set-up was the interaction of the body against the busy colors of the background. There were difficulties, as several colors within the background were very similar to the skin tones. However, the artist was able to resolve this potential problem, and in so doing found surprising color links between skin and background, such as the greens in the shadow area of the wall appearing on the torso, and the purple/violets running through the painted decoration recurring on the figure in various places. As mentioned earlier, reflected light always affects skin tones, as colors from the background will bounce back, causing important changes to those of the body.

Materials used

Primed and pre-toned canvas

●

Oil paints:
Cadmium yellow, Lemon yellow, Naples yellow, Yellow ochre, Alizarin crimson, Indian red, Vermilion, Cerulean blue, Ultramarine, Burnt sienna, Burnt umber, Raw sienna, Black, Titanium white

●

Turpentine and linseed oil

●

Bristle and sable brushes

1 *The artist begins with a brush drawing, using burnt umber diluted with turpentine. The aim of the drawing is to establish the positioning of the figure in relationship to both the background and the proportion of the working surface.*

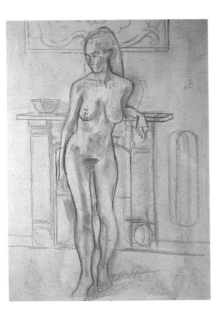

2 *The monochrome drawing is taken only as far as is needed as a guideline for the color application. An over-elaborate drawing can inhibit the use of color for fear of spoiling the drawing.*

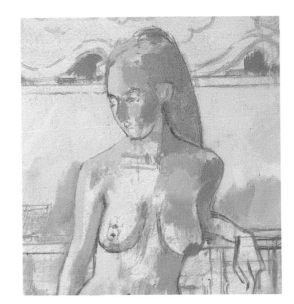

3 *You will not be able to judge the colors needed for the figure until some of the background color is in place, so the two areas are worked simultaneously. The first mixtures of color are always to some extent approximate.*

4 It is never wise to take one area to a more finished stage than another, so the artist continues to work all over the canvas.

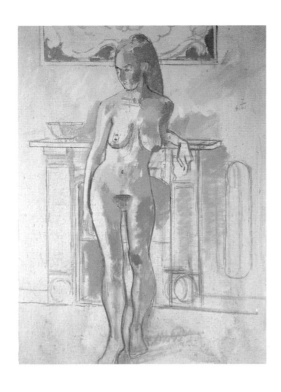

5 At about this stage you can begin to subtly alter the drawing in a painterly rather than a linear way. Here two colors are placed side by side, which creates an edge.

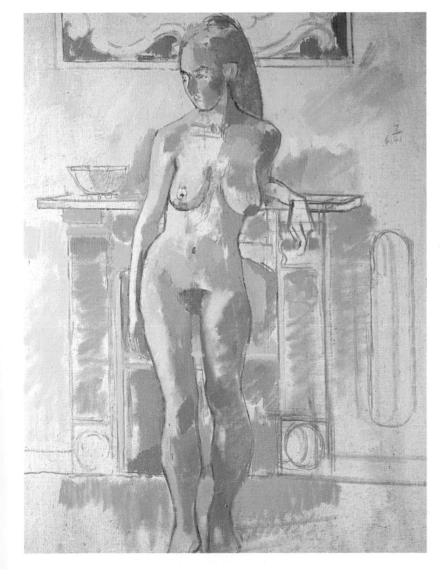

6 Although the main colors have been blocked in to establish a skeleton of the painting, it is still a long way before real color-value judgements can be made.

7 The artist uses a palette knife to remove surplus paint, thus preserving the weave of the canvas. Methods such as this are of course personal to each artist, depending on preferences for thin or thick paint.

8 The torso has now been well developed with applications of color, and a finger is used to gently blend the adjacent colors. Many painters use their fingers occasionally in this way, but again, such methods are personal, and it is up to each person to decide if techniques such as this suit their approach.

9 The figure is now quite well developed in relation to the background. Although areas of the background remain unpainted, the immediate area surrounding the figure is well established in terms of color and tonal values.

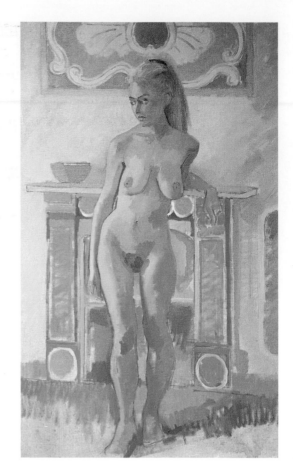

10 A fine brush is now used to redefine some areas of drawing, a useful practice at this stage. As before, the line need not be too prominent and can easily be overpainted.

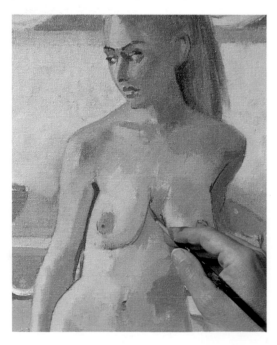

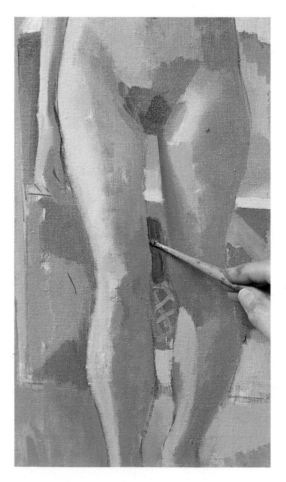

11 The drawing is now altered in the same way as in step 5, by redefining an edge with a block of color. The dark paint which the artist is cutting in around the inner leg improves the contour as well as boosting the contrast in that area.

12 *This detail shows the way in which the figure relates to the background in terms of tone. Notice how the tones alter; the light-struck side of the right arm is lighter than some parts of the background but darker in one small area, while the shadowed side of the body is dark against light. This sort of interchange is of fundamental importance in a life study.*

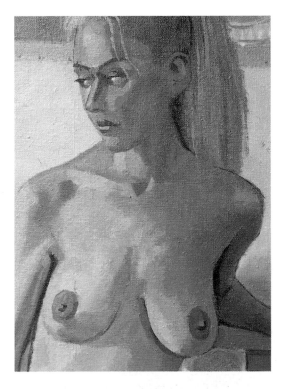

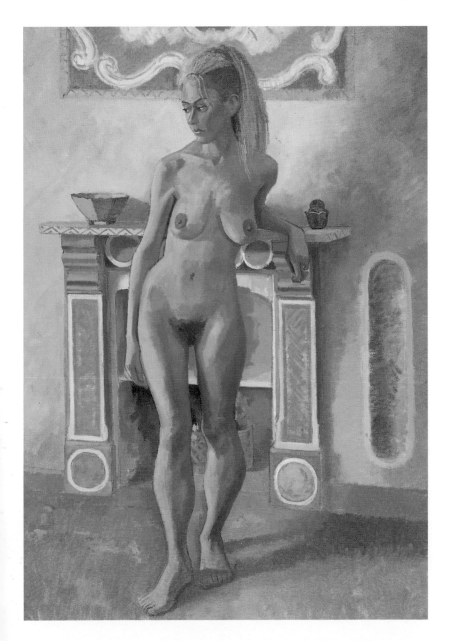

13 *Here you can see the development of the head and chest areas, with the character of the head now much more defined than previously, and subtle color relationships built up across the shoulders and breasts.*

◄ **Nude by a Mantelpiece**

The finished painting shows a sensitive handling of color, and is also interesting in compositional terms. JAMES HORTON *has taken considerable care in setting up the pose and arranging the other elements, so that the vertical lines of the mantelpiece counterbalance the sinuous curves of the body, which are in turn echoed by the scrolled decoration visible above the model's head.*

PROJECT 14

Exploring color relationships

These three pastel studies were made first to explore the general "key" of the skin color, second to exploit color relationships and third to experiment with a dark paper color. In all pastel work, the paper color plays an important part in determining the key of the final painting.

Skin appears dark against light background

Here it appears lighter by contrast with black

The rich red has been stressed in the painting, but the black background omitted

Materials used

Pastel paper

•

Compressed charcoal

•

Soft pastels:
Violet, Cobalt blue, Ultramarine, Olive green, Burnt sienna, Raw sienna, Black

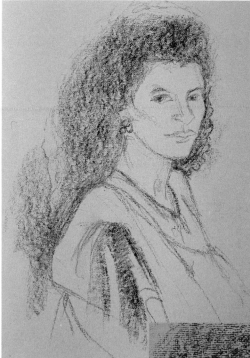

Study 1

1 *The artist begins with a charcoal drawing. Because the charcoal will mix with the overlaid pastel colors and darken them, she has used tone only for areas that will be dark, such as the hair.*

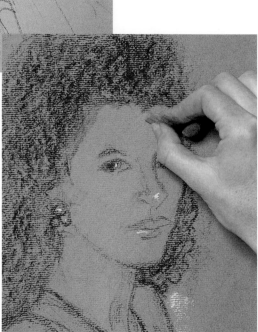

2 *There is already enough indication of tone on the hair to assess the tonal values and color needed for the face. Light strokes are made with the side of the pastel stick.*

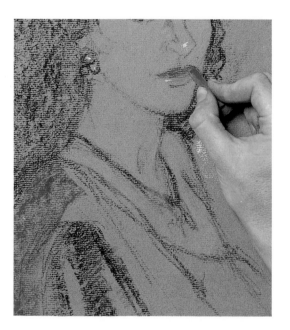

3 *A broad stroke of crimson establishes the color of the model's wrap, and the same crimson is now used for the lips, with the tip of the pastel stick employed to give precise definition.*

4 This photograph shows how pastels can be mixed by laying one over another on the paper. A purplish red has been applied on the cheek and neck, and highlights are added with pale yellow.

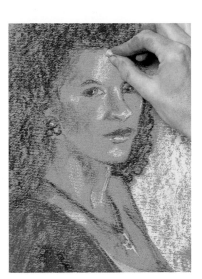

5 To make the edge of the cheek and brow stand out more strongly, she now adds black around the face. The stick is used on its edge, with a firm pressure that yields a crisp line.

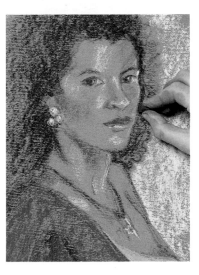

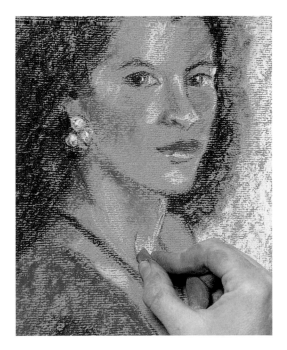

6 There is always a danger of smudging pastel paintings as you work, so fine details are left until last. Here a linear touch of mid-brown is applied.

▶ **Francie**

In the final stages of HAZEL SOAN's painting, a little light blending was done to soften the tonal gradations of the skin. Notice how the black of the hair has been applied lightly so that the gray paper shows through to suggest small highlights.

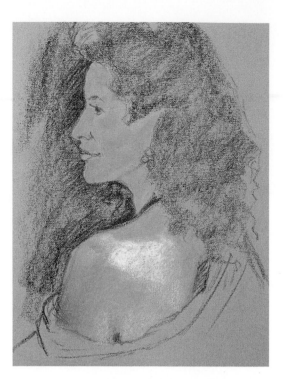

Study 2

1 *Here the model has been placed in profile to give maximum contrast with the dark background. As before, the drawing has been made in charcoal, and a basic mid-tone laid over most of the face and neck. In the shadow areas, the gray paper is deliberately left uncovered.*

2 *The purple now laid over the black and gray of the background helps to qualify the skin tone. Throughout the building-up process the artist considers the effect of juxtaposing various ready-made pastel colors.*

3 *The crimson of the cloth encases and enlivens the flesh tones. Compare this detail with step 2, where the skin is seen only against gray, and you will appreciate the effect of this juxtaposition of colors.*

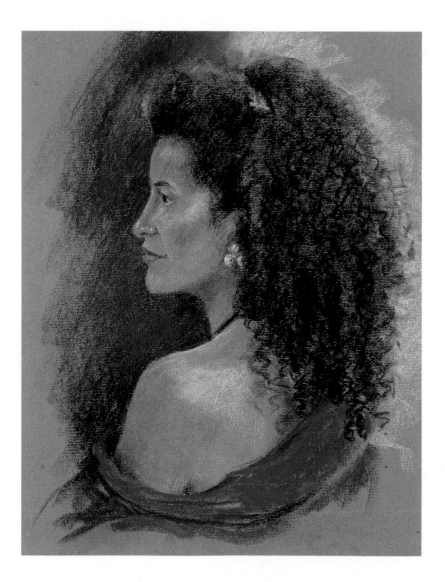

◄ **Francie: profile view**
The finished painting shows how HAZEL SOAN *has brought out the flesh tones by surrounding them with purple, black and crimson. Understanding how to play colors off against each other is particularly important in pastel work because only limited color mixing is possible.*

Study 3

1 *Again the work is begun in charcoal, with the underdrawing establishing a fairly full tonal structure. Because of the dark paper, the base tone used for the skin is lighter than that chosen for the previous study; the color of the ground influences the painting right from the outset.*

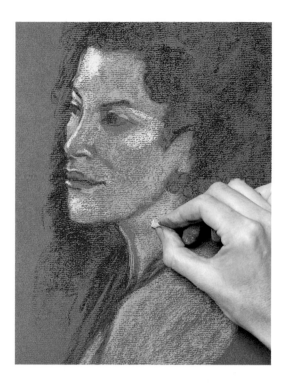

2 *It is not necessary to put color on the background before building up those of the skin because the background already exists. The artist thus works on the skin immediately with darker and lighter tones of the basic skin color.*

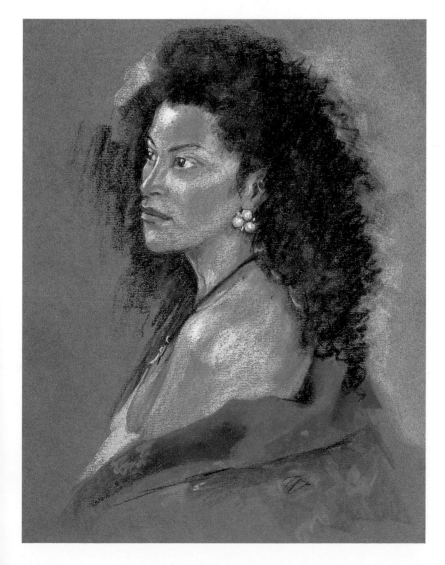

◄ **Francie: side view**

Because of the paper HAZEL SOAN has chosen for her final study, the colors are stronger and the tonalities darker than in the other two. It is also interesting that the crimson cloth worn by the model does not register so prominently, as there is less contrast, in either tone or color, between it and the background.

Portrait head

In this painting, the aim was to convey the dark tonalities and tonal contrasts without losing the fascinating variety of colors. Highlights tend to be more obvious on dark skin than on light, and these sharp, positive divisions between light and dark make black skin easier to read in terms of form; changes of plane are more clearly defined by the highlights than on white skin, which reflects less light.

Contrasts of tone are noticeable, but colors are rich and subtle

Materials used

Primed and toned canvas board

•

Oil paints:
Cadmium yellow, Lemon yellow, Naples yellow, Yellow ochre, Alizarin crimson, Indian red, Vermilion, Cerulean blue, Ultramarine, Burnt sienna, Burnt umber, Raw sienna, Black, Titanium white

•

Turpentine and linseed oil

•

Bristle and sable brushes

1 *The board has been given a relatively dark overall tone, in keeping with the subject, and the drawing is made with diluted burnt sienna.*

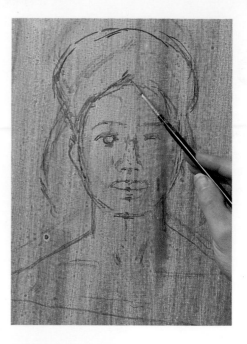

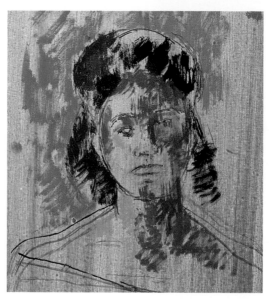

2 *In order to establish the general pitch of the skin, patches of color have been laid on the background before work begins on the face itself.*

3 *The artist is working mainly in mid-toned color, but has brought in one or two highlights as well so that he can get a feel for the contrasts.*

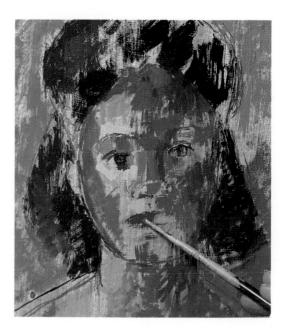

4 The angle of the head altered slightly as the sitter relaxed into the pose, so further definition around the eye was needed in order to stabilize the drawing.

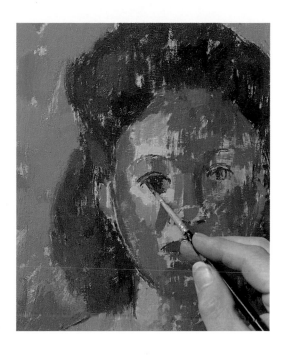

5 The yellow dress is painted in before the rest of the picture becomes established.

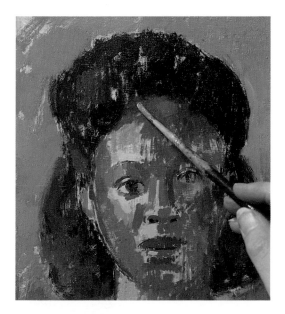

6 The junction of the forehead and hair is very indistinct because of the overall darkness of the tones, so the colors are gently blended by laying one over another.

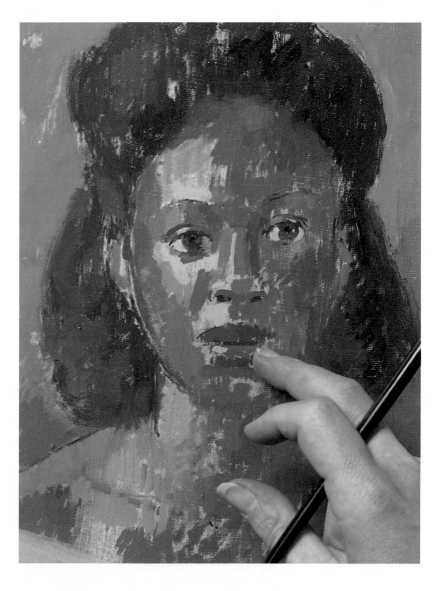

7 Here again colors are blended; this time the artist uses his finger, which is the perfect "tool" for the job.

8 *The painting is now at about the half-way stage, with drawing and colors solidly established, although there are areas of board that remain unpainted.*

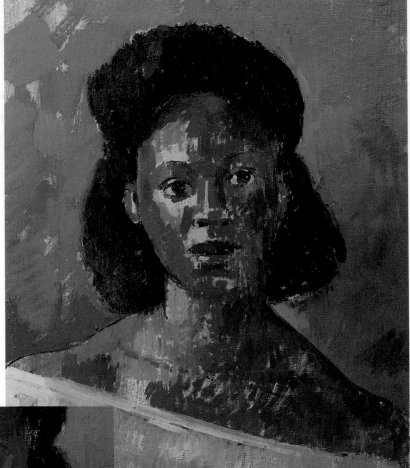

9 *The highlights around the eye socket are strengthened with thick, juicy paint, giving a feeling of solidity to the forms. Notice how the area of neutral, unpainted board beneath the other eye still works quite well.*

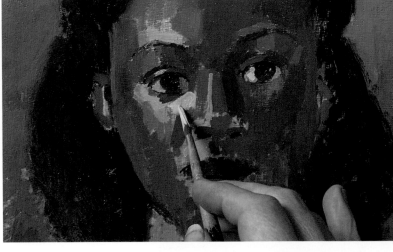

10 *Moving from one area of the picture to another, the artist continues the process of refining the tones and colors.*

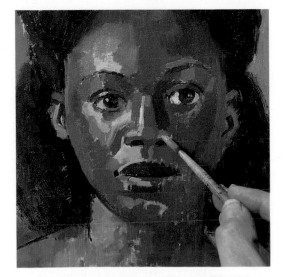

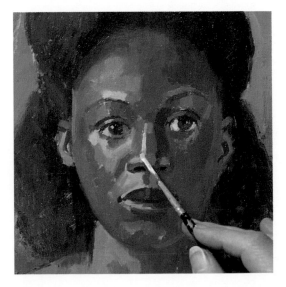

11 *The highlight on the nose is first modified and then sharpened to achieve the strong contrast that defines the shape.*

12 *Some attention is now needed on the chest and neck to prevent this part of the painting getting left behind the others. A dab of slightly lighter color describes the collar bone.*

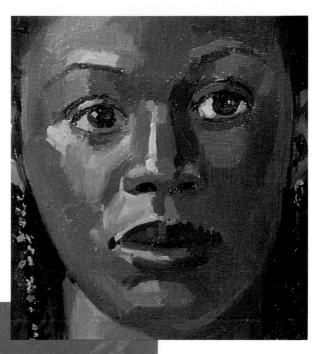

13 *This close-up of the face shows that the artist has achieved a good balance of tone and color as well as a convincing likeness of the sitter.*

◄ **Beverley**

In the final painting you can see the importance of the other colors JAMES HORTON has chosen for the composition. The blue back-ground and yellow dress provide a counterbalance for the rich skin colors.

EXERCISES

Painting a self-portrait

You never need be stuck for a portrait model, because you always have one at hand – yourself. This is an excellent opportunity for studying skin and hair colors and the shapes and forms of individual features, and the great advantage is that you are not reliant on another person's time and goodwill. Experiment in front of a mirror with different viewpoints and compositions, and try to convey something of your own character and your feelings about yourself, just as you would if you were painting someone else.

▲ **Painting the "wrong way round"**
Most self-portraits are painted in front of a mirror – although you could also use photographs. The mirror, of course, produces a reversed image and this photograph of the artist with his self-portrait shows the results of the reversal process very clearly. If you know the person in the painting you can tell whether it has been done from a photograph – features such as hair partings will be on the "right" side.

▲ **The familiar image**
Something to bear in mind when painting self-portraits is that we do not see ourselves as others see us – we are only familiar with the reversed image provided by the mirror, so your self portrait will also be reversed. Also, as you can see from the photograph, a mirror image of our face is much smaller than the face itself, and yet we automatically read it as the same size.

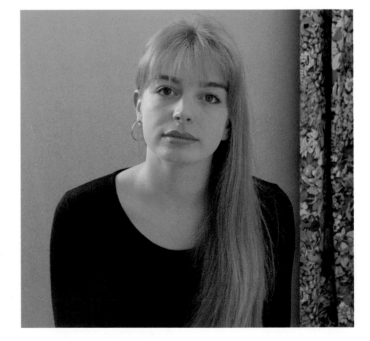

▲ **The unfamiliar image**
A photograph, on the other hand, shows us as everyone else sees us. This is one reason why photographs often look odd and unfamiliar – they are providing an image which, to us, is the wrong way round. A good way to check any slight asymmetry in your face (few faces are completely symmetrical) is to compare a photograph with your mirror image.

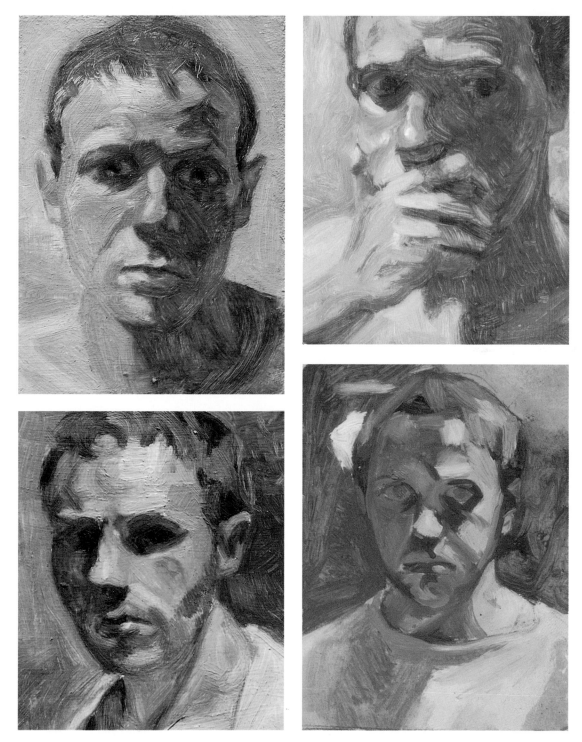

► **Experiment in self-portraiture**

In this group of self-portraits in oils the artist has handled the paint freely and with great expression. There is no superficial detail, but the likeness is completely convincing. He has experimented with various viewpoints, lighting effects and placings of the head to convey different atmospheres.

1 *Full frontal view, with the head touching the top of the canvas, conveys a feeling of intensity.*
2 *Here the inclusion of the hand creates drama as well as suggesting some thought process in the artist's mind.*
3 *The head is now pushed farther back, showing more of the neck and shoulders. The side lighting creates a strong tonal pattern.*
4 *With the light coming from above, the dark shadows make the eyes almost invisible, creating a mysterious, brooding atmosphere.*

Index

Credits

1 *Hill*, in pastel by Kay Polk; 2 *Duncan Stewart*, in oil by Daphne Todd; 51 from the collection of Dr H. Horsley; 53 from the collection of A. J. Moses; 56 left reproduced by kind permission of Susannah Church; 59 reproduced by courtesy of the Fitzwilliam Museum, Cambridge; 81 below reproduced by courtesy of The Fine Art Society/Bridgeman Art Library, London; 100 reproduced by kind permission of the University of Buckingham; 104 from the collection of B. Wunder; 105 right reproduced by courtesy of Agnew & Sons/Bridgeman Art Library, London; 106 sketches by Moira Clinch; 107 studies of a man by James Horton; 116–117 all sketches by James Horton; 121 reproduced by courtesy of the Ferner Gallery of Fine Art, Auckland, New Zealand; 125 right reproduced by courtesy of the Visual Arts Library, London; 126 above left *Nude Study* by Karen Raney; below left *Figure Study* by Mike Hoare; below right *Kathleen Standing* by Donald Holden, from the collection of Richard and Betty Smith; 127 above *Golden Girl* by Maureen Jordan; below left *Resting*, in watercolour by Maureen Jordan; below right *Nude* by Terry Longhurst; 140 above right *Self Portrait*, in oil by James Horton; 141 self portraits, in oil by Ashley Hold. The paintings on these pages used the following media (clockwise from left): 8–9 oil, pastel, oil, oil; 18–19 pastel, oil, pastel; 50–51 oil, pastel, oil, watercolour.

Quarto would like to thank all the artists who kindly submitted work for this book, including the following who carried out demonstrations: Rima Bray, David Carr, Brian Dunce, James Horton, Ken Paine, Karen Raney, Ian Sidaway (22, 23, 26–49), Hazel Soan and Mark Topham.

The help of the following models is also appreciated:

Matthew Collis, Dorothy Dawes, Tim Donnelly, John Henshaw, Marcus Hinds, Victoria Lloyd, Maleni Manuel, Amanda O'Reilly, Sadie Rule, Justine Thomas, Beverley Williamson, and Francie.